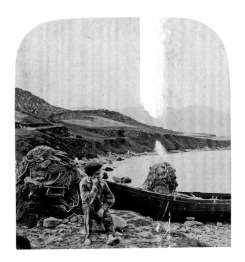

the Irish

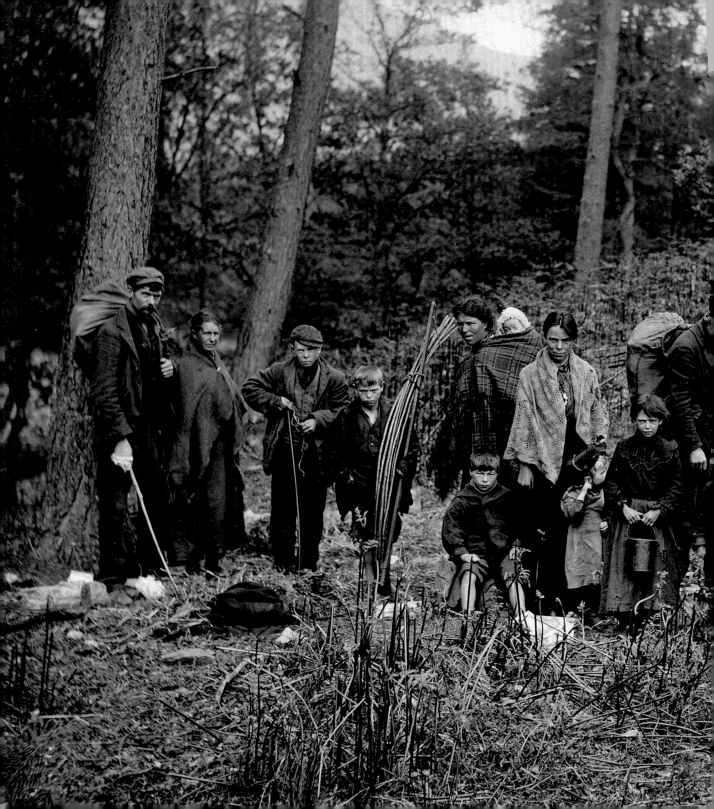

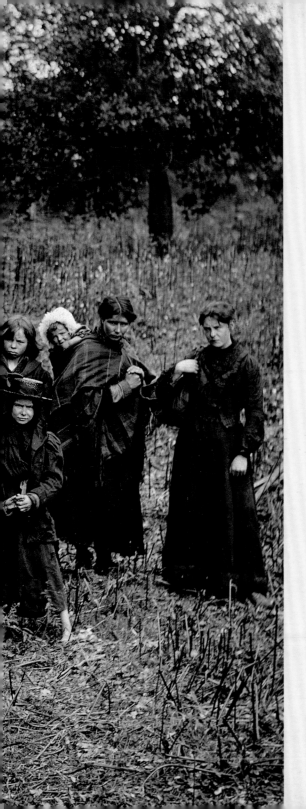

the Irish

a photohistory 1840–1940

sean sexton and christine kinealy

with 271 illustrations

Thames & Hudson

Page 1 Portrait of a boy, Teelin, County Donegal.
Photographer unknown, *c.* 1865.
Pages 2–3 Irish vagrants in Scotland.
Photographer W. Reid, *c.* 1909.
Page 6 Belfry of Aghadoe, County Kerry.
Photographer Mr Mercer, 1864–69.
Page 7 West doorway of Kilmalkedar Church,
County Kerry. Photographer Mr Mercer, 1864–69.

First published in the United Kingdom in 2002 by
Thames & Hudson Ltd, 181A High Holborn,
London WC1V 7QX

This compact edition first published
in paperback 2013

British Library Cataloguing-in-Publication Data
A catalogue record for this book is available from
the British Library

ISBN 978-0-500-29079-8

Printed and bound in China by C & C Offset
Printing Co. Ltd

To find out about all our publications, please visit
www.thamesandhudson.com.
There you can subscribe to our e-newsletter, browse
or download our current catalogue, and buy any titles
that are in print.

contents

8 introduction

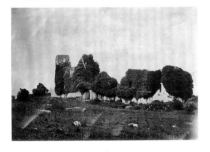

chapter 1

32 land, landlords and the big house

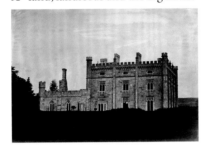

chapter 2

68 poverty, famine, evictions

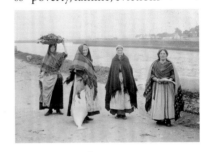

chapter 3

120 from union to partition

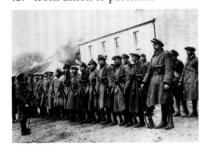

chapter 4

172 towards a modern ireland

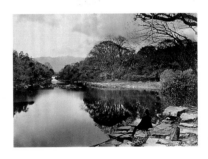

215 chronology

217 further reading

218 list of illustrations

222 acknowledgments

223 index

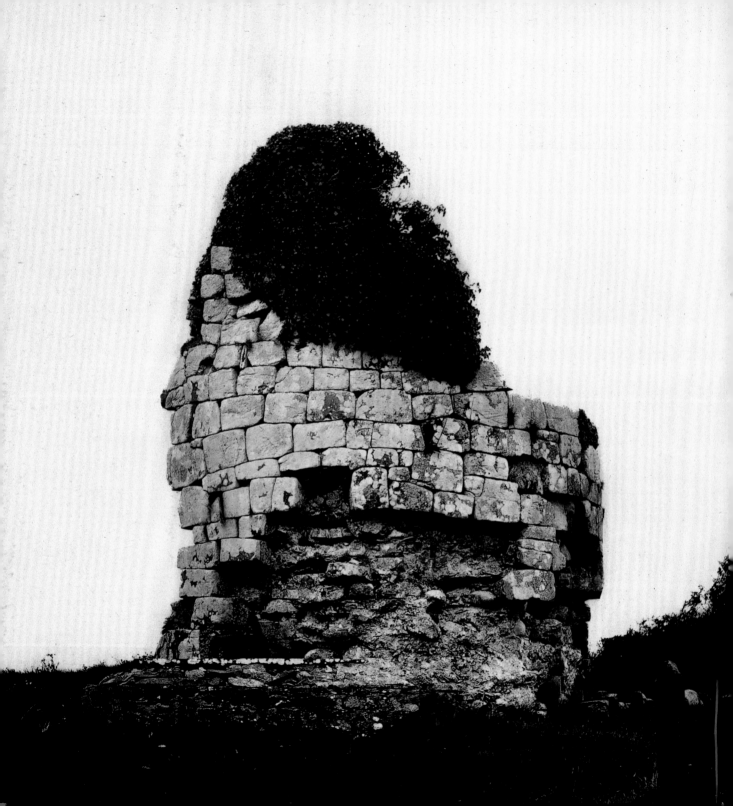

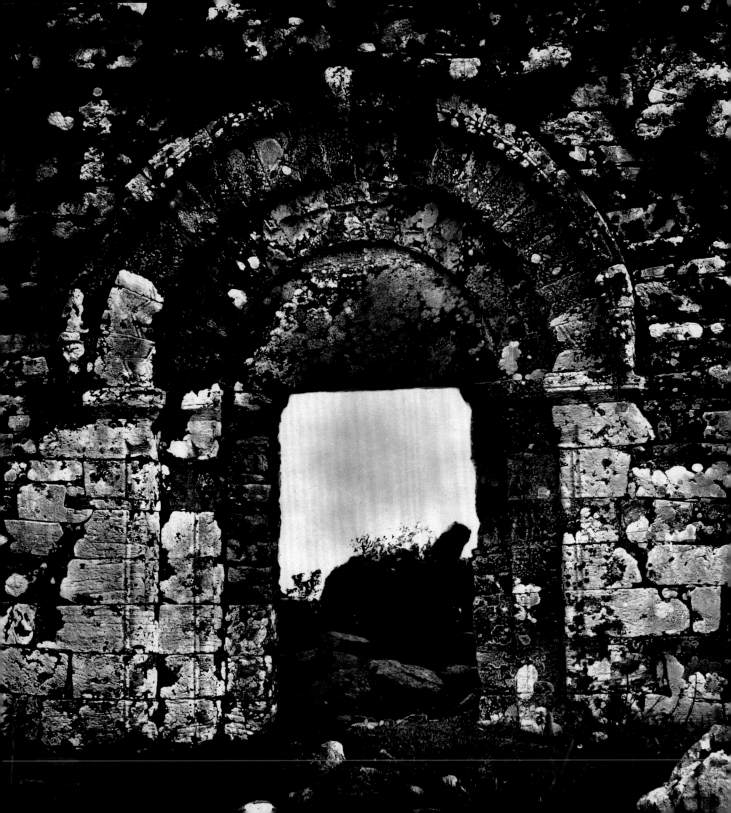

introduction

In 1800, an Act of Union was forced upon the Irish parliament in Dublin. The parliament initially refused to vote itself out of existence, but agreed to do so following a concerted campaign of bribery, threats and coercion by the British authorities. Thus, on 2 August 1800, the Irish parliament held its last sitting in Dublin, and on 1 January 1801, the Act of Union formally came into operation. Under the terms of the Act, Ireland was governed from Westminster in London as part of a new, unitary state known as the United Kingdom of Great Britain and Ireland. Only Protestants could be elected as members of the Westminster parliament (as had been the case in the Irish parliament) and this restriction was not lifted until 1829, when Catholic Emancipation granted Catholics the right to sit in the British parliament. Overall, becoming part of the United Kingdom made little difference to the everyday lives of most people in Ireland. By the end of the nineteenth century, however, the repeal of the Union had become the most pressing question in both Irish and British politics.

Thus, in 1839, when Louis Daguerre announced his discovery of the process of photography, Ireland was ruled from Westminster, by a parliament that was predominantly Protestant, British and drawn from a small landowning elite. The Irish population, in contrast, was overwhelmingly Catholic, Irish-speaking and dependent on a subsistence crop – the potato – for its livelihood. At this stage, neither the Irish poor nor the British government could possibly have foreseen the traumatic events to come only a few years later when Ireland was ravaged by a famine triggered by the appearance of a previously unknown form of potato blight. As a consequence of the food shortages between 1846 and 1851 the population of Ireland fell by over twenty-five per cent to just over six million; over one million people died from hunger or disease and an even higher number emigrated. Nor did the country ever recover from the demographic shock of the Famine. In 1839, when the first photographs were taken in Ireland, it was one of the most densely populated countries in Europe, with over eight million inhabitants; one hundred years later, its population had fallen to under five million. This level of demographic decline was unique within Europe. Large-scale emigration not only contributed to the depopulation of the country but also led to the emergence

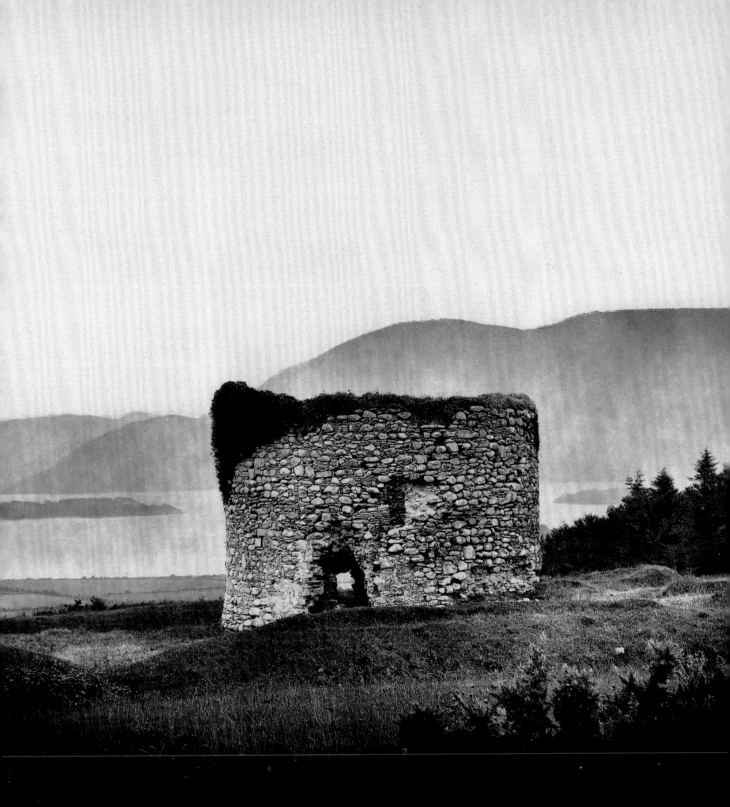

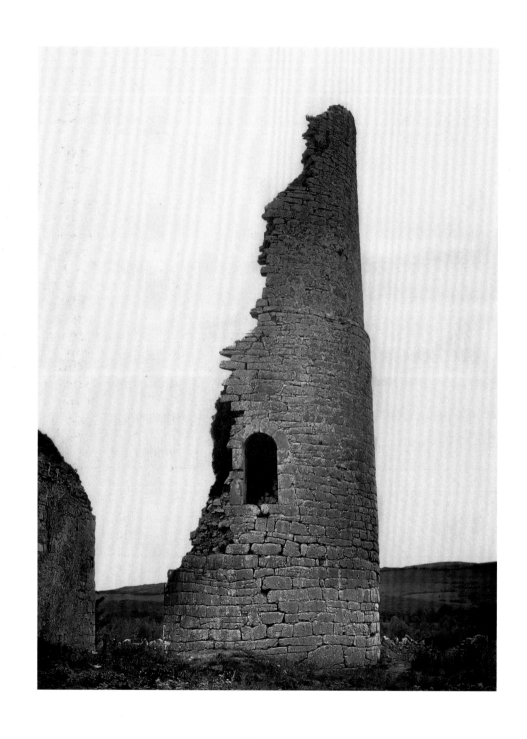

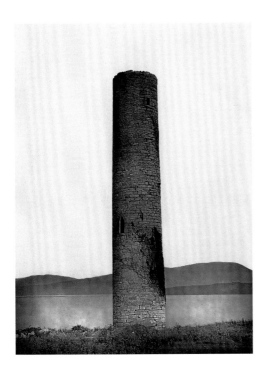

Monuments to ancient faith. Opposite: belfry of Dysert O'Dea, County Clare. The church was built over a monastery founded in the eighth century by the hermit O'Dea. It was the site of the battle of Dysert O'Dea in 1318, and at one time the round tower was adapted for military use. Photographer Mr Mercer, 1864–69. Previous page: Aghadoe Military Tower, Co. Kerry, part of a Romanesque church built on the site of an earlier monastery. Photographer Mr Mercer, *c.* 1864–69. Above: the belfry of Iniscealtra (or *Inis Cealtra*, 'Holy Island'), County Clare. Iniscealtra was a popular site of pilgrimage. Photographer Mr Mercer, 1864–69.

of an Irish diaspora that was scattered throughout the world, many of whom viewed their emigration in terms of exile and dispossession. The first hundred years of photography, therefore, coincided with a period of transformation that altered not only the progress of modern Ireland but also, as a consequence of mass emigration, the subsequent development of British, American and Australian history.

Population change was accompanied by political, economic and social transformation. In 1839, landlords – and the Anglo-Irish Ascendancy that they represented – appeared supreme. Their arrogance and assuredness is reflected in numerous photographs of the landed class, generally at play. They clearly did not foresee their demise, which was both rapid and absolute. The extinction of the landlord class was accompanied by the disappearance of a whole way of life, a disappearance embodied by the dissolution of the 'Big House'. Ironically, some of the earliest photographs taken in Ireland are of round towers and the decaying ruins of castles – remnants of earlier periods of invasion and settlement – and hindsight makes it tempting to see these images as prefiguring the demise of the new ascendancy class. Photographs, more than any other historical source or document, communicate the lifestyle of an elite who were generally separated from the mass of the population by their wealth, religion and political allegiances. The Famine had also expedited the rise of a Catholic landowning class who were frequently both socially conservative and economically parsimonious, but were nonetheless regarded by Irish nationalists as being different from, and so less hateful than, the Anglo-Irish Ascendancy.

The Act of Union also had an impact on the landscape and architecture of Ireland. The building of national schoolhouses after 1831 and workhouses after 1838 was characteristic of the high level of intervention by the British government in Irish life. The police barracks and army garrisons scattered throughout the countryside were constant reminders of political links with Britain, as were the Union Jacks that adorned public buildings, statues of Queen Victoria and Nelson, and other emblems of Britishness. In the second half of the nineteenth century, nationalist memorials, including a statue to Daniel O'Connell in the centre of Dublin, and various monuments to those involved in the 1798

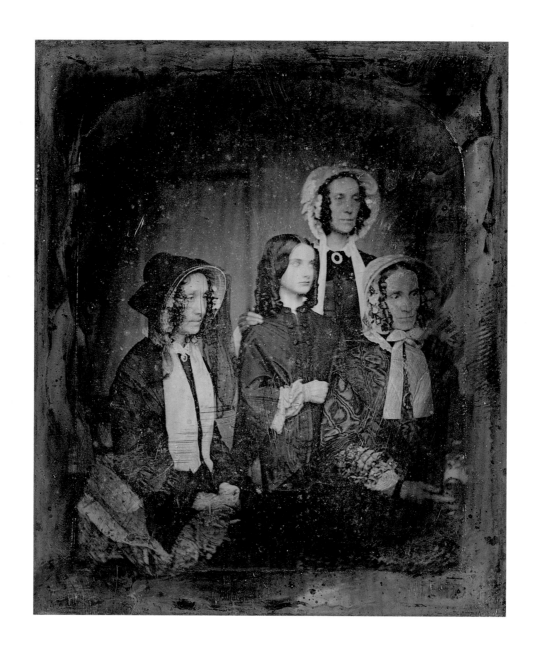

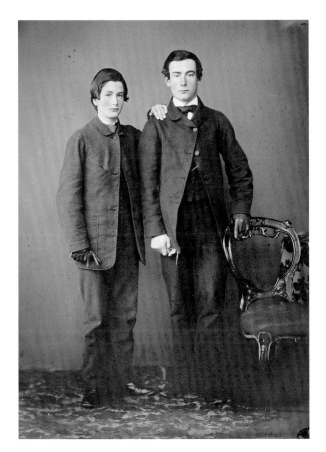

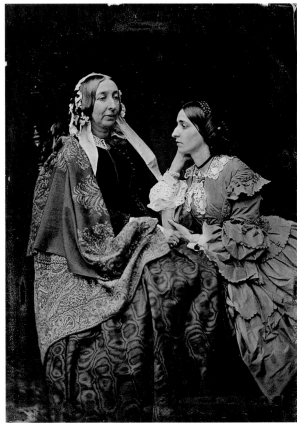

Early portraiture. In these early
processes, the image was produced
directly on a light-sensitized surface.
There was no negative; each photograph
was unique. Opposite: hand-coloured
daguerreotype by an unknown
photographer, *c.* 1850. Above: hand-
coloured wet-collodion positives on
glass (or 'ambrotypes'). Photographer
Robinson, Dublin, *c.* 1858.

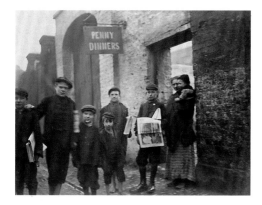

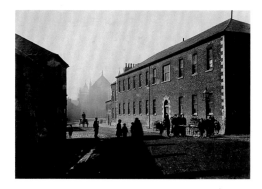

Urban poverty in early twentieth-century Ireland. Dublin's high mortality rates were caused by slum housing, low income and casual employment. In 1891 Belfast officially overtook Dublin as Ireland's largest city. Mortality rates were high there too, but the active intervention of the Corporation gave the city some of the best working-class housing in the United Kingdom. Top: newspaper sellers breaking for dinner. Photographer Christine Chichester, 1909. Above: A Belfast street scene. Photographer unknown, *c.* 1900.

and 1848 uprisings, acquired a patriotic significance and provided a public reminder of unfinished political business.

Although Ireland at the beginning of the twentieth century was still a predominantly agricultural country with most of its population employed in the agricultural sector, urban life was also important. Developments in Dublin and Belfast were particularly significant in the economic and political history of the country after 1840. Dublin in the eighteenth century had been dominated by its role as the capital and political centre of the country. The growing independence of the Irish political establishment was manifested through the building of Parliament House, between 1729 and 1739, opposite Trinity College. Both buildings were for the use of Protestants only, despite the fact that since the mid-eighteenth century, Dublin had been a predominantly Catholic city. The physical removal of the parliament from Dublin as a consequence of the Union contributed to the economic decline of the capital city in the nineteenth century. The parliament buildings were sold to a bank.

The demographic decline of Ireland in the wake of the Famine was also reflected in the reduced rate of growth of the Dublin population after 1850. In the post-Famine decades, Dublin had one of the highest mortality rates in the United Kingdom, largely as a result of low-paid casual employment, poor accommodation and little regard for public health issues, which meant that disease was endemic in the city. The abjection of the slums of Dublin on the eve of the First World War was captured in a ground-breaking collection of photographs published under the title *Darkest Dublin*. At the same time, however, Dublin was home to a number of manufacturers of world repute, notably in the areas of brewing, distilling and biscuit-making. The 1916 uprising was to a large extent a Dublin-based uprising and many of the fatalities and much of the physical destruction that accompanied it took place in the city centre. The further damage done to the city centre during the Anglo-Irish War and Civil War resulted in a massive rebuilding programme by the new Free State government. The re-establishment of a native parliament following the signing of the Treaty in December 1921 also contributed to the revival of Dublin. The jurisdiction of the Free State

The parliament at Stormont in east Belfast. This imposing neoclassical building, reached by a mile-long drive, was built by Sir Arnold Thornely to house the Northern Ireland government following the Partition of Ireland. A statue of Sir Edward Carson stands prominently on its approach. The official opening in November 1932 was attended by the Prince of Wales. The occasion was used for displays of unionist triumphalism against northern Catholics. Sir James Craig, leader of the Unionist Party, was Prime Minister of the Northern Ireland parliament from 1921 to 1940. Photographer unknown, *c.* 1945.

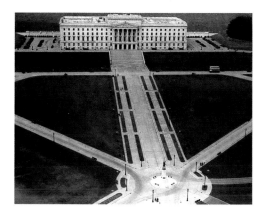

parliament was confined to twenty-six counties, which although no longer part of the United Kingdom, remained an unwilling dominion within the British Empire.

The growth of Belfast in the late nineteenth century was largely a consequence of industrial development although the town also benefited from trading access to the British Empire as a result of the Union. By the middle of the century, Belfast was the world's leading producer of linen, with substantial shipbuilding, tobacco, engineering and rope-making industries. The development of railways from the 1840s onwards also benefited Belfast by creating links with other industrialized parts of Ulster. In the second half of the nineteenth century, as the overall population of Ireland fell, Belfast achieved the distinction of being the fastest growing town in the British Empire. In recognition of this growth it was granted city status in 1888. Belfast was a predominantly Protestant town, with Catholics accounting for only ten per cent of the population at the time of the Act of Union, rising to thirty-four per cent in 1861, but falling again to twenty-four per cent in 1911. As a consequence of discrimination by many employers, Catholics were concentrated in low-paid, unskilled occupations. Despite Belfast acquiring the epithet 'The Athens of the North' in the late nineteenth century, poverty there was endemic, as it was in Dublin. In 1853, Reverend W. O'Hanlon published *Walks among the Poor in Belfast,* in which he characterized parts of the town as being 'a hell below a hell' and described the housing as 'crowded with human beings in the lowest stage of social degradation'.

Religious divisions were also reflected in the patterns of settlement in Belfast, with Catholics and Protestants living in distinct areas. Moreover, sectarian conflict accompanied economic and population growth so that by the end of the nineteenth century Belfast was the most heavily policed town in the United Kingdom. Despite the presence of such a large police force, there was violent sectarian rioting in Belfast in 1864, 1872, 1886, 1893, 1912 and 1920. By the end of the nineteenth century Belfast was the unofficial capital of Protestant and Unionist Ireland, and in 1921 was made the official capital of the new state of Northern Ireland. A new parliament house was built in Stormont in Belfast. The partition of Ireland was accompanied by further sectarian conflict, and

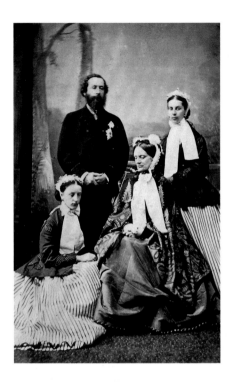

between 1920 and 1922 ten-thousand Catholics in Belfast were locked out of their workplaces. The birth of the new Northern Ireland state was accompanied by anti-Catholic pogroms, and subsequently the Catholic population of Belfast fell dramatically.

In the century following the passing of the Act of Union there were intermittent attempts to repeal it and restore an Irish parliament in Dublin, using means both constitutional and violent. A series of nationalist uprisings – by Robert Emmet in 1803, Young Ireland in 1848, the Fenians in 1867, Patrick Pearse and others in Easter 1916, and Sinn Féin during the War of Independence between 1919 and 1921 – were testimony to a desire to end the Union. Constitutional attempts to achieve that end were led by Daniel O'Connell, who founded the Loyal National

Fenianism was a secret revolutionary movement aimed at establishing a democratic Irish republic. It was also known as 'The Brotherhood'. A planned uprising in 1867 involving Fenians in Ireland, Britain and America was hampered by poor organization and divided leadership. In contrast, the British government acted quickly and decisively. Above: the Duke of Abercorn, Lord Lieutenant of Ireland (here pictured with his family), was responsible for dealing with the rising and its aftermath. Photographer Alex Ayton, c. 1868. Right: police mugshots of Fenian prisoners James Donahy, Henry Hughes and Hugh McGrishin, 1865–66.

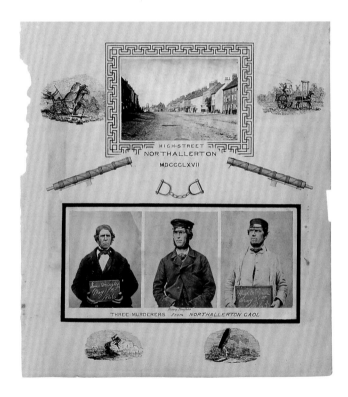

Jeremiah O'Donovan Rossa (1831–1915, below) was a Fenian and writer. Between 1863 and 1865 he managed the *Irish People*, the journal of the Fenian movement. In 1865 he was arrested and sentenced to twenty years penal servitude. He was released in 1871 on condition that he leave Ireland. He went to America and resumed Fenian activities, including managing a 'skirmishing fund' to finance further resistance. He organized the first bombing campaign in Britain between 1881 and 1885. The Rising Sun public house in London (right, photographed by B. Lemere) was damaged in an attempt to destroy New Scotland Yard in 1884. O'Donovan Rossa died in New York in 1915 but his body was returned to Dublin for burial. His funeral was attended by thousands. Patrick Pearse delivered a graveside oration that became a nationalist rallying cry: 'The fools, the fools, the fools! – they have left us our Fenian dead, and while Ireland holds these graves, Ireland unfree shall never be at peace.' The photographer of the portrait below is unknown, *c.* 1860.

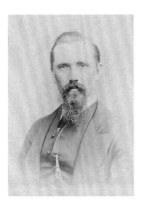

Repeal Association in 1840, and by Charles Stewart Parnell, who made the Home Rule movement a powerful force within parliamentary politics after 1875. The foundation by Michael Davitt in 1879 of the Land League marked the beginning of the Land War, and thus a new stage in nationalist politics. It was an indication that the Anglo-Irish landlord class was no longer a symbol just of social oppression, but also of the Union with Britain. While Irish landlords were regarded in England as a barrier to necessary economic progress, in Ireland they were seen as defenders of colonial rule and their removal became an important part of Irish political demands. Charles Stewart Parnell, leader of the Home Rule Party, and himself a Protestant landowner, recognized the potential of the Land League and worked closely with it. One of his achievements was to attract support from both radical nationalists and moderate Protestants. However, the high military presence in Ireland throughout the nineteenth century was evidence of the British government's determination not to allow the United Kingdom to be broken up. Moreover, the emergence of militant unionism in the late nineteenth century demonstrated that in Ireland there was a group who desired to remain within

The American Civil War (1861–65) took place shortly after the Famine had triggered the emigration of over two million Irish people to North America. Irish men fought on both sides, gaining military experience that some utilized in subsequent Fenian agitation, including a raid into Canada in 1866. Right: guarding the suspension bridge at Niagara Falls against Fenian incursion. The raid was intended to strike a symbolic blow against the British government, though in the event it amounted to little more than a few skirmishes. Photographer George Barker, 1866. Below: Philip Henry Sheridan (1831–88) was born in County Cavan, but his family emigrated to America when he was a child. He was educated at West Point Military Academy. During the Civil War, following his successes against General Lee's army, he was appointed commander. Photographer Matthew Brady, c. 1862.

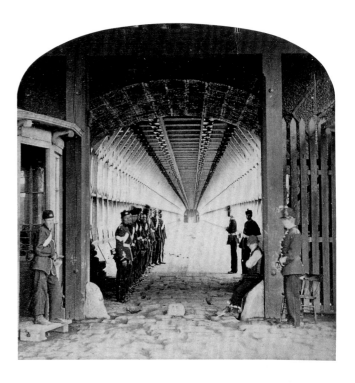

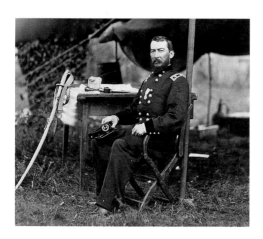

the Union and who viewed themselves as British subjects. The so-called 'Ulster Question' dominated both Irish and British politics after 1880. The Irish Unionist Party, founded in 1886, had the support of Conservative politicians, including Lord Randolph Churchill. In that year, he made a famous speech in the Ulster Hall in Belfast in which he warned 'Ulster will fight: Ulster will be right'. The question of Home Rule split the Liberal Party, while the British Conservative Party was reinvigorated by having a new cause to promote. For members of the Conservative Party, political independence for Ireland signalled not only a break-up of the United Kingdom, but also the dismemberment of the British Empire, both of which they were opposed to. Thus, nationalism and unionism not only dominated political allegiances in Ireland, they also divided the main British political parties. The British Liberal Party

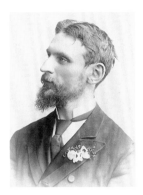

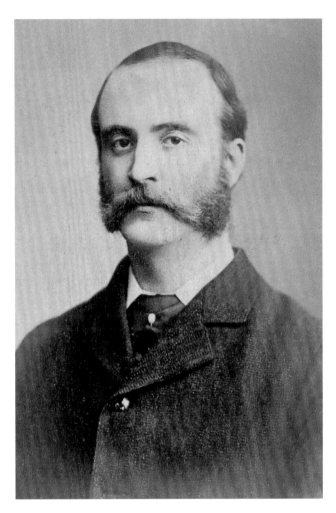

Leading the nationalist cause.
Above: William O'Brien (1852–1928) was a writer, an MP (1883–95 and 1900–18), and a key figure in Irish nationalist politics for almost forty years. Above right: Michael Davitt (1846–1906) was a Fenian and a founder of the Land League, seeing it as a vehicle for both agrarian and social reform. Right: Charles Stewart Parnell (1846–91) was the leading nationalist figure in the second half of the nineteenth century. His family were Protestant landowners in County Wicklow, although they had nationalist sympathies. Elected Home Rule MP for County Meath in 1875, he quickly proved adept at keeping nationalist demands at the forefront of parliamentary debate. He was also able to harness popular nationalist support through his presidency of the Land League. His political career was brought to an abrupt end when he was named as co-respondent in the O'Shea divorce case in December 1889. This action split the nationalist party and divided public opinion in Ireland. Parnell died in 1891. Photographers unknown.

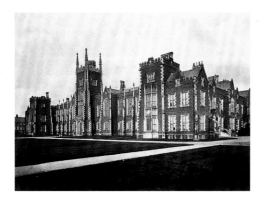

Queen's College, Belfast was one of three universities created by Sir Robert Peel's government in 1845, and so-named as a tribute to Queen Victoria. It was one of a number of steps intended to appease nationalists and deflect them from demanding repeal of the Union. In order not to offend any denomination, university entrance was free from religious tests and theology was not taught. The professors were also appointed by the Crown. However, neither Daniel O'Connell nor the hierarchy of the Catholic Church supported the new universities, O'Connell referring to them as the 'Godless Colleges'. Consequently, the student population was overwhelmingly Protestant. Photographer Robert French, *c.* 1880.

officially abandoned its support for Irish Home Rule in 1902, while the British Conservative Party moved closer to the Unionist Party and in 1912 adopted the title 'The Conservative and Unionist Party'.

Religion has also helped to mould Ireland's recent past. The Reformation in the sixteenth century had little popular impact in Ireland, unlike in England, Wales and Scotland, each of which adopted various forms of Protestantism. Under English rule, in the wake of the Reformation, the Church of Ireland was made the established state church, governed by the English monarch. Nonetheless, Ireland remained a predominantly Catholic country. From the late sixteenth century, successive British monarchs and governments strove to make Ireland Protestant. For centuries, therefore, religion reinforced existing economic, social and political divides between natives and settlers of Ireland.

Under James I (who was also James VI of Scotland) after 1603 a plantation was carried out, by which Protestant settlers from England and Scotland were given free or subsidized land in parts of Ulster. The express purpose of the plantation was to 'reform' Ireland, that is, to colonize an area that was regarded as economically backward and politically troublesome. To make this possible, many Catholics were forcibly removed from their land. In addition, the new settlers were forbidden from mixing with the natives or adopting their language, religion or culture. A violent uprising in 1641 marked an unsuccessful attempt by Irish natives to regain their properties. The significance of the plantation was that it increased antagonism between natives and settlers in Ireland. Moreover, it placed a large body of Protestants (mostly Presbyterians) in Ireland and thus changed the religious composition of the population of Ulster. The Battle of the Boyne in July 1690, in which the Protestant monarch William of Orange defeated the Catholic king, James II, confirmed the supremacy of Protestantism in Ireland. In the nineteenth and twentieth centuries, the Protestant profile of the northeast of Ireland was visible in the emergence of Protestant organizations such as the Orange Order and the Unionist Party, which identified with fellow Protestants in Britain rather than Catholics in Ireland. The partition of Ireland in 1920 and the creation of two parliaments, in Dublin and in Belfast, was an admission that the Union had consolidated rather than eased religious divisions.

The Orange Order (an exclusively Protestant organization) was founded in County Armagh in 1795. One hundred years later, it had become a mass movement with strong links with the Unionist Party. Numerous Orange Halls were built in the final decades of the nineteenth century. There were two in Belfast: in Ormeau Road, completed in 1887, and in Clifton Street (below), completed 1889. In contrast to the opulence of the Orange Hall, some of the children in the foreground of this image are barefoot. Photographer unknown.

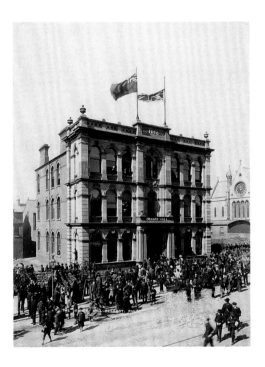

In the centuries after the Reformation, the Catholic Church in Ireland had a chequered history as repeated attempts were made to undermine the allegiance of the population to Catholicism. The introduction of the Penal Laws after 1695 restricted the economic and political power of Catholics and of the Catholic Church, forbidding Catholics from buying or inheriting land from Protestants, from practising law, from holding positions in government, from serving in the army or navy, from voting, and from sitting in parliament. The number of Catholic priests and their activities were also severely restricted. At the beginning of the eighteenth century, Catholics owned approximately fourteen per cent of land in Ireland; within a few decades of the Penal Laws being in force, this had fallen to five per cent. Economic, social and political power increasingly fell into the hands of a small elite who were known collectively as the 'Protestant Ascendancy'. It was not until the end of the eighteenth century that the Penal Laws began to be dismantled. The lifting of the restrictions on Catholics, however, made many Irish Protestants very nervous and was followed by the formation of a number of conservative Protestant Defence organizations, the most famous of which was the Orange Order, founded in 1795. The Order took its name from William of Orange, victor at the Battle of the Boyne, and its members decided to hold a parade each year on the twelfth of July in his honour. By the late nineteenth century, the Orange Order had become an important force in shaping Protestant identity in Ireland and in influencing the emergence of militant unionism.

Although the Act of Union confirmed the Anglican Church as the state church of Ireland, the nineteenth century saw the emergence of an increasingly organized and politically powerful Catholic Church. The winning of Catholic Emancipation in 1829 was regarded as a significant victory for Catholics in general and Daniel O'Connell in particular. From the middle of the nineteenth century there was a massive church-building programme in Ireland, which transformed both the Irish landscape and also the religious practices of many Catholics, who were now increasingly able to attend mass and other religious services. The memory of the proselytism that had been carried out by a number of Protestant evangelicals during the Famine, also known as the Great

The struggle for faith. Below: Ballintubber Abbey, founded in 1216. The poverty of this congregation at mass, kneeling on grass in a roofless abbey, is clear. Photographer Thomas Wynne, *c.* 1872. Below right: the Protestant Mission Colony on Achill Island, County Mayo. Established in 1834 by an Anglican clergyman, the mission comprised schools, church, hotel, printing press and gardens. A doctor cared for the sick of all denominations, and all teaching was in Irish, the first language of the islanders. Aid was not conditional on conversion during this period. However, the mission soon became the centre of controversy. Archbishop MacHale received papal support for his resolve to close it. Photographer Robert French, *c.* 1885.

Hunger, made the hierarchy of the Catholic Church determined to protect their followers from the threat of Protestantism. The growing influence of the Catholic Church coincided with a period of mass emigration, so that many emigrants took their religious practices to their new countries of settlement. Religious conformity was also promoted by the growth in the number of clergy and nuns in Ireland. Following the partition of Ireland, the new Free State took on an increasingly Catholic character, despite claiming to be religiously neutral. The treatment of Catholics in the state of Northern Ireland, which was a trigger for the commencement of the 'Troubles' after 1969, demonstrated the on-going links between religion and politics in Ireland.

Photographs remain an undervalued and underused source by those who are interested in Ireland's past. Too often they are treated as appendages to the written word rather than as pieces of evidence in their own

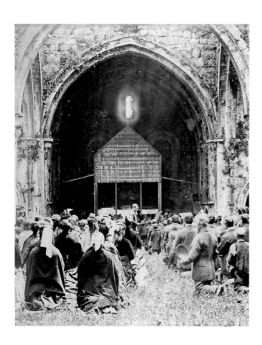

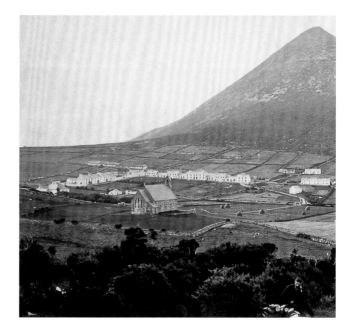

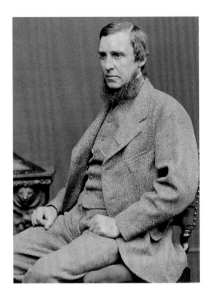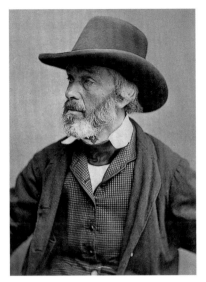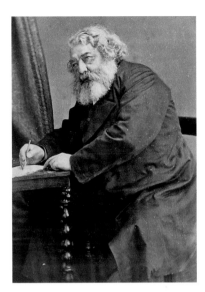

Opinion shapers. Above: James Anthony Froude (1818–94) was a writer and historian. His writings, together with those of his friend Thomas Carlyle, helped to turn public opinion against Irish Catholics in the nineteenth century. Photograph by H.J. Whitlock, *c.* 1870. Centre: Thomas Carlyle (1795–1881) was born in Scotland to a family of strict Calvinists. He believed in racial difference and superiority, and his writings contributed to a discourse on racial stereotyping that viewed Irish people as inferior to British people. Photographer Charles Watkins, 1875. Right: the journalist Mark Lemon (1809–1870) was one of the founders and editors of *Punch*, first published in 1841. *Punch* cartoons were renowned for expressing anti-Irish views. Photographer D. Everest *c.* 1868.

right. Yet photographs provide a contemporary record which can complement and expand upon other sources, both written and oral. They can challenge or confirm our perceptions of Ireland between 1840 and 1940 by providing fuller and more nuanced information than many written records. The collection of photographs presented here fully attests to the ability of the image to express what is so often inexpressible in the written word. It also provides a unique photohistory of the development of modern Ireland during a period of extraordinary and often turbulent change.

The photographic process was discovered in 1839. The first photographs or daguerreotypes (named after the founder of the process, Louis Daguerre) to be taken in Ireland date to the same year. The steps involved in both taking an image and developing it were slow: the latter, for example, required exposing the plate to heated mercury and other noxious chemicals. Demand for photographs increased in the 1850s, due largely to the discovery of the wet collodion process by Frederick

Ancient sites, natural and manmade, were a popular subject of early photographers. Below: the Giant's Causeway in County Antrim was already a favourite tourist attraction in the nineteenth century, and its popularity increased following the spread of railways in Ulster. This image reveals a fine eye for composition and for capturing light and shade. Photographer unknown, *c.* 1865. Opposite: The remains of the ancient abbey of Tarmon, County Leitrim (sometimes referred to as Creevelea). The abbey was founded by the Franciscan Order at the end of the fifteenth century and was closely associated with the O'Rourke family. Photographer Mr Mercer, 1864–69.

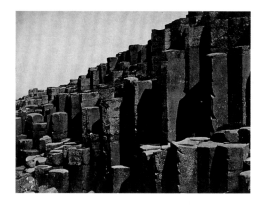

Scott-Archer in 1851, which reduced exposure time from minutes to seconds. However, heavy and cumbersome equipment remained a practical limitation to the earliest generation of photographers. Inevitably, the first photographic studios were in the major towns, which were situated on the east coast of the country. They specialized in portraits of individuals or family groups. The high cost of such photographs placed them out of the reach of the poorest classes. Although photographs of scenery and landscape were also taken, the lack of public roads or railways made overland travel to Ireland's more inaccessible districts difficult. The introduction of the dry-plate process in 1878, which meant that photographs did not have to be developed immediately, gave photographers relative freedom to move around, since they no longer had to carry their darkroom with them.

The late nineteenth century was a period of 'photographic realism' as photographers tried to keep up with public demand for unfamiliar scenes and settings, both in their own country and further afield. Moreover, they were able to show scenes 'so far known only through the inaccurate descriptions of travellers or exaggerated engravings, which were now regarded with suspicion since photography revealed the truth'. But the power of photography as a tool of propaganda or persuasion was also apparent. Photographs made politicians, monarchs and other famous people more accessible to the general public. As politics became more democratic with the extension of the franchise, and the population became more literate, the creation of a public image became increasingly important for politicians. The value of photography as a tool of commerce was also apparent. Realistic visual images could be used to sell a product or a place. For emigrants in particular, photographs provided a link with home, often highly idealized. Increasingly also, photography was an art form that was accessible to the general masses, and they did not have to own a camera, or even read or speak English, to be able to appreciate its message and importance.

Many of the defining moments in Ireland's past have been captured in the photographs reproduced in this book. Not only do these images each provide a snapshot view of a particular moment in time, they also provide an insight into the cultural and political contexts that framed

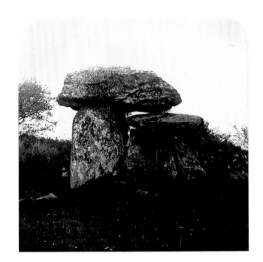

Views of rural life and ancient monuments appealed to early photographers, and helped fuel the beginnings of the tourist industry. Opposite: peasant boys. Attributed to Humphrey Haines, *c.* 1860. Above: a neolithic burial chamber, known as a dolmen. Photographer unknown, *c.* 1895.

them. For example, public displays of allegiance by all sides of the political divide increased in the late nineteenth century, especially in the form of commemorations; of Empire Day (24 May), of the Battle of the Boyne (12 July), of Covenant Day (28 September) and of St Patrick's Day (17 March). Photographs of such displays are not merely representations of festivities or celebrations, they are powerful statements of political and religious identity, and also, in the case of Unionism, of supremacy. But apart from chronicling such momentous events, these photographs also capture private and personal moments, moods and emotions which are so often elusive in the written record. Many of the images take as their background the Irish rural landscape – beautiful, rugged, mystical and menacing. Apart from its aesthetic qualities, the economic significance of the landscape is evident. Photographs of rural pursuits such as weaving and fishing – leisure activities for the rich, but survival for the poor – provide unique documents of Ireland's social history.

In the latter decades of the nineteenth century, Ireland developed an impressive railway network, which by the 1890s extended to remote districts, such as Achill in County Mayo and Clifden in County Galway. The opening up of areas of natural beauty encouraged the development of a tourist industry in the west of Ireland. Photographers benefited both from the promotion of the industry and from the universal desire of tourists to have a visual record of their visit. Photographic studios were also quick to realize the potential of the tourist market and they sent photographers to take pictures of some of the most popular destinations and beauty spots. Some of them also recorded the local people at work in traditional pursuits, such as peat-cutting or seaweed collecting, skills that would have been as alien to urban dwellers and the upper classes in Ireland as to foreign visitors. It is unlikely that any of the ordinary people featured in these images would have been able to afford to buy their own portraits. Nonetheless, they provide a vital link to, and a continuity with, earlier generations of Irish rural dwellers.

While the poor are often under-represented in photographic history, women are a visible and vibrant feature of early photography, both as practitioners and as subjects. So often excluded from public involvement in clubs and societies, women were allowed to join the Dublin

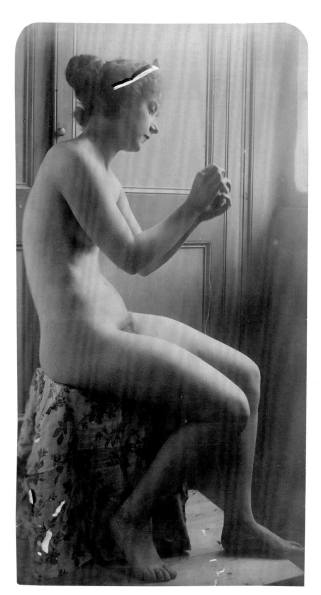
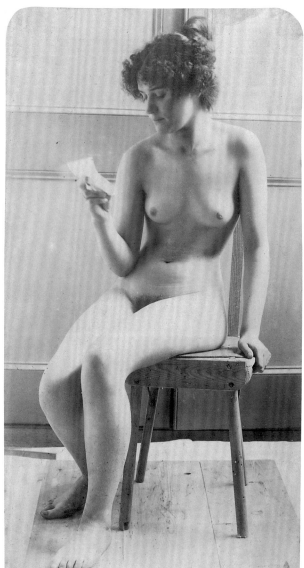

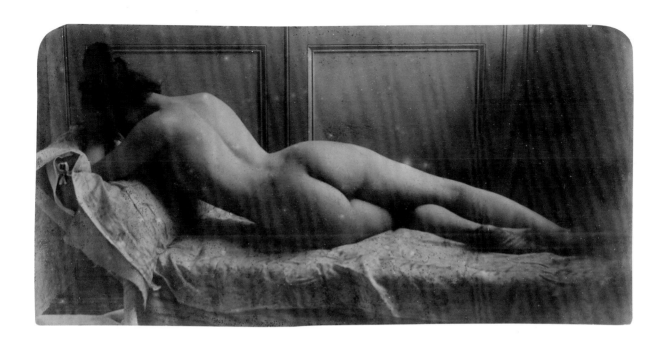

Nude studies by Louis Jacob, part of a series of photographs taken between 1892 and 1911. Most of Jacob's work was undertaken in Waterford. Many of the nudes in his studies appear to be influenced by classical compositions.

Lady Augusta Crofton was a prolific photographer who primarily documented fellow members of the Irish landed gentry, such as these ladies outside Rockingham House in *c.* 1858 (below) and the Tighe family in *c.* 1865 (opposite below). The Tighe group comprises of Lou, Georgy, Susie, W.F. Tighe, Arthur and Totty. The exposure in this photograph would have taken some seconds. Opposite above: Lady Crofton at a writing table in *c.* 1865. The stereo camera seen in the photograph was a relative rarity at the time. It may have belonged to her friend and fellow photographer Lord Dunloe. Behind her is a cast-iron photographic stand, used to help the sitter remain still during a long exposure.

Photographic Society from the 1850s, and a large number were keen amateur photographers. Many of these early female photographers, such as Mary, Countess of Rosse and Lady Augusta Crofton of Clonbrock House in County Galway, excelled in the art, as their collections demonstrate. Inevitably, they came from the gentry classes, and for the most part they photographed images of their world – a world that was privileged, leisured, and unrepresentative of the harsh realities of life for the majority of people. But there are valuable exceptions. The work of Rose Shaw, a governess in County Tyrone, portrays women at work both in the home and on their small farms at the beginning of the twentieth century. A few years later, many of these smallholdings had disap-peared, their owners having emigrated or sold their property and moved to the local towns.

As well as reflecting changes in Ireland's development, the images in this book also chart the transformation of photography from the leisure pursuit of a small elite to a favourite pastime for the masses. By the end of the nineteenth century, photographic equipment had not only become cheaper and more generally available, but the emergence of a working class with leisure time and disposable income provided a ready

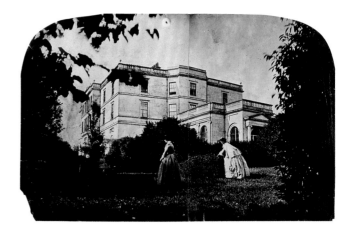

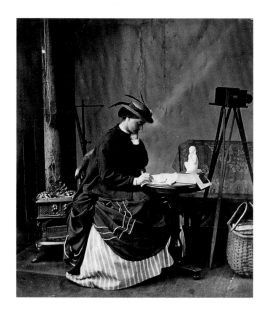

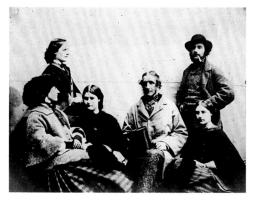

consumer market for both cameras and photographs. In the 1840s, however, only the upper and the middle classes could afford to have their images recorded. The process was expensive and very time-consuming: only a group with time on its hands could participate. Consequently, in the early decades of photography there is sometimes a divergence between the historic and the photographic record. For example, soon after photography appeared in Ireland, the Famine of 1845–51 devastated the poorer classes, with no part of the country spared from its impact. Yet no photographs exist of this pivotal episode in Irish history. Moreover, because no mortality records were kept, neither the precise number of people who died during the tragedy, nor their names, are known.

In the short term, the Famine was a clear sign that the Act of Union had failed the population of Ireland. In the longer term, the legacy of the Great Hunger continued to reverberate into the twenty-first century. By the 1940s, when this photohistory ends, Europe was engaged in a World War. In Ireland, not for the first time, war proved to be divisive. Northern Ireland participated, but the British government decided not to extend conscription into the province, although it had the support of the Northern Ireland Cabinet and Prime Minister, Lord Craigavon. The Free State, although officially part of the Commonwealth, remained neutral, referring to the war years as 'the Emergency'. Despite the unofficial support given to Britain between 1939 and 1945, the Free State was upbraided at the end of the war by Winston Churchill for its non-involvement. In April 1949, Éire formally proclaimed itself a Republic, and shortly afterwards the new Republic of Ireland was officially declared to be no longer part of the British dominions. The continuation of Partition, however, was a reminder that the cost of achieving statehood was high.

chapter 1

land, landlords and the big house

Land shaped the economic, social, political, cultural and psychological profile of Ireland in the nineteenth century. The importance of land as an economic provider or as an indicator of position in society was unrivalled. Landlords and the landless, farmers and tenants, merchants and labourers, were united by the fact that they depended on it for their livelihood. Any failure of the land to provide for its dependants – as occurred between 1845 and 1851 – could send shockwaves through the whole of society. In this instance, the failure of one crop, the potato, changed the course of Irish history and had significant repercussions in other countries.

From the seventeenth to the nineteenth centuries, the landed estate system dominated Irish society. The majority of Irish landlords were Protestant and of British origin. They were referred to collectively as the 'Ascendancy'. Most of their land had been obtained through an extended policy of dispossession of the native proprietors who had been overwhelmingly Catholic. This type of landholding was an integral part of the colonial system, placing both economic and political power with people who were loyal to Britain. Successive governments introduced legislation to contain further the Catholic presence in Ireland, despite the fact that over eighty per cent of the population were members of the Catholic Church. Under the Penal Laws, a body of repressive measures introduced after 1695, Catholics were not allowed to own land or lease it for long periods. The abolition of these laws from the 1770s meant that in the early nineteenth century,

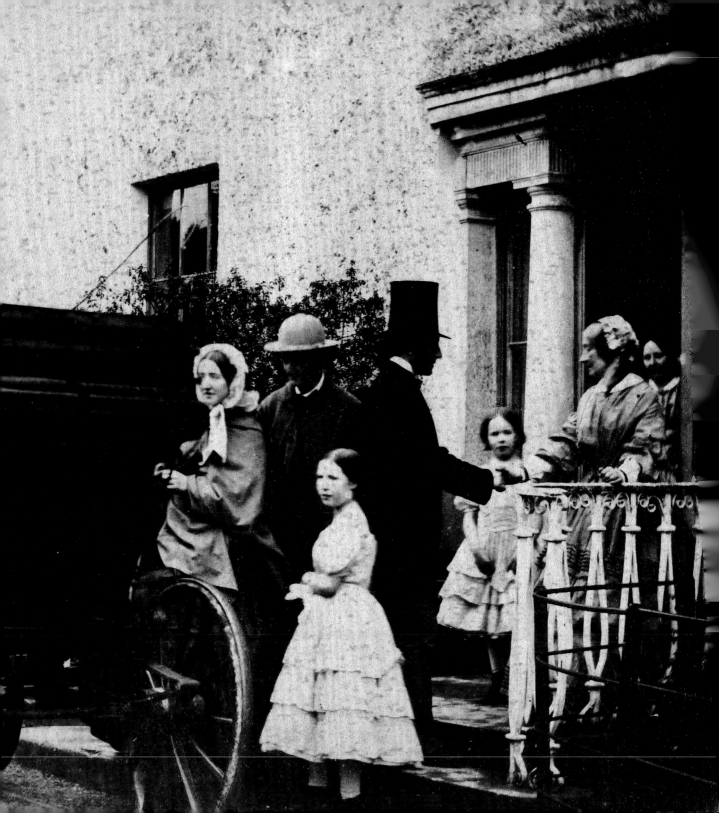

The women and girls in the image opposite are unidentified, as is the photographer. It was taken *c.* 1860 and the ivy-clad house was located in County Cork. This image is a gold-toned albumen print. The albumen process was so-called because the light-sensitive chemicals were held within a coating of albumen (egg-white) upon the paper surface. Albumen printing dominated early photography between *c.* 1850 and 1890. Because the albumen had a tendency to discolour, turning the highlight yellow, a blue aniline dye was sometimes added. It was common for albumen prints to be gold toned, giving them richness and depth.

more Catholics and native Irish were able to become landowners. However, the pattern of landownership had been established, while anti-Catholic measures had served to increase the divide between landlords and tenants. Consequently, nineteenth-century nationalists regarded landlords as the source of many of Ireland's ills. Nonetheless, as a social group, landowners were diverse. Politically too, they were not homogeneous, but were split between the British Liberal Party and the British Conservative Party. Irish landlords did not therefore form a coherent group within parliament. With few exceptions, however, they did support the Union and were opposed to the Home Rule movement of the late nineteenth century.

Landownership in Ireland had been complicated further by an intricate system of letting and sub-letting. Originally this had been a way of securing a high income with little investment. It also meant that landlords did not have to reside on their estates, but could leave them in the hands of agents. Due to a slump in agricultural prices, however, by the beginning of the nineteenth century, sub-letting was becoming less common. To maintain their income, landowners needed to maximize their rentals, which they generally did by increasing rent. Rapid population growth after 1750 had also placed more pressure on the land and increased the value of poor quality, marginal land. Potatoes, which had first been introduced to Ireland by Sir Walter Raleigh in the sixteenth century, could be grown even in rocky and barren areas. For

a population that had little access to good quality land, they made an ideal subsistence crop. They were both prolific and nutritious, enabling the survival of whole families on small plots of land. Potatoes quickly replaced dairy and grain products in the diet of the poorest groups until, by 1840, about half of the Irish population subsisted on potatoes. Simultaneously, this shift to potato cultivation released the better quality land for growing corn and raising cattle, much of which was exported. As a consequence, a successful export trade developed alongside the subsistence economy. Large quantities of grain, dairy products and cattle were sold in Britain. By the 1840s, Ireland was exporting annually to Britain sufficient corn to feed two million people, earning it the title of the 'bread basket' of the United Kingdom. The high level of exports of foodstuffs continued throughout most of the Famine period.

Prior to the Famine, agricultural production in Ireland was regarded by outsiders as backward and underdeveloped. The changes in agricultural production and technology that had been so vaunted in Britain had made little impact within Ireland. Both Irish landlords and Irish peasants were blamed for a lack of progress and the failure of Irish agriculture to modernize. Irish landowners, although in reality a diverse group, were generally believed to be bad landlords and poor estate managers. They were criticized for their lack of interest or investment in their properties. This disinterest was compounded by high levels of absenteeism, whereby landlords left the

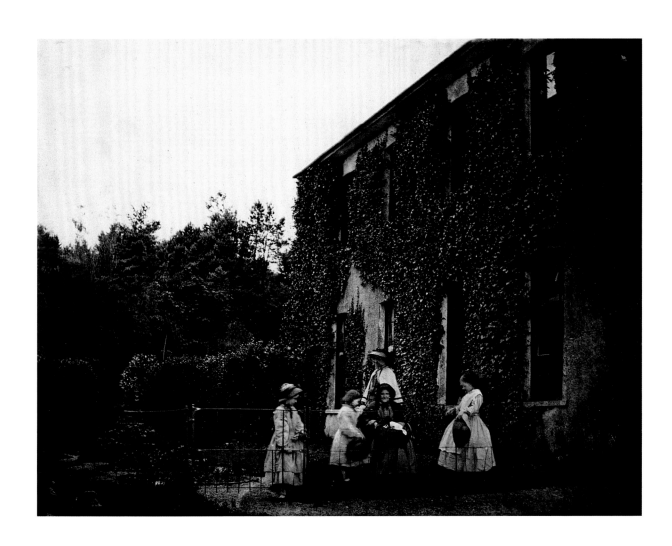

The heavy taxes imposed on Irish landlords to finance relief policies during the Famine were an incentive to landlords to clear their estates of smallholding tenants. Below left: the Fourth Earl of Clarendon (1800–1870) became Lord Lieutenant in Ireland in 1847, the worst year of the Great Hunger. He privately warned the Prime Minister, Lord John Russell, that the inadequacy of relief policies was contributing to the high levels of emigration and mortality. When this photograph was taken, Clarendon was nearing the end of his political career. Photographer Mr Watkins, *c.* 1864. Below right: Charles Trevelyan (1807–1886) was a civil servant who held the position of Permanent Secretary at the Treasury during the Famine. He has been associated with the inadequacy of relief policies of the Whig administration perhaps more than any other individual; yet in 1848 he was knighted for his services during the Famine. Photographer unknown, *c.* 1865.

management of their estates to an agent or middleman. This was particularly prevalent amongst landlords who owned property in the west of the country, where land tended to be of poorer quality. In addition, many landowners possessed several estates making some degree of absenteeism unavoidable. Following the Act of Union of 1800, when Ireland lost her own parliament, social and political life inevitably shifted from Dublin to London.

What transformed the food shortages of 1845–51 into a famine was the failure of the British government, and landlords and merchants in Ireland, to provide the poor with

adequate relief, especially cheap supplies of food. The decision by the government not to import cheap food into Ireland after 1846 was a result of its promise to merchants to leave the importation and distribution of food to free-market forces. While massive amounts of foodstuffs continued to leave Ireland, insufficient was brought into the country, and what was brought in was expensive and out of the reach of the poor. During the course of the Famine, the policies of the government were used increasingly to bring about changes in Irish land occupation rather than to alleviate suffering, in an attempt to rid Ireland simultaneously of poor small-holders and inert landlords. In 1847, for example, the Quarter

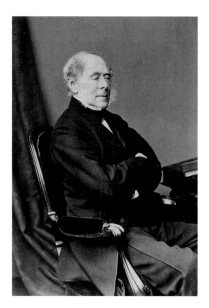

 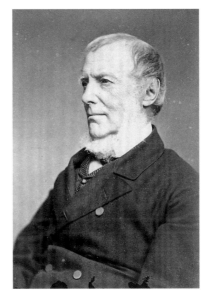 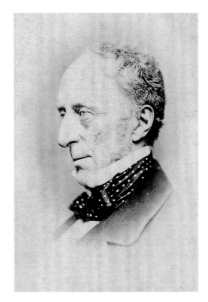

These Whig politicians were closely associated with relief provision during the Irish Famine. Above: Lord John Russell (1792–1878) was twice Prime Minister. His first Premiership coincided with the most severe period of the Hunger. Photographer J.E. Mayall, *c.* 1865. Above centre: Sir George Grey (1799–1882), Home Secretary from 1846 to 1852. Like many influential politicians, he accepted a providentialist view of the potato blight. Photographer unknown, *c.* 1865. Above right: Sir Charles Wood (1800–1885), Chancellor of the Exchequer after 1846, worked closely with Charles Trevelyan to implement relief policies during the Famine. The parsimonious policies of the Whig government were criticized by nationalists for resulting in high levels of mortality and emigration. Attributed to W. Walker, *c.* 1870.

Acre Clause was introduced as part of a new, more stringent package of relief measures. The Clause deemed that people who occupied more than a quarter of an acre of land were not eligible to receive poor relief. Consequently, poor people were forced to choose between giving up their land or being ineligible for government assistance. One of the results of this legislation was that after 1847 homelessness became as much of a problem as hunger. The Famine also changed the rural landscape in Ireland. Deserted villages, depleted populations and a decrease in small holdings were all visible reminders of the six years of hunger and suffering. The collapse of the peasantry class as a consequence

of evictions, emigration or death also resulted in changes in land occupation. The rich communal life disappeared and the use of the Irish language declined rapidly. A female survivor of the Great Hunger, who lived in the Rosses in County Donegal, described this less tangible legacy:

'The years of the Famine, of the bad life and of the hunger, arrived and broke the spirit and the strength of the community. People simply wanted to survive. Their spirit of comradeship was lost. It didn't matter what ties or relations you had, you considered that person to be your friend who gave you food to put in your mouth. Recreation and leisure ceased. Poetry, music and dancing died. These things were lost and

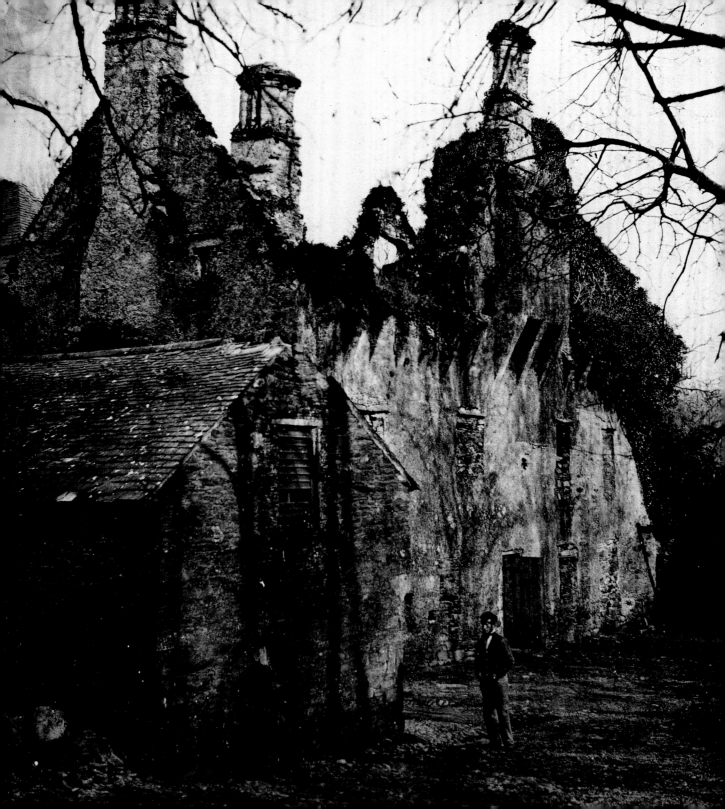

Ruins and remains of 'Big Houses' provide an insight into Ireland's turbulent economic and political history. Until the nineteenth century, demesnes, complete with a Big House, were an important feature of the Irish rural landscape. Many estates had medieval origins and ruined towerhouses or churches often survived, sometimes adapted for other purposes. After 1700 there was a fashion for having 'sham ruins' on demesnes, such as at Castle Oliver in Limerick. Demesnes often included farmland, gardens, orchards, and woods, and their economic function – in producing food both for consumption on the estate and for sale – was considerable. By 1860 the fortunes of the Irish gentry were in decline. During the Famine and in the decades that followed, many demesnes experienced financial difficulties as a result of falling rentals, and they had to be sold. Various land acts accelerated the process of land distribution. Political conflict after 1916 further undermined the demesne system. The 1923 Land Act, introduced by the Free State government, provided the Land Commission with the power of compulsory purchase of demesne land. The photographer of the ruin opposite is unknown, *c.* 1860.

completely forgotten. When life improved in other ways, these pursuits never returned as they had been. The famine killed everything'.

Because no photographic record of the Great Hunger was made, its destitute victims remain invisible to later generations. Yet photographs survive of the key politicians and administrators involved in famine relief such as Lord John Russell (the Whig Prime Minister), Sir Charles Wood (the Chancellor of Exchequer), Sir George Grey (the Home Secretary), and Charles Trevelyan (the Permanent Secretary at the Treasury). These four Englishmen, through their control of policy formulation during the Famine, governed Ireland through one of her most tragic episodes.

Land usage also changed after the Famine: depopulation meant that more land was available for commercial rather than subsistence production, and livestock became more commonplace on the landscape as grazing replaced tillage. In the decades after 1850, the land question moved to the top of the political agenda, and reform of the landownership system, together with repeal of the Union, became a demand of Irish nationalists.

Despite the incompetence, indebtedness and insolvency of an estimated twenty-five per cent of Irish landlords in the years before the Famine, it was difficult for them to be removed from their properties. The Famine proved to be a turning-point. The combination of falling income due to the non-payment of rents, and

the concurrent increase in local taxes in order to pay for poor relief, placed a heavy financial burden on many landlords. The government and British public opinion were unsympathetic to their situation and the former responded by passing the Encumbered Estates Act in 1849, which forced landlords who were in debt to sell their properties. Yet, despite the indebtedness of many landowners and minor gentry, their sense of superiority was implacable: the assuredness, arrogance and conspicuous consumption of this class marked them out from the majority of the Irish people.

Approximately one-quarter of land changed hands during the Famine, most in the wake of the Encumbered Estates legislation. The landlords who survived the crisis tended to be in a stronger financial position than they had been before 1845. A portion of the new landlords were Catholics. However, the new owners of land were no more sympathetic than their predecessors to the needs of their tenants. Despite the shock of the Famine, investment in Irish agricultural improvement continued to be low after 1850. Instead, much of the income was spent on expanding already ornate properties, and on maintaining an active social life in Dublin or London, with consumption being paid for by rents derived from Ireland. The 'Big House' in which many of the richest landlords lived symbolized a society of massive social and economic inequalities.

If the landlords knew that their days were numbered, it was not apparent in their demeanour or behaviour. Ironically, despite

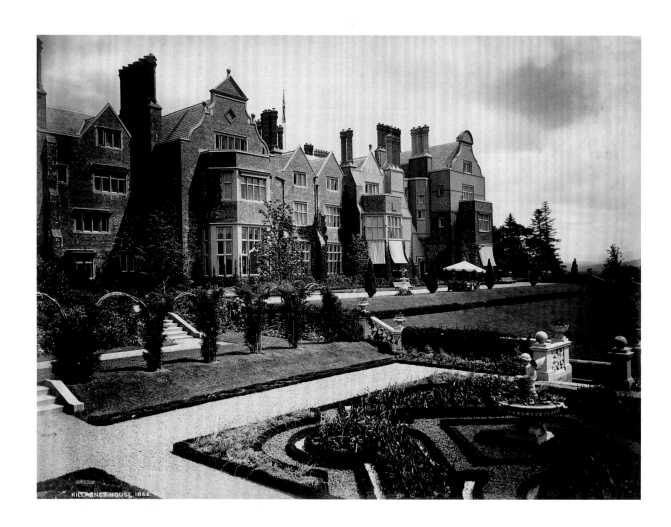

KILLARNEY HOUSE, 1862.

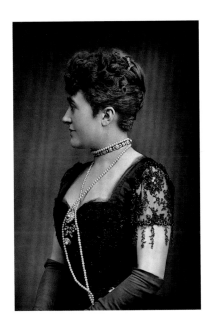

Kenmare (Killarney) House in County Kerry (opposite) demonstrates the splendour of the Big House. It was built by the fourth Earl of Kenmare in 1872, replacing an eighteenth-century residence. Its location on a hilltop ensured that it commanded views of the nearby lakes and mountains. The building, designed by the English architect George Devey, combined features of Victorian and Tudor architecture, with some Anglo-Norman influences. The opulent internal decorations gave Kenmare House the reputation of being one of the visual wonders of Ireland. This photograph by Robert French was taken approximately twenty years before it was gutted by fire in 1913. The House was not rebuilt; instead the family made their home in the eighteenth-century stables. Above: Lady Charles Beresford. Photographer unknown, *c.* 1890.

the British and Protestant origins of Irish landlords, they had never been popular in Britain. Their collective behaviour during the Famine, and in a number of highly publicized evictions of impoverished tenants in the following years, reinforced their unpopularity. High levels of emigration in the post-Famine decades suggest that despite the population reduction that had resulted from the Famine, the land in Ireland was still not adequately supporting its dwindling population. The crop failures of 1862 and 1879, and the near famine in the west of Ireland in 1889–90 were also cruel reminders that poverty and vulnerability remained embedded in the Irish countryside.

By the end of the nineteenth century, key members of the British government were convinced that radical and long-term changes were required to be made to the landholding system in Ireland. Within this vision, landlords were viewed as being expendable. The various land acts passed in 1881 (associated with Gladstone), 1885 (Ashbourne), 1891 (Balfour), 1903 (Wyndham) and 1909 (Birrell), transformed landholding in Ireland from a system based on large estates to one of owner-occupancy. The Congested Districts Board created by Arthur Balfour in 1891 was envisaged as a means of ending endemic poverty in parts of the Irish countryside by encouraging agricultural and industrial development. Initially the work of the Board was restricted to the coastal areas running from Donegal to Cork, but within a few years its work covered one-third of the country. The budget of the Congested Districts Board

was also generous, with its annual expenditure being increased to £250,000 in 1909. Together, all this legislation marked the death knell for the Ascendancy. This was because the land acts not only transferred the land from them, but also removed the social and political influence that had accompanied landownership. These various pieces of legislation, therefore, brought about a social revolution in Ireland that had implications far beyond the agricultural sector. The concessions made by the British government, however, were regarded by some members of the Land League as inadequate, and land agitation occurred intermittently until the creation of the Free State.

Following the Partition of Ireland in 1921 and the dissolution of the Congested Districts Board in 1923, the Free State government established a Land Commission for the purpose of completing the transfer of land to owner-occupiers. By this stage, many of the Ascendancy had already lost their economic and political power base, forcing some of them to abandon Ireland, where their families had resided for generations. The demise of the Big House was hastened by the creation of the Irish Free State. It was mourned by some, including liberal members of the Anglo-Irish gentry. In *The Big House of Inver* (1925), Somerville and Ross wrote of the embitterment of a now outcast class remembering what it had suffered and sacrificed doing what it held to be its duty. In post-Partition Ireland, empty or decaying Big Houses became a symbol of the passing of the landlord system and the colonial rule it had represented.

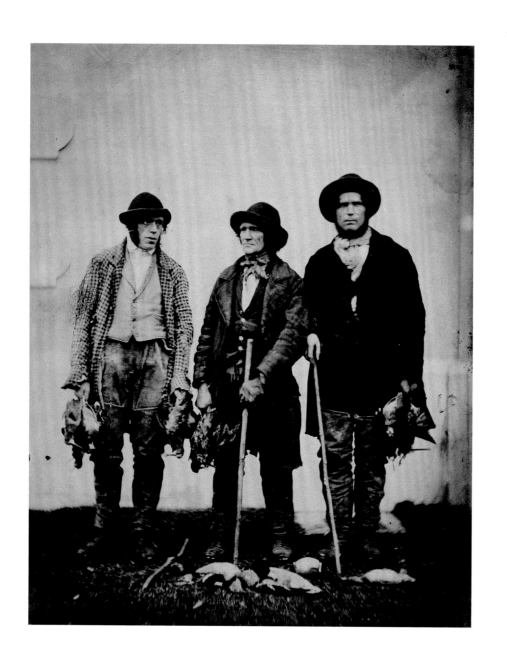

Hunting, fishing and shooting were among the favourite leisure pursuits of the gentry. The introduction of stringent poaching laws in the early nineteenth century further divided the lifestyle of Irish landlords from that of their tenants. After the Famine, due to a combination of falling incomes, legislation and tenant resistance (notably the Land War of 1879–82), the economic fortunes of the gentry declined. One consequence was that fewer staff were employed on estates. Opposite: beaters from Muckross House in County Kerry. Their job was to beat the undergrowth in order to scare the wildfowl into flight in advance of a shoot. Photographer unknown, *c.* 1857. Right: a huntsman with dead game. Attributed to Augusta Crofton, *c.* 1865.

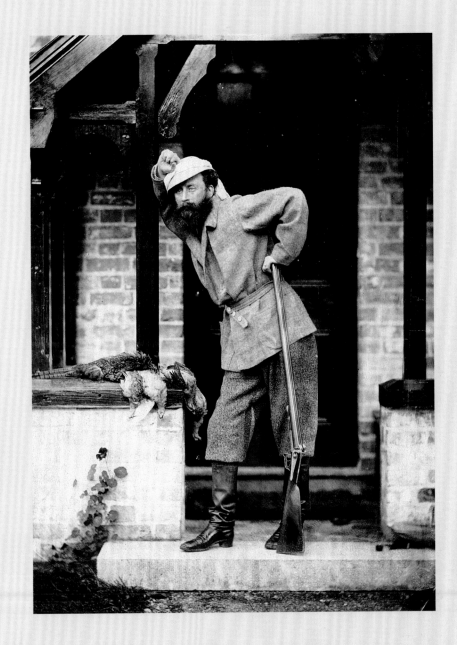

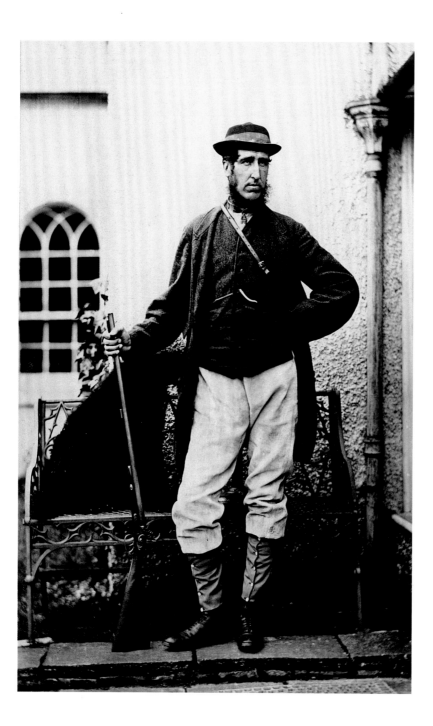

The poise and assuredness of the
unidentified huntsman on the
left contrasts markedly with the
unassuming poses of the two servants
opposite. The ongoing development
of photography provided glimpses
into previously unseen areas of
Irish country life; servants and the
poor rarely featured in photographs
before the twentieth century. The
huntsman was photographed
c. 1865 at Kilronan Castle in County
Roscommon, the estate of Edward
King-Tenison, who was also a noted
gentleman photographer (though
the photographer here cannot be
identified with certainty). Opposite:
servants at Kilronan or Rockingham.
Photographer probably Edward King-
Tenison, *c.* 1860. In Ireland, King-
Tenison was a pioneer of the use of
calotype (or Talbotype, patented by
William Fox Talbot in 1841) in which
a negative could be used to make a
number of positive prints on paper.
His work was frequently exhibited,
appearing as early as 1854 at a London
exhibition of the Photographic Society.

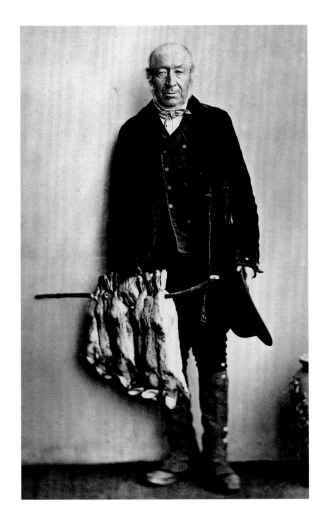

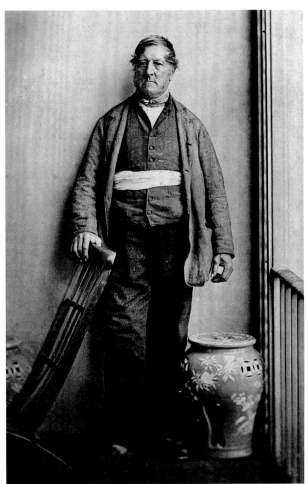

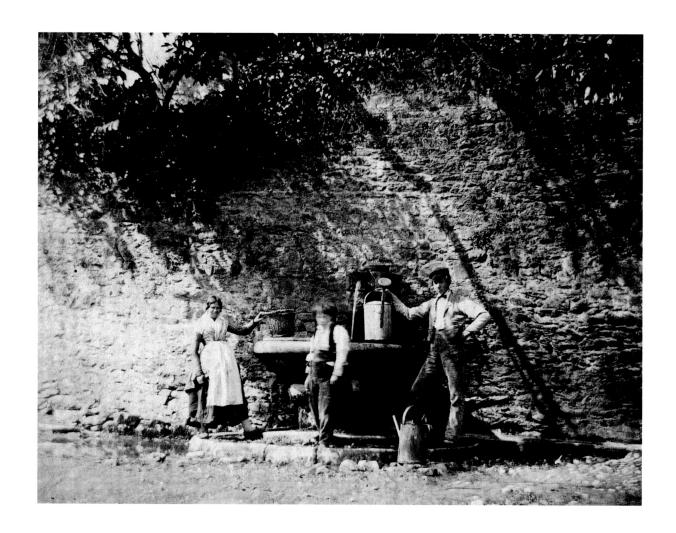

Rural workers. Francis Edmund Currey's photographs reflect his interest in ordinary people, unusual among contemporary photographers. The long exposure time required to produce such images would also have been a deterrent to potential subjects. Thus these images of water carriers (opposite, taken in May 1855) and cart workers on the Lismore estate (*c.* 1855) are a rare example of early documentary photohistory. Currey was land agent on the estates of the Duke of Devonshire in County Waterford, a prestigious position (despite the negative portrayal in popular memory), and sufficiently well paid to allow expensive leisure pursuits such as photography. Currey built a darkroom adjacent to Lismore Castle, which was also used by other photographers. Local folk tradition claims that the tenants of the Lismore estate were well treated during the Famine, with rents being reduced and soup kitchens established.

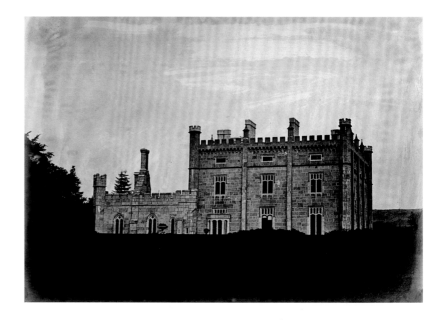

These castles give a clue to the affluent lifestyle of the landed classes in the nineteenth century. Right above: Kilronan Castle, Roscommon, was built in two stages in the nineteenth century. This photograph was taken in *c.* 1858 by its owner, Captain Edward King-Tenison, a keen photographer who was visited there by other gentleman photographers. Right below: the building of the Gothic-style Clifden Castle in 1815 helped to regenerate the district, leading its owner, John D'Arcy, to boast that 'Fifteen years ago it [Connemara] was inhabited by a race of people, wild as the mountains, whose principal occupation was smuggling. About that time I undertook the difficult task of improving the land and civilizing the people, for which purpose I commenced building the town of Clifden on the Bay of Ardbear, and I have so far succeeded'. The Famine bankrupted the D'Arcy family and the castle was sold in the Encumbered Estates Court. Photographer Thomas Wynne, *c.* 1872. Opposite: Lismore Castle, built in 1185, and remodelled and extended in the nineteenth century, was the Irish seat of the Duke of Devonshire. Photographer Robert French, *c.* 1890.

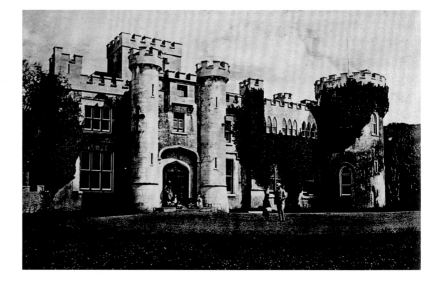

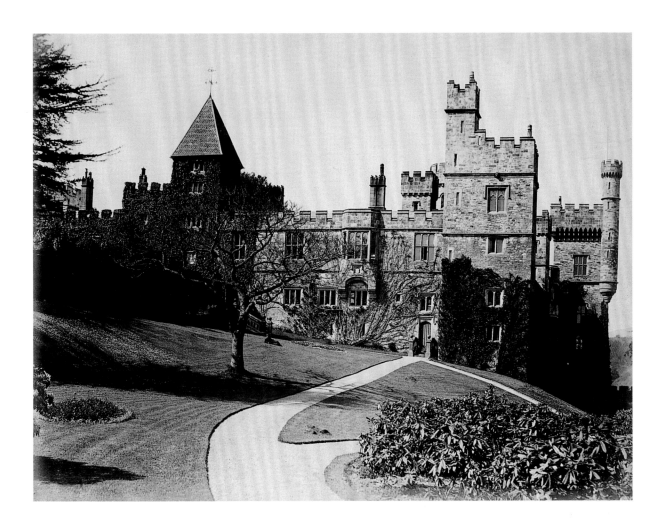

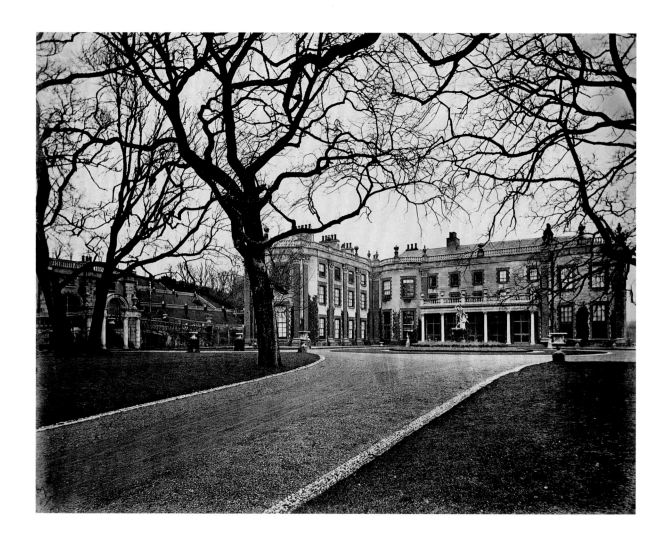

50 land, landlords and the big house

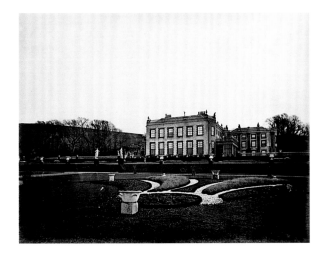

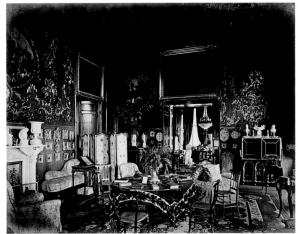

Bantry House (opposite and above) in County Cork was built around 1740. It overlooked Queenstown Harbour (right). In the mid-nineteenth century, the Earl of Bantry extended the residence and filled it with art and other treasures collected during his tours in Europe. The sumptuousness of the interior is evident in the drawing room (above right) which contained marble Corinthian columns and portraits in frames of gilt foliage. The House and the family survived the political and economic turmoil of the early twentieth century. In 1945, Bantry House became the first Big House to be opened to the public. Robert French, who took many of the photographs in the Lawrence Collection, took this series of images in *c*. 1880–90.

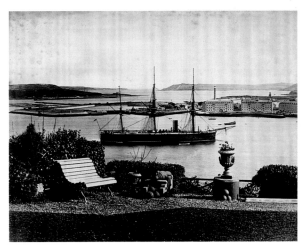

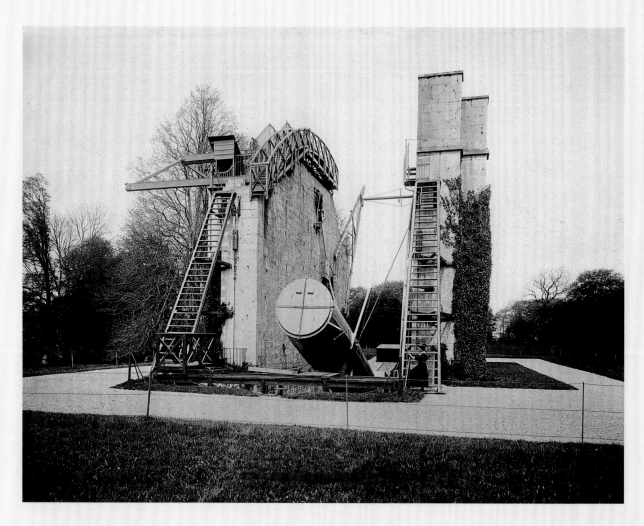

The Great Telescope at Birr Castle in
King's County (County Offaly) was
built by the third Earl of Rosse in the
1840s. Fifty-eight feet long, it remained
the largest in the world until 1917.
Photograph by Eason and Son, *c.* 1900.

Medical provision was by churches or charitable bodies until the eighteenth century. A law of 1765 facilitated the opening of county infirmaries, including the Roscommon Infirmary (above). In response to the Famine crisis, a Medical Charities Act was passed in 1851, which extended the dispensary system. Infirmaries and dispensaries continued to be in operation until the 1940s. Photographer Edward King-Tenison, *c.* 1858.

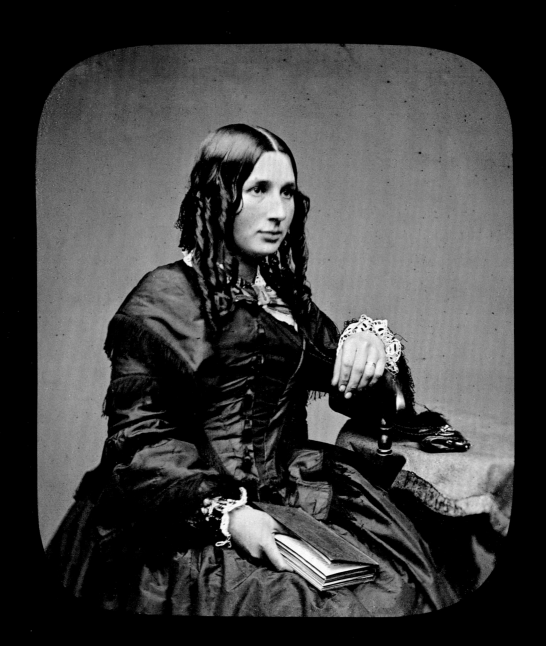

Portraiture was a favoured genre among early photographers, despite the problems associated with the subject having to remain absolutely still. Opposite: Mrs Osborne holding a book, photographed in *c.* 1858 by William Despard Hemphill, a successful surgeon and keen amateur photographer. Right: a young girl standing. Photographer unknown, *c.* 1860. Both images are representative of the formality with which early photographers approached their subjects. Above: this image of a recently deceased gentleman is unusual not only because of the subject matter, but because it is one of the earliest surviving Irish daguerreotypes. The daguerreotype process was used between 1839 and the late 1850s. Because no negative was produced, each image was unique. Photographer unknown, 1840s.

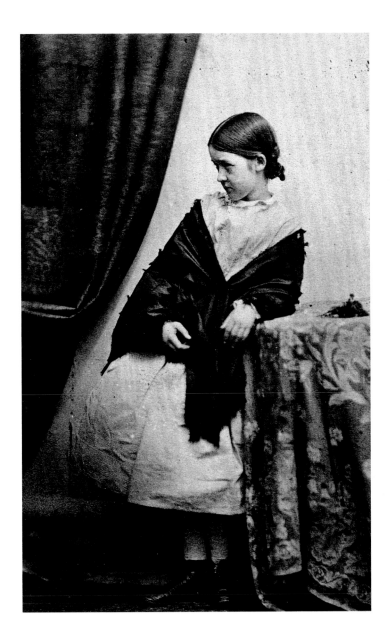

The artistry of early photographers is evident in these posed studies of a woman and two boys, taken in a photographic studio *c.* 1860. The photographers of both images, James Simonton and Thomas Millard, owned a studio together in Sackville Street in Dublin between 1856 and 1862. The process they used here – wet collodion positive on glass (or 'ambrotype') – was invented in 1851 and remained in use until about 1880. The light-sensitive salts were held in a layer of collodion (cellulose nitrate) on a sheet of glass. The plate was prepared, exposed, developed and fixed while the collodion was still wet. This produced a negative that was presented as positive by displaying the photograph with a black backing. Wet collodion positives were therefore characteristically dark, unless the photograph was treated with poisonous mercuric chloride. As with the daguerreotype process, no negative was produced, making each image unique. Because the collodion process was faster and simpler than earlier techniques, it contributed to a growth in the number of both amateur and professional photographers.

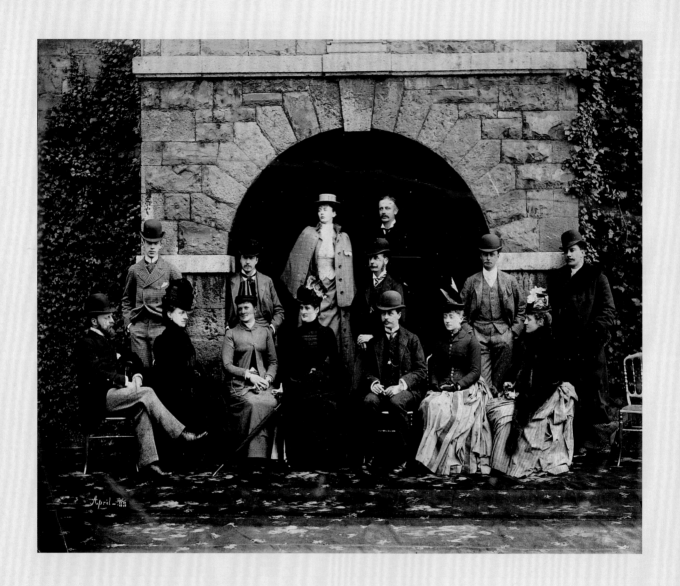

The dress and demeanor of the individuals opposite reflect their social and political superiority. This carefully posed group comprises (back row, left to right) Sir A. Guinness, Lady Helen Duncombe, Colonel Mildmay Wilson, Lord Castleross, Colonel A. Paget; (front row, left to right) Duke of Leinster, Lady Guinness, Duchess of Abercorn, Duchess of Leinster, R. Winn, G.G. (sic), Lady Castleross. Photographer unknown, April 1888. Right: portrait of Mrs Osborne, another carefully choreographed photograph intended to show its subject to her best advantage. Photographer John Lawrence, *c.* 1860. William Lawrence took over his brother John's studio and established the most successful photographic company in Dublin. The Lawrence Collection, housed in the National Library of Ireland, contains approximately 40,000 photographs.

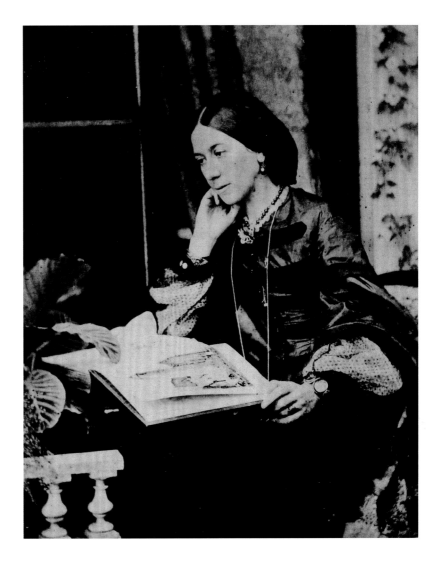

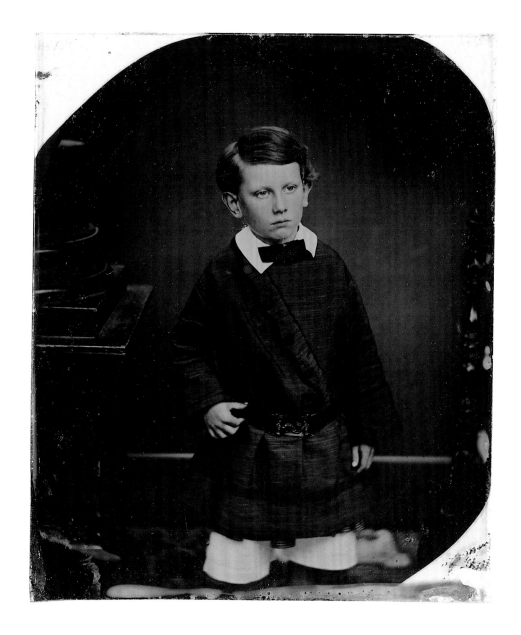

Formal poses and stylized dress express economic and social status even in the youngest age groups. Opposite: a young boy photographed by Simonton and Millard, *c.* 1855. Below (left to right): Lord Anson, the Honourable George Anson and Lord Henry Anson photographed at Kilronan Castle, the home of the photographer, Edward King-Tenison, *c.* 1865.

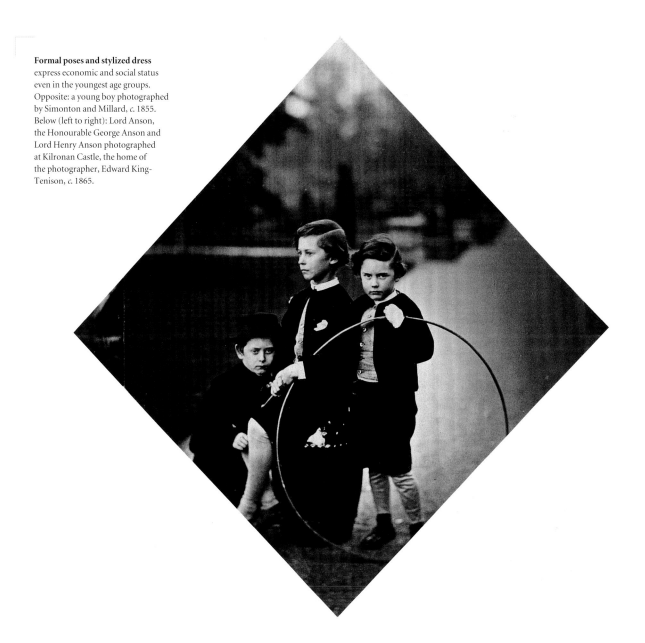

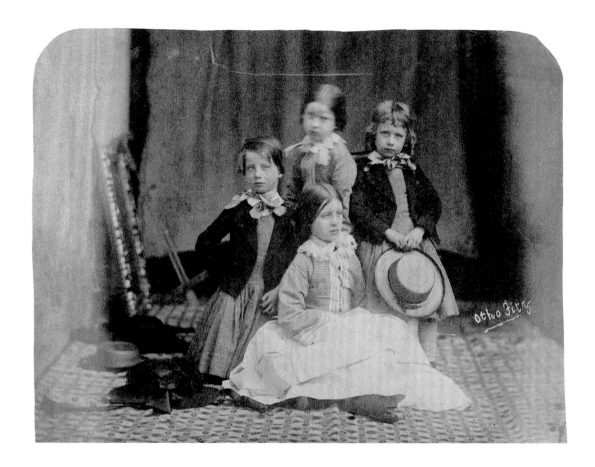

Children and young people were always
popular subjects for photography.
Above: a group of children by Lord
Otho Fitzgerald, *c.* 1855. Opposite left:
two children from an album compiled
by Georgina Harriet Tighe, *c.* 1865.
Opposite right above: woman and girl.
Photographers W. and D. Downey, *c.* 1880.
Opposite right below: the young Oscar
Wilde (1854–1900). His parents were
William Wilde, a Dublin oculist, and Jane
Frances Elgee, a poet, nationalist and writer,
who wrote under the pseudonym Speranza.
Photographer A.J. Melhuish, *c.* 1872.

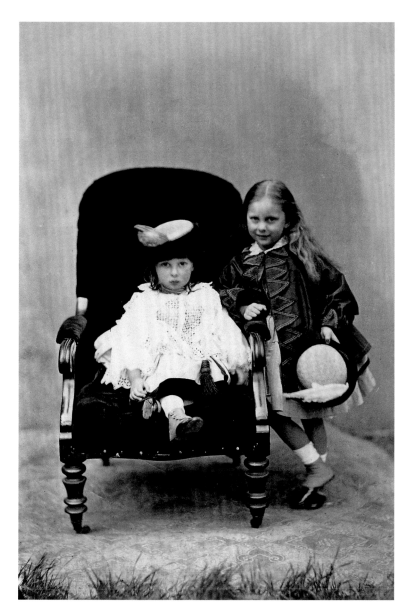
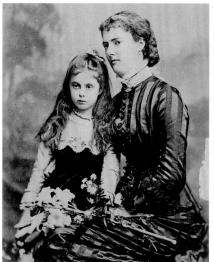
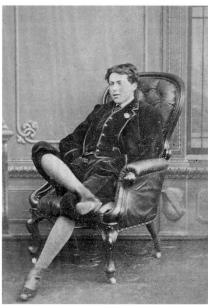

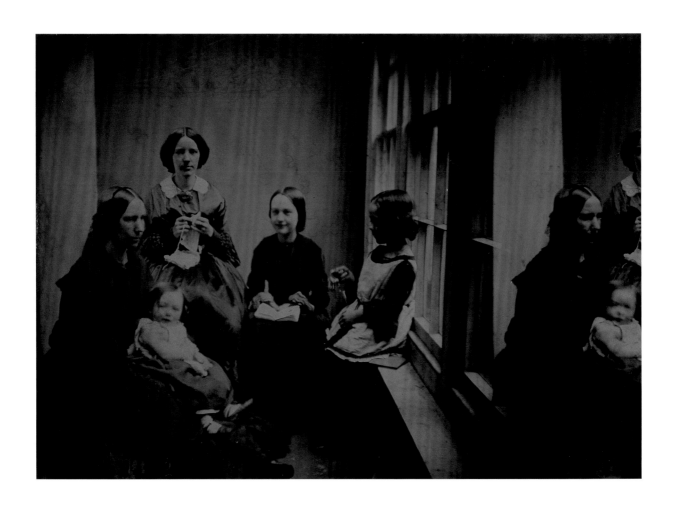

Real glimpses of domestic life are rare in the early years of photography. Opposite: women and children indoors. Photographer Humphrey Haines, *c.* 1858. Right: Mary Fitzgerald with a bandaged arm, an unusual early documentary image of an injury. This is a salted paper print, a process popular between 1839 and the 1850s. It derived its name from the fact that before exposure, the paper was soaked in a salt solution, dried and sensitized with silver nitrate solution. The final image was brown but the colour could be changed with toning. Photographer Francis Edmund Currey, *c.* 1853.

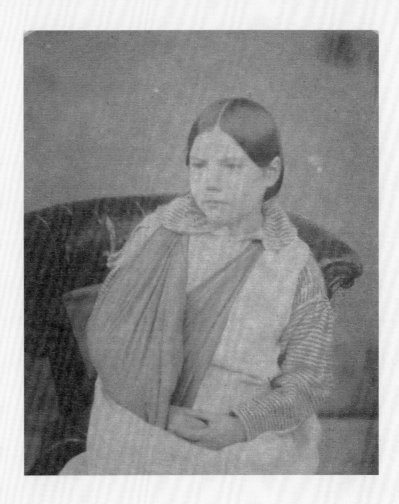

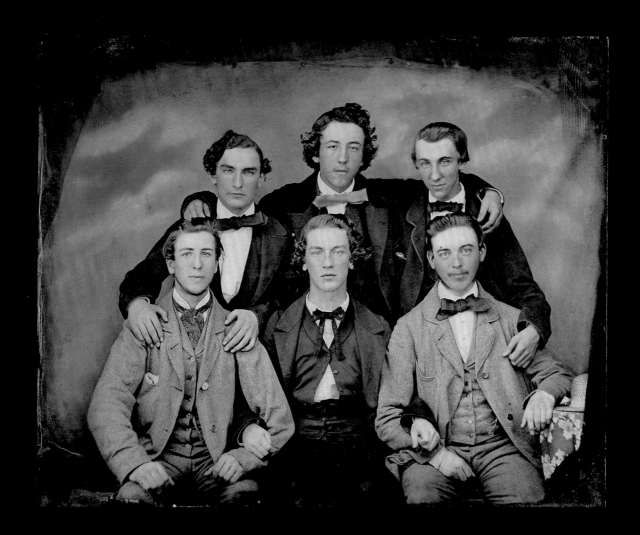

The obvious camaraderie and the
relaxed pose of the young men opposite is
unusual in early Irish photography. The
photographer, James Robinson, owned
one of the most successful studios in
Dublin after 1850, which survived into the
twentieth century. This image was taken
c. 1858. Above: the formality and hauteur
of these portraits provide a more typical
representation of the Irish upper classes.
Photographer Sir Robert Shaw, *c.* 1865.

chapter 2

poverty, famine, evictions

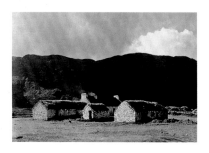

Stone-built cottages speckled the Irish countryside. They originally consisted of one undivided room, with a byre for cows at one end, but it became increasingly common to divide them, and for animals to be kept in a separate building. Above: thatched cottages in Ardara, County Donegal. Photographer unknown, *c.* 1920. Opposite: women gathering seaweed (see also p. 92).

Poor people are not well represented in either visual or written records. One of the strengths of the photographic record is that it includes images of the impoverished and the underprivileged. Furthermore, whilst the nineteenth century witnessed an increasing political divide between the north and south of Ireland, photographs can be a powerful reminder that poverty did not recognize political or geographic divisions. Ordinary people, especially poor people, had more in common than has sometimes been suggested.

By the 1840s, approximately fifty per cent of Ireland's population subsisted on a diet of potatoes. Although the diet was monotonous, it was nutritious, and the Irish peasantry were among the tallest, healthiest and most fertile populations in Europe. Yet potatoes were regarded by the upper and middle classes as the food of poverty. The high dependence on potatoes was considered a gauge of the innate laziness of the Irish peasantry. They were, it was commonly said, 'a lazy people, dependent on a lazy crop grown in lazy beds'. Potatoes were also held accountable for Ireland's large and fast-growing population, because they allowed the subdivision of land and thus encouraged early marriages. In fact, while the subsistence sector of the economy was large, Irish agriculture was diverse and a number of sectors were highly commercialized. By the 1840s, for example, Ireland was exporting to Britain each year almost one million cattle and sufficient

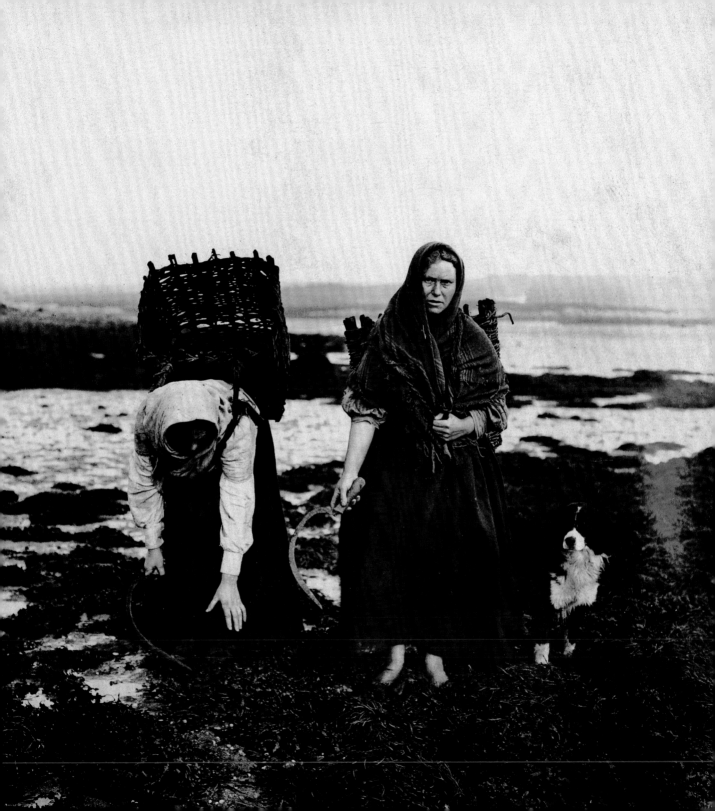

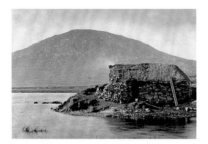

Single cabins or cottages were generally built from local materials – stone or mud for the walls and straw or rushes for the thatch. The change from thatched to slate roofs spread after 1850. Top: cottages in Falcarragh, County Donegal, photographed by Robert Banks in 1888. Above: Mick McQuaid's Cabin, photographed by Robert Welch, *c.* 1895. Opposite: the owner of this farm in Lough Dan, County Wicklow, would have been relatively prosperous. Photographer unknown, *c.* 1865.

corn to feed two million people. Large amounts of eggs, butter, fish, processed meat, porter (including Guinness) and whiskey were also exported. Despite the widespread assumption of under-production, Irish agriculture was, in reality, producing enough food not only to feed the country's own large population, but also to export massive amounts of foodstuffs to Britain.

Although poor in material terms, the Irish peasantry in the early nineteenth century had a rich social and cultural life. Many were Irish speakers and they had a vibrant tradition of storytelling, music and dance. They lived in close-knit communities, known as *clachans,* and many of their activities were shared communally. Because of the widespread availability of peat in the country, they also had easy access to a free and plentiful supply of fuel. The majority of people who died during the Great Hunger were drawn from this social group. Their deaths weakened the use of the Irish language, wiped out many *clachans,* and diminished the spirit of community and cultural life that had sustained the poor. In the decades following the Famine, visitors to Ireland noted the social torpor of the poorest classes. This change had a number of causes: the belief of a large number of people that the Famine was a punishment of God for some imagined misdemeanour; the rise of organized religion, based on ideas of sin, retribution and damnation; and the continuation of mass emigration, which removed the youngest and fittest members of society. All of these factors

served to undermine the quality of life of the poorest classes in the late nineteenth century. The faces of the poor in this collection, so frequently hidden from view, are powerful reminders that these people were survivors of the catastrophe of the Famine, and that the fruits of the richest empire in the world were unevenly distributed.

Evictions – the forcible removal of people from their rented property – remain one of the most contentious issues in nineteenth-century Irish history. They are a potent indictment of landlords and proof of their indifference to their poorest tenants. Images of evictions are among the most poignant in the history of Irish photography, especially where they show the force of the military and the constabulary being used against impoverished, defenceless people. The army, especially the officer class, were more often photographed at leisure or in full regimental regalia; the photographs of evictions evoke a less palatable aspect of their duties, and one that has abided in Irish folk memory. These photographs also brought the horrors of the process to a wider public and confirmed the hostility of many British liberals towards Irish landlords. By the second half of the nineteenth century, evictions had become the most powerful symbol of the remoteness, the mismanagement and the heartlessness of landlords in Ireland.

In law, Irish landlords possessed many rights. They could raise rents with ease, and the fact that by the nineteenth century many tenants

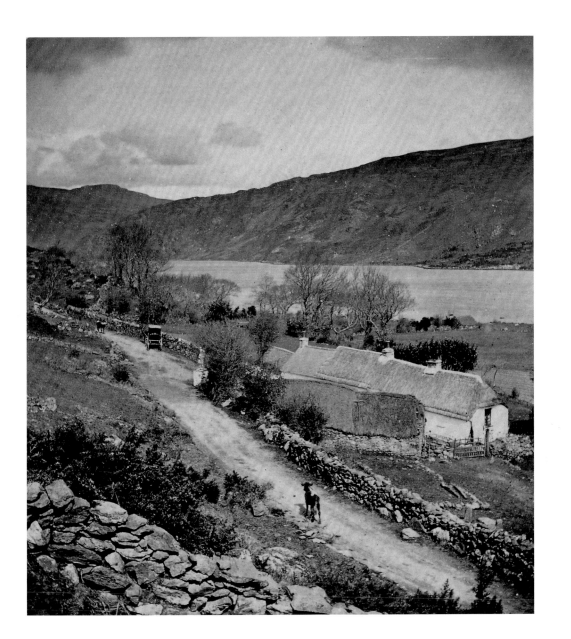

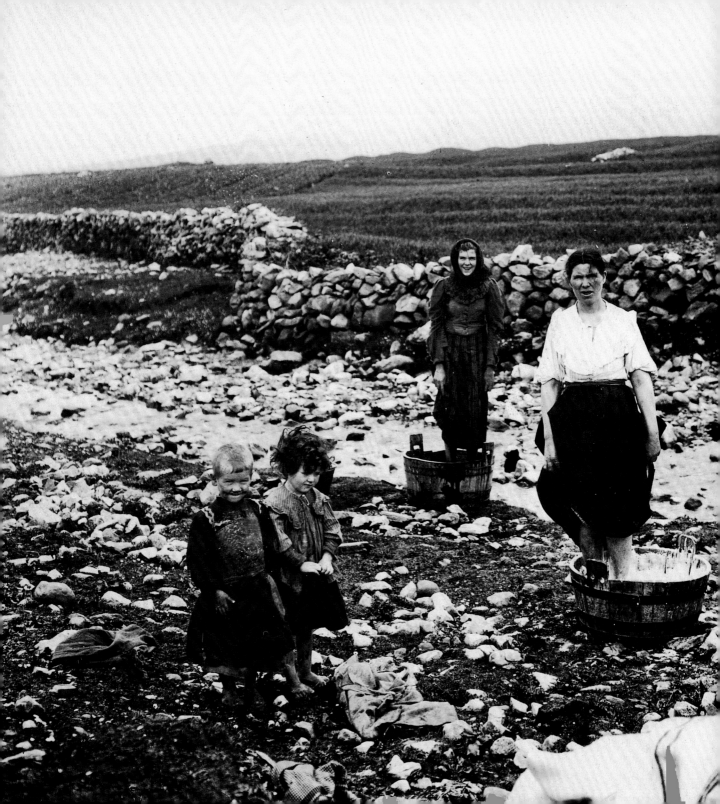

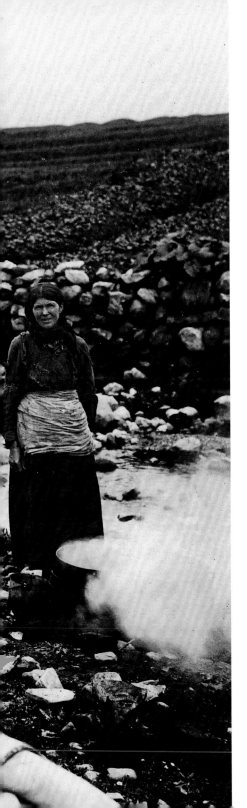

had short leases or none at all meant that the process of eviction was quick, cheap and easy. Before the Famine crisis of the 1840s, however, large-scale evictions were rare, partly due to the threats of violent resistance from rural secret societies. Evictions peaked during the Famine years, and between 1849 (when statistics began to be collected) and 1854, over one quarter of a million people were legally and permanently evicted from their holdings. Many others were illegally ejected or reluctantly surrendered their holdings in order to be eligible for workhouse relief. For landlords, an extra incentive to evict smallholders was the particularly heavy taxation of subdivided land. The consequence was that in the latter years of the Famine, especially after the introduction of the Quarter Acre Clause in 1847, homelessness joined hunger as a cause of death and disease. Following the Famine the number of evictions dropped. Between 1855 and 1880, only three to four per cent of families were permanently evicted from their holdings. However, in addition to evictions, many smallholdings of land were voluntarily abandoned as a consequence of mass emigration.

Rural life was harsh for the poor. Left: washing clothes was traditionally a female activity. In this photograph the women are washing blankets. Water was heated on location for this cumbersome process. Photographer Philip Hunt, *c.* 1910.

The Famine did not mark an end to agricultural crises within Ireland. The years 1859 to 1861, and more importantly 1879 to 1881, saw poor harvests, rising prices and falling rentals. A sharp increase in evictions and emigration served to polarize and embitter landlord–tenant relationships. One of the most infamous episodes occurred in Derryveagh in County Donegal in 1861, where evictions were precipitated by the murder of the local land steward. The murder of landlords and their agents, although not widespread, was not unknown: between 1857 and 1878, over one hundred cases were recorded. They generally received extensive coverage in the press. Often, the murder of a landlord or his agent was preceded by the threat of eviction and the replacement of families with sheep. A number of landlords responded to the violence with further evictions, as happened at Derryveagh.

Evictions again increased in the wake of a series of bad harvests after 1879 when falling agricultural prices and unpaid rents provided an incentive for landowners to clear their estates. In 1880 alone, over two thousand

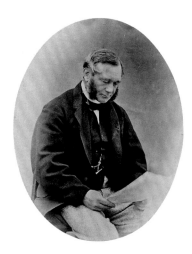

Land agents were often employed by large proprietors to manage their estates. Above: Ross Mahon, land agent. Attributed to Augusta Crofton, *c.* 1865. Opposite: a cabin near Roundstone, Connemara. The stones in the foreground are typical of the Connemara landscape, which is rocky with little fertile soil. Stretching between Galway Bay and County Mayo, Connemara's high rainfall and driving, Atlantic winds made the weather frequently inclement. Photographer unknown, *c.* 1895.

families were evicted. The resultant discontent was expressed in a sharp increase in the number of agrarian 'outrages', or crimes, the clearest indicator of rural anger. In that year, there were 2,500 recorded agrarian outrages. Initially centred on Connaught, they gradually spread to other parts of Ireland including the north-east. The process of eviction was relatively simple because the rights conferred by law onto the landlords were virtually absolute. Rents were generally paid annually and tenants could be evicted either if they failed to pay on time or following a six-month notice to quit. These notices were cheap and easy to obtain, and if the tenants were not gone within the time allowed, they could be taken to court and forcibly removed. In Derryveagh, the sub-sheriff was given the support of 200 constables in order to evict 47 families, consisting of 85 adults and 159 children. Twenty per cent of the families were eventually allowed to return in the role of 'caretakers' but the remaining eighty per cent were permanently evicted from their homes. The Derryveagh evictions were widely reported and publicly debated. They were discussed in both the press and in parliament and were chronicled in ballads, novels and even in a tourist guide. One of the most poignant descriptions of an eviction came from the local Poor Law Inspector – witness to many such scenes – who recalled watching an old man and his family kissing the walls of their house before they left. Scenes of evictions were published in the Irish and British press and they helped to reinforce a prevailing belief

that many Irish landlords were cruel and uncaring. In addition to providing an authentic record of the horrors of eviction, they also provided the nationalist movement with a powerful propaganda tool. Within this climate of uncertainty, it was easy to make landlords the scapegoat for all of Ireland's ills. In reality, much rural protest was also directed at tenant farmers by their employees and subtenants.

Evictions during and after the Famine highlighted in the cruellest of ways the need for land reform, an issue which dominated the political agenda in its aftermath. In the 1850s, the Tenant League emerged, establishing the demand for the 'Three Fs' – fair rent, fixity of tenure and free sale – which was to become the lynchpin of subsequent agitation for land reform. Initially the rights of landlords rather than the institution itself were attacked, but gradually there was a demonization of the landlord class, especially in nationalist discourse. The agricultural depression of the late 1870s coincided with a period of effective political leadership which was able to harness the fears and aspirations of the rural population. Increasingly, landlords were identified as the enemy and their position was further undermined by the emergence of other powerful elite groups such as strong farmers, merchants and Catholic priests. The foundation of the Land League in County Mayo in 1879 energized the demand for the Three Fs and gave coherence and a national

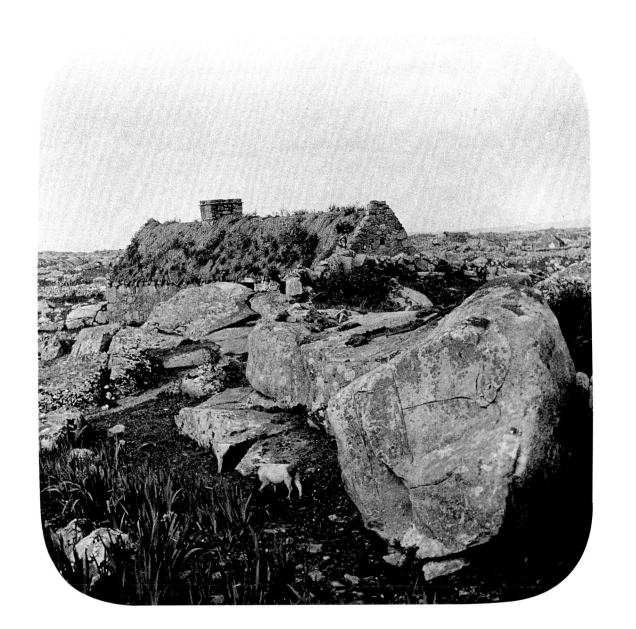

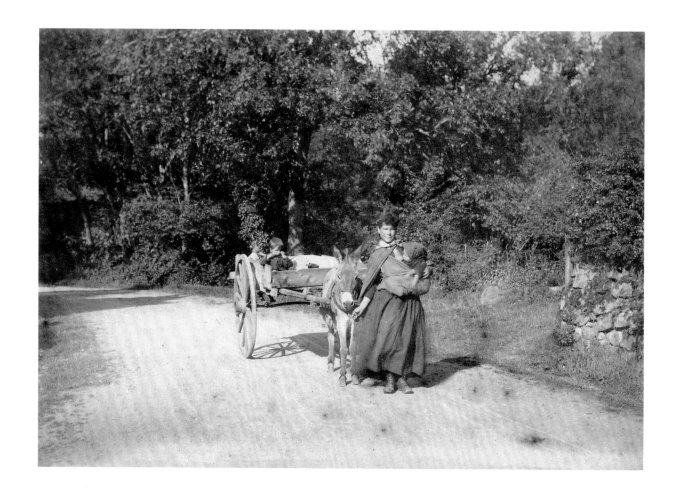

Babies are unusual in nineteenth-century Irish photography. Even more striking is that this woman is shown breastfeeding, yet appears at ease with being photographed. Photographer unknown, *c.* 1890.

Spinning woollen and linen fibres into yarn was considered to be women's work and was taught to girls at a young age. The spinner usually had an assistant who wrapped the spun yarn around a reel. Early spinning wheels were turned by hand, but later models had a foot pedal. If the man of the house was a weaver, the yarn would be made into cloth before being sold. This system of domestic production declined after 1830 as industrial manufacture spread. Below: woman spinning. Photographer unknown, *c.* 1900.

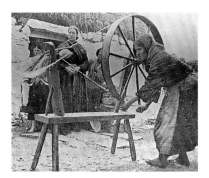

structure to widespread agitation. Under the leadership of Davitt and Parnell a system of civil resistance was organized, in which the strategy of boycott (named after an Irish land agent, Captain Boycott) was pioneered. More impressively, this movement brought together diverse interest groups ranging from rich farmers to landless labourers, Fenians and tenants. Part of Davitt and Parnell's success was due to the fact that they united both revolutionary and constitutional elements within Ireland, although the Catholic Church, traditionally viewed as the leader of the poor, was ambivalent in its attitude. Successful farmers were frequently in the vanguard of the movement rather than the labourers or the landless who were less likely to benefit from the changes demanded. Nonetheless, some of the more radical demands of the Land League were disliked by large farmers who wanted to use the organization to further their own more limited aims of ownership rather than the complete redistribution of land. The League's strategic use of isolation or boycott, occasionally underpinned by the threat of violence, proved to be successful. Support was provided to evicted families in a number of practical ways, including the provision of alternative, protected accommodation.

Although the majority of evictions were concentrated in the early 1880s, a number took place after the depression had ended, such as the Bodyke evictions in east Clare in 1887. These continued to receive much public attention and were debated in both the press

and in parliament. The sympathy of some British MPs provided both the Land League and evicted families with a voice in the House of Commons. Moreover, the images of evictions that appeared in the international press brought the stark realities of the Irish land question into the homes of a wider audience in Ireland, Britain and America. Some cases of eviction achieved widespread notoriety and they became symbols of a deeper struggle between tenants and landlords in Ireland. Increasingly, it became apparent that although the landlords had the law on their side, the political tide was turning in favour of the tenants.

The involvement of the British government in Irish land reform was helped by the support of the Liberal Prime Minister, William Gladstone, who was also a supporter of Home Rule. He became convinced of the need for a change in the landholding system in Ireland, and felt that reform and concessions were preferable to violence or revolution. He also believed that land reforms would help to safeguard Britain's political relationship with Ireland. The Land Act of 1881 recognized formally the Three Fs. While this measure was radical – no comparable legislation had ever been passed in Britain – it was no longer enough to satisfy the rising expectations of the tenant class. It was the first in the series of land reforms introduced by successive British governments, including Conservative governments between 1895 and 1905, who adopted a policy of 'constructive unionism'. A key component of

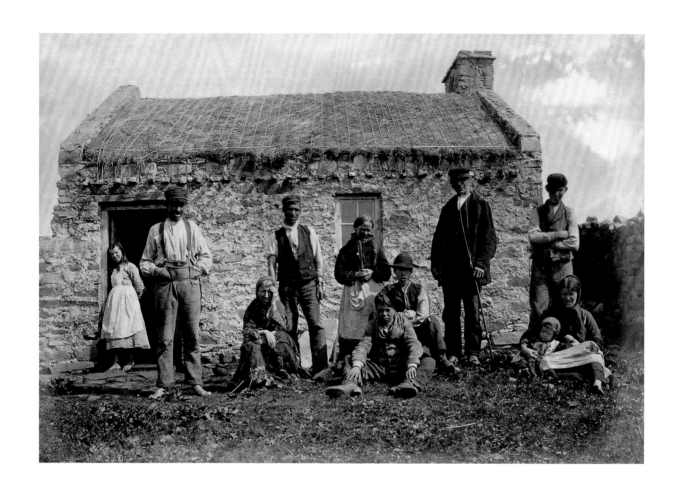

Although living standards rose in Ireland in the decades following the Great Hunger, poverty was still widespread. Above: in this photograph of inhabitants of Gweedore, taken by Robert French *c.* 1890, a number of the adults are not wearing shoes. Their clothing and headwear are characteristic of County Donegal.

Poteen or 'Irish Mountain Dew', distilled from grain or potatoes, was illegal in Ireland. However, the high cost of whiskey meant that illicit distillation flourished, especially in the west and north of the country. Poteen was also considered to be of superior quality to commercial whiskey. This still in Connemara (below right) is watched over by barefoot children. If discovered by the police, it would have been destroyed. Photographer Robert Welch, c. 1890. Welch (1859–1936) was the leading photographer in Ireland at the turn of the century. Although much of his work concerned Ulster, he travelled throughout Ireland taking photographs.

these policies was the creation of the Congested Districts Board in 1891, with powers to purchase and redistribute land and relocate tenants where necessary. The Board was responsible for improving the infrastructure in the west of Ireland, helping to establish new industries and introducing new farming techniques and technology. Its impact on landlords was devastating. By the First World War, two-thirds of Irish tenants owned their own properties. When the Board was dissolved in 1923, it had purchased over 1,000 estates. Nonetheless, radical members of the Land League viewed the land reforms introduced after 1880 as a tool employed by the government to diffuse agricultural tensions and weaken the demands for self-government – to 'kill Home Rule with kindness'. Consequently, the activities of the Land League continued, albeit in a reduced form, until the creation of the new Free State.

Although the population fell in such a dramatic and tragic way after the Famine, and although landlords were by the end of the century being replaced by smallholding proprietors, certain aspects of rural life changed little in the century after 1840. Bogs continued to be an important aspect of the rural economy, especially in the western counties. Fishing also tended to be practised along traditional lines. The onset of commercial and large-scale agriculture is evident from photographs of threshing machines and other agricultural machinery as early as the 1860s. The photographic record

also confirms the pivotal role of women in a wide range of occupations in the countryside, many of which were physically demanding. Regardless of the valuable role played by women, unless they had employment, land or a husband, there was no place for them in post-Famine Ireland and, uniquely within Europe, as many women as men emigrated from the country. The growth of towns in the late nineteenth century provided women with an increased number of employment opportunities, especially in shops, which were regarded as more respectable places of work for women than factories. The status of women improved little with political independence, despite the contribution they had made to achieving it. The low social status of women was confirmed in the 1937 Free State Constitution, which was largely the work of Eamon de Valera. For the majority of women who lived in Ireland in the century after 1840, therefore, housework, child-bearing, farmwork, domestic service, shopwork, factory employment, or joining a religious order continued to provide the main alternatives to emigration.

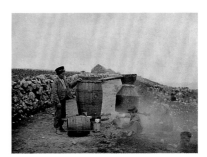

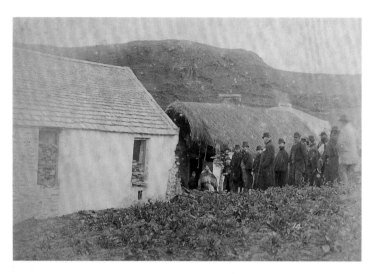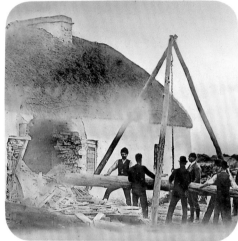

Evictions increased antagonism between
landlords and tenants. Between 1846 and 1853,
approximately 250,000 people were evicted,
greatly adding to the problem of homelessness.
After the Famine evictions continued, especially
following poor harvests. Above left: eviction
at Falcarragh, County Donegal. Photographer
Robert Banks, 1888. Encouraged by the formation
of the Land League in 1879, some tenants resisted
eviction, and landlords responded with force.
Above right: a battering ram, suspended from
a wooden tripod, could break through even
thick stone walls. Photographer Robert French,
1888. Opposite: the Widow Quirk's cottages at
Coomasaharn, County Kerry, after she had been
evicted and her home deliberately destroyed.
Photographer Francis Guy, 1888.

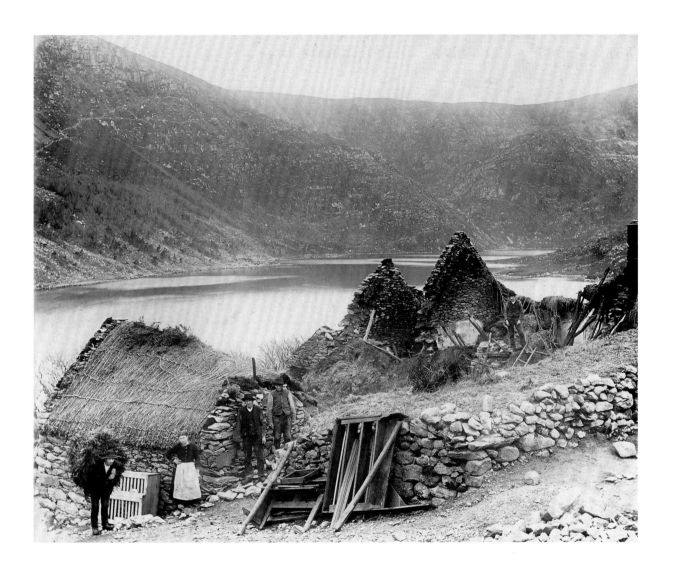

One strategy of the Land League was to invite reporters, photographers and politicians to attend evictions, and consequently the Vandeleur evictions in County Clare in July 1888 were widely reported in the press. Robert French attended and took these three photographs. Michael Cleary's house was the third eviction of the day. Right: unable to enter the cottage using crowbars and hatchets, the police brought in a battering ram, which broke through the north wall (below). Michael and his four children were arrested and remanded by a provisional court held in what had been their field. Opposite: the Cleary family were given temporary accommodation by the Land League.

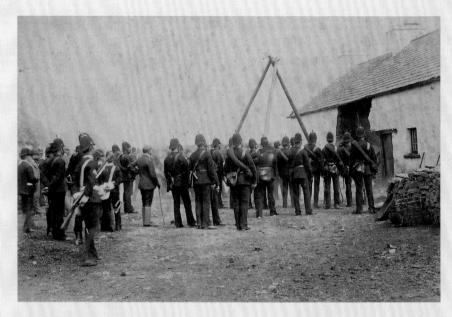

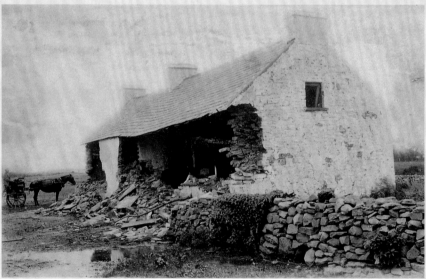

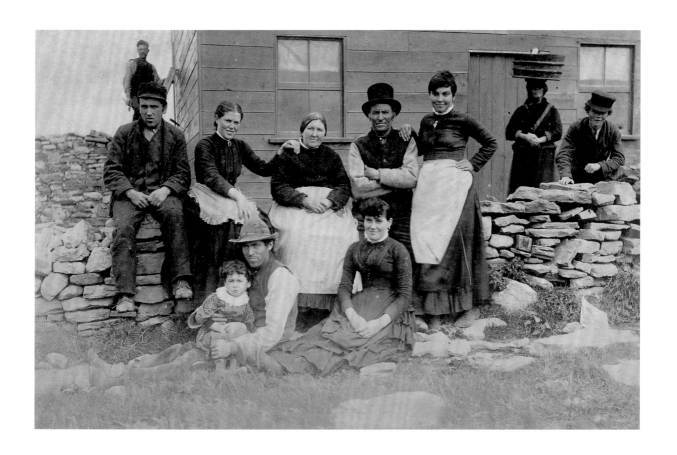

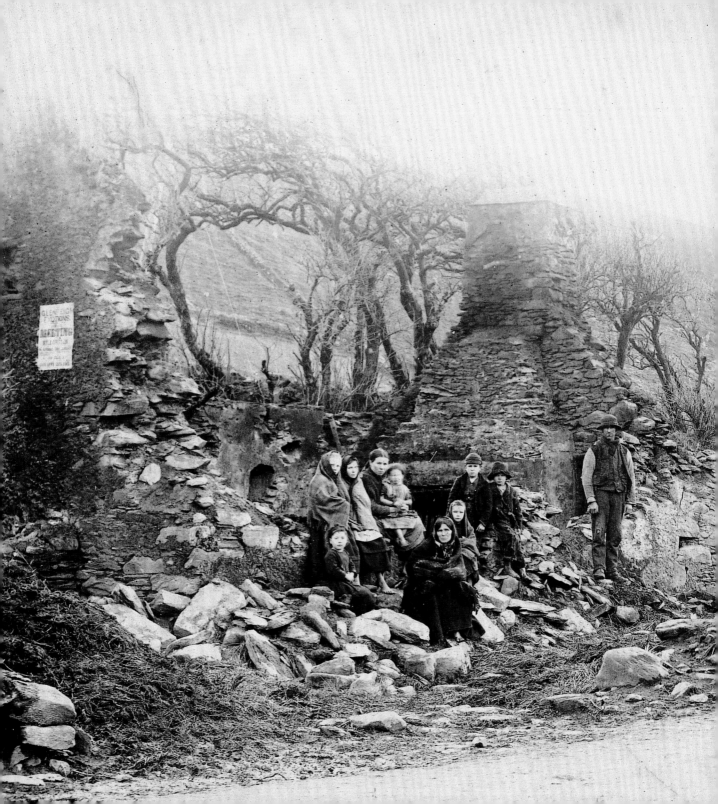

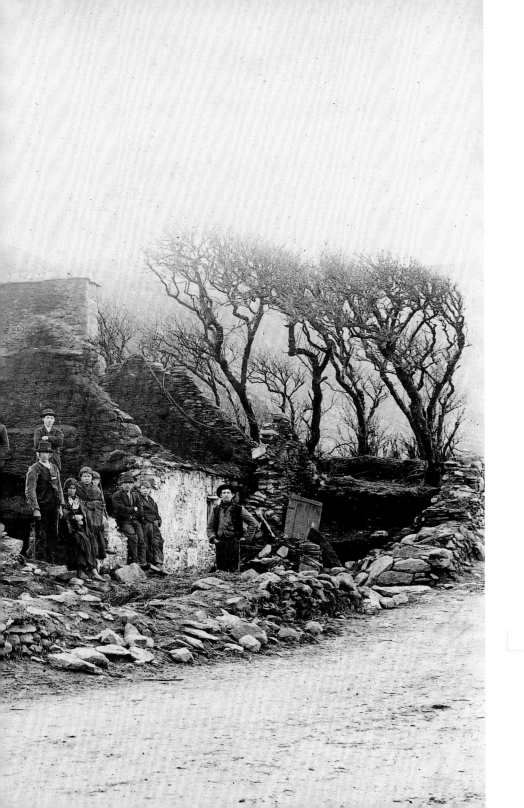

The period after 1879 was
dominated by the activities of
the Land League which, under
the leadership of Michael Davitt,
orchestrated the Land War. The
notice on the gable of one of these
destroyed cabins in Glenbeigh,
County Kerry announces a protest
meeting against the evictions.
Photographer Francis Guy,
winter 1888.

Despite the spread of mechanization in the second half of the nineteenth century, some aspects of rural life changed only slowly. Horses and donkeys continued to play a central role in the Irish economy. At seed-time and harvest, small farmers who owned only one horse would get together to form a two-horse team. Above: cutting corn in County Donegal. Photographer T.H. Mason, 1920s. Right above: a blacksmith, photographed by Philip G. Hunt, *c.* 1910. Right: thatch was the traditional roofing material in Ireland. Like dry-stone walls, thatching exhibited considerable regional variations. Photographer T.H. Mason, 1920s.

High quality grain, usually for export, was grown throughout Ireland in the nineteenth century, often alongside potatoes. Ballycopeland Mill, near Millisle in County Down, was built in the eighteenth century. Its mobile cap allowed the sails to turn to face the prevailing winds. A small miller's house was situated next to the mill. Photographer J. Johnson, *c.* 1910.

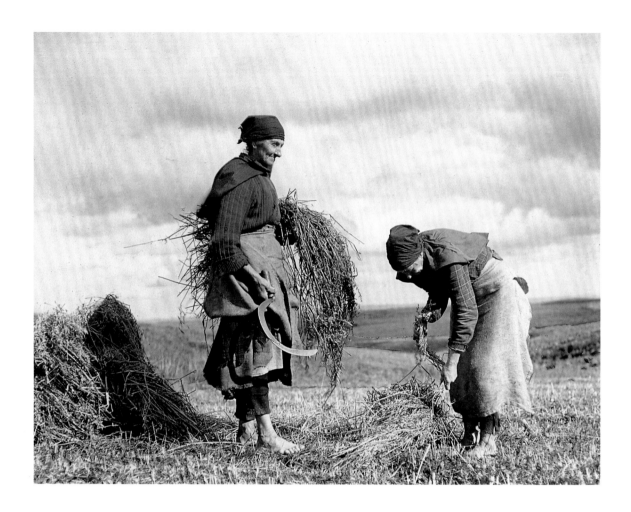

Women were involved in most
aspects of agricultural work, especially
during harvest. These women reaping
corn in the Clogher Valley, County
Tyrone, *c.* 1912, are barefoot, despite
the sharpness of the corn. The
photographer, Rose Shaw, was one of
the finest artistic photographers in early
twentieth-century Ireland. Many of her
images portray women at work.

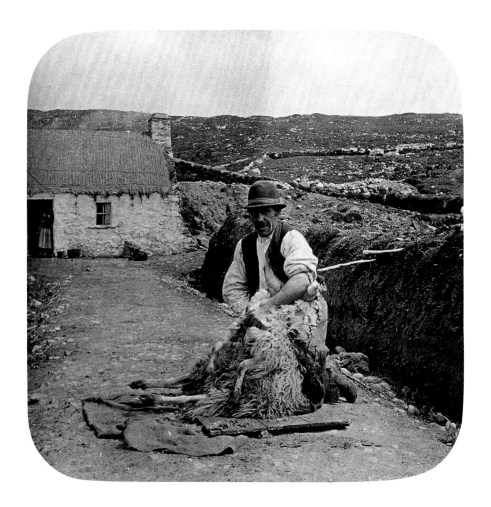

Wool was an important part of the Irish rural economy. The shorn wool was traditionally spun into yarn by women in their homes. The depopulation resulting from the Famine contributed to an increase in sheep-rearing and by 1900 there were four-and-a-half million sheep in Ireland. Above: Sheep shearing in Gleninagh, Connemara. Photographer unknown, *c.* 1895.

Peat bog or turf covers approximately one-fifth of Ireland. For the poor, turf has traditionally been a major source of fuel, though Irish industry, as it developed, preferred imported coal, which was more efficient and reliable. Turf-cutting was usually carried out in April or May, allowing it time to dry before the winter. It was a big job, involving the whole family. Right: a boy loading turf. Photographer T.H. Mason, 1920s. Below: a woman bringing home the turf. Photographer Philip G. Hunt, *c.* 1910.

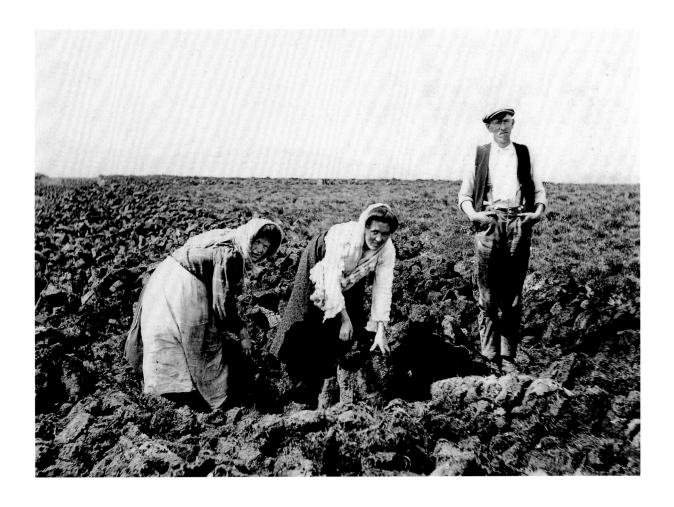

Cutting turf was known as 'footing'.
It was heavy work. Photographer
Philip G. Hunt, *c.* 1910.

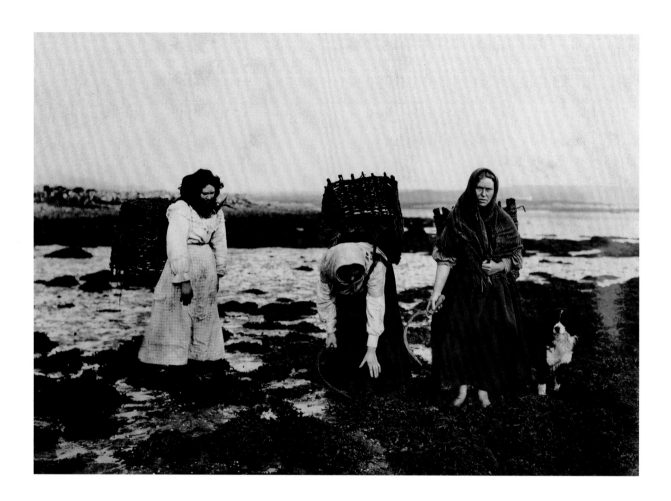

Seaweed collected from the beaches at low tide was widely used as a fertilizer, especially for root and vegetable crops. It could also be eaten as a delicacy or used to flavour food. When burned, the calcinated ash could be sold to be commercially processed into iodine. These women are gathering seaweed in creels. Photographer Philip G. Hunt, *c.* 1910.

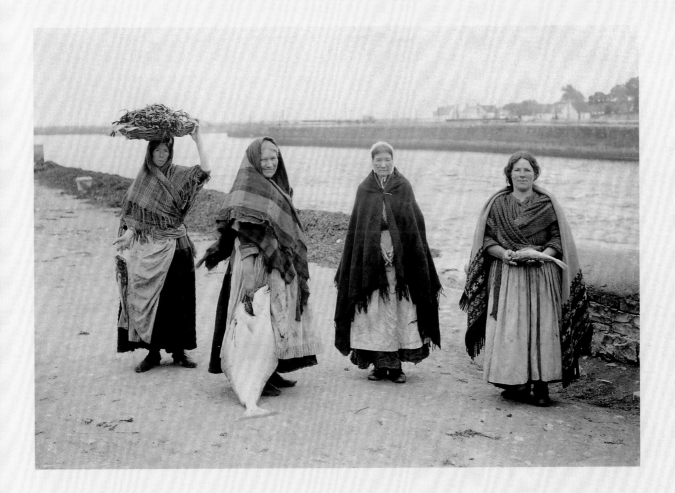

Fishwives from the Claddagh, County Galway, wearing traditional costume, which included a petticoat of coarse wool, or drugget, and a number of shawls that were often fastened with a pin and could be drawn over the head. Photographer Philip G. Hunt, *c.* 1905.

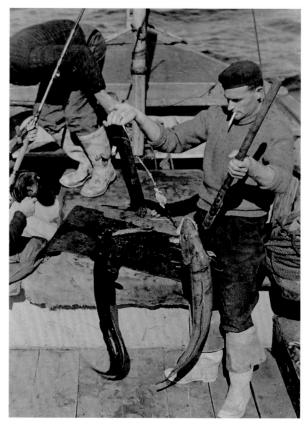

The development of an Irish fishing industry was
slow, even though nowhere in the country is more
than sixty miles from the coast. Before the Famine,
Ireland was a fish importer and the demand for fish
was low. In the second half of the century, there
was a partial revival, especially of the herring trade.
These images show fishing off the coast of Down.
The gaff (pole) and rods were used for coastal
fishing. Photographer S.M. Baliance, *c.* 1938.

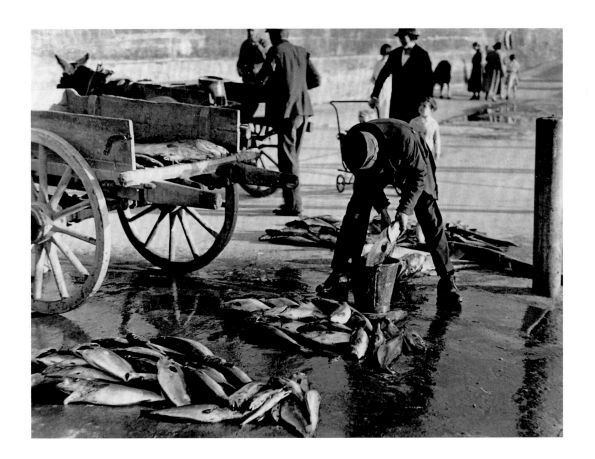

Gutting the fish on the quayside. One of
the constraints in developing a fishing
industry was that fish are highly perishable.
After the mid-nineteenth century, the
spread of steam shipping and refrigeration
meant that Irish-caught fish could be
marketed abroad, particularly in Scotland
and England. Photographer S.M. Baliance,
c. 1938.

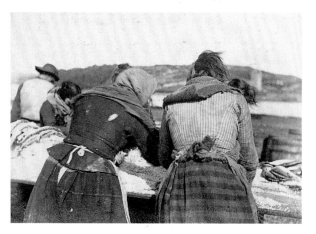

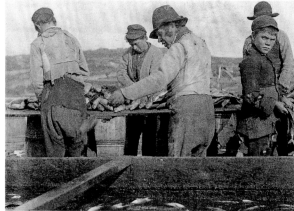

Louisa Warenne's artful and
humanitarian eye created some
highly captivating images. It took
considerable confidence in her artistic
ability to photograph subjects from
behind, as she did here. Warenne
also showed sensitivity in capturing
intimate yet unsentimental images
of working people. Above: fishwives
at Castletownshend, County Cork,
c. 1892. Right: two different views of
curing mackerel at Castletownshend,
c. 1892. Opposite: four portraits,
c. 1892. The three older people are
survivors of the Great Hunger, while
the young cooper was probably born
in its immediate aftermath.

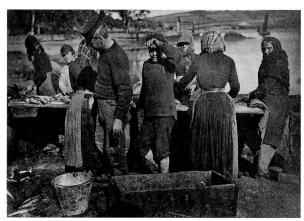

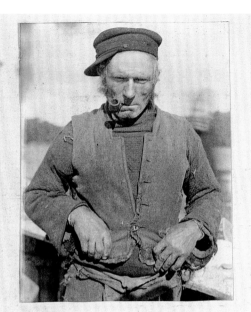

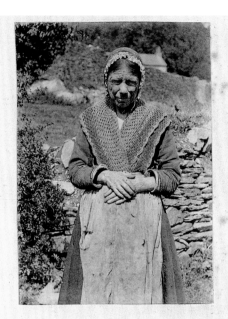

One of the Fish curers.

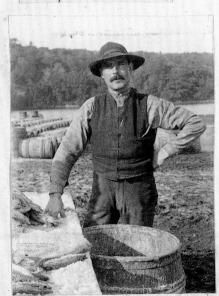

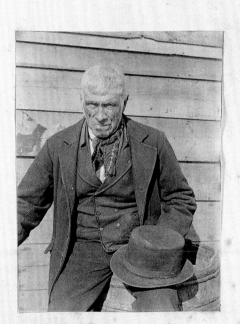

Old Store-Keeper. age 80.

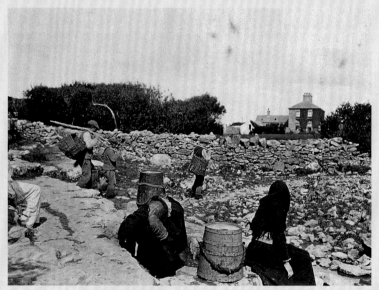

Christine Chichester, like Louisa Warenne, was interested in capturing people at work. Her images are composed in the manner of landscape paintings and are usually signed and titled on the verso. Above: *Horse and Rider in the Aran Islands*, Galway, *c.* 1910. Right: *Activities at the Shore*, *c.* 1910. The seashore made a significant contribution to the coastal family economy at the beginning of the twentieth century. Aside from fishing, shell sand was added to acid soils; rock mussels were spread on the potato ridges as a fertilizer; winkles, limpets and sprats were gathered for food; molluscs were used as fishing bait; scallop shells were recycled as containers; and seashells were burned to make lime for whitewashing houses and walls. Opposite: *Alexandra Hotel, Killarney, County Kerry*. Photographer Christine Chichester, *c.* 1905.

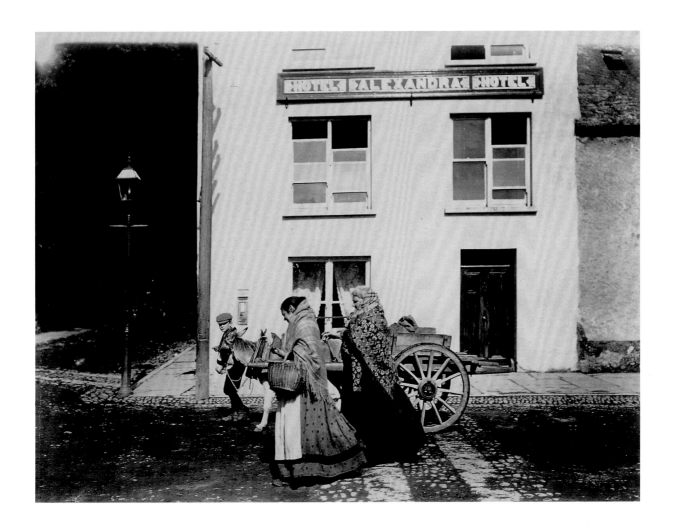

poverty, famine, evictions 99

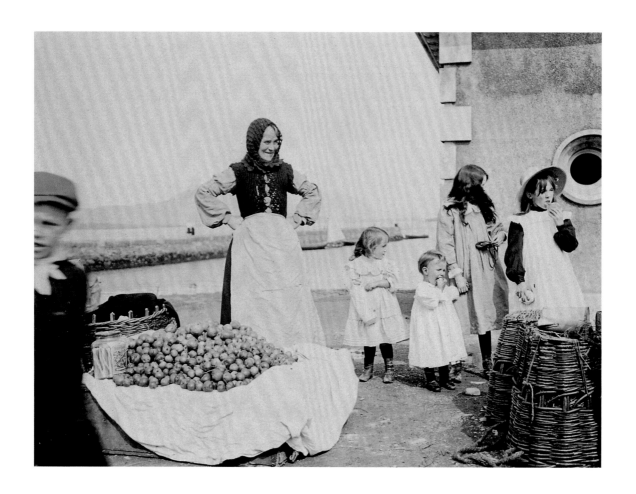

Christine Chichester titled this
photograph *Mrs Griffin of Cahirciveen
Selling Apples at Valencia Regatta,
County Kerry*. Taken *c.* 1910, it
demonstrates Chichester's artistic
ability in transforming ordinary
events into extraordinary images.

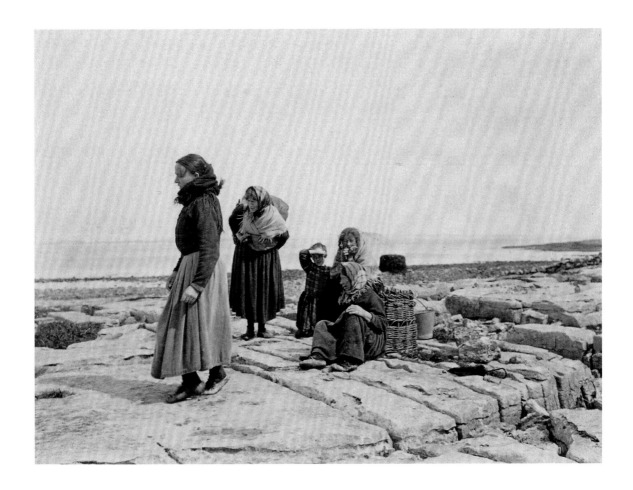

Dancing was a vital part of social life. Jigs
and reels were performed solo or in groups.
Irish step dancing was an integral part of the
Gaelic revival of the late nineteenth century.
Above: *Dancing, with no Accompanying
Music, on Aran Island.* Photographer
Christine Chichester, *c.* 1910.

Market days were not only important in the economic life of a community, they were also social gatherings. Above: a market at Kilronan, Aran Islands. The style of dress of these people was distinctive to the inhabitants of the Aran Islands. Photographer T.H. Mason, *c.* 1912. Above right: taking turf to market in Galway in the 1920s. Photographer unknown. Opposite: a horse and cart accident at Thurles, County Tipperary, a vivid and unusual glimpse into everyday life and its mishaps. Photographer W. Ritchie, *c.* 1900.

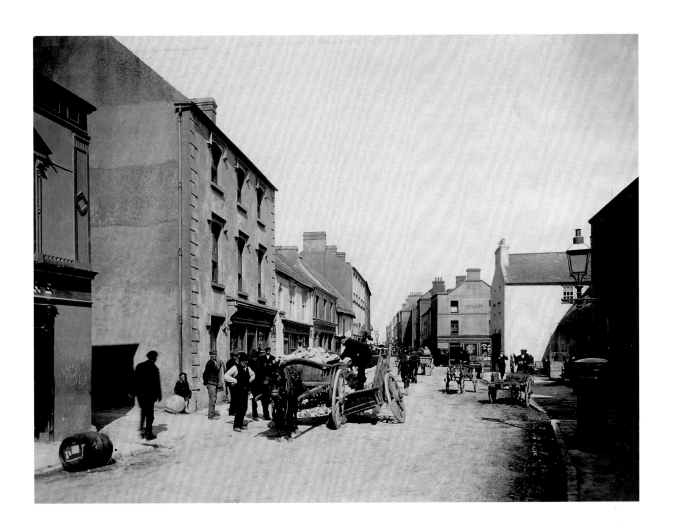

Hawkers and street sellers were an important part of the local economy. The merchandise was usually carried in baskets, as in this Galway street scene, which shows the informality of street trade. The headwear of the men indicates the varieties of styles that were worn, while the woman wears the characteristic shawl. Photographer unknown, *c.* 1895.

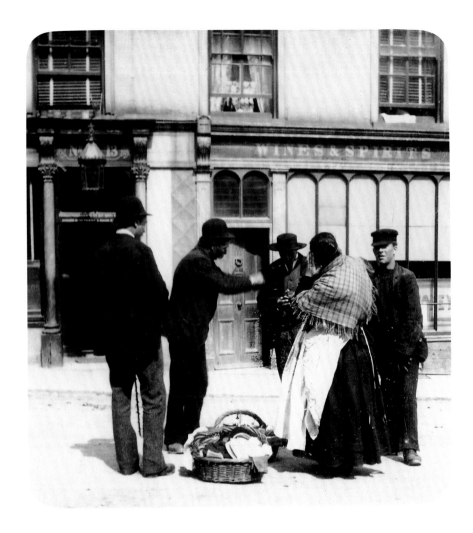

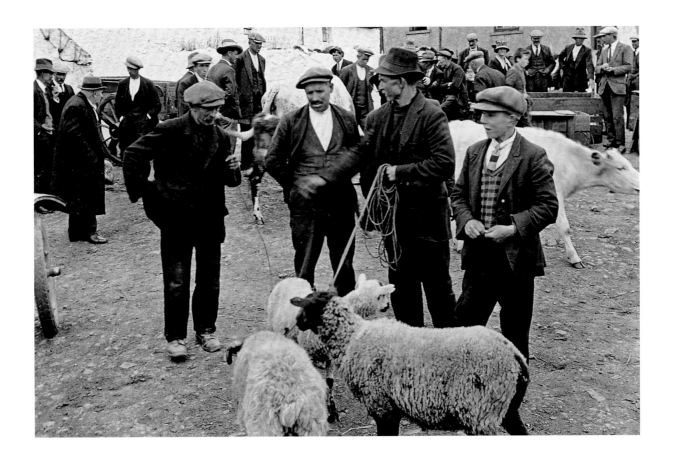

The standard of living of farmers rose after the Famine, despite intermittent crop failures. This image of men striking a deal at a livestock market suggests a buoyant local economy. Rising incomes were boosted by the practice of emigrants sending money or remittances back to their families in Ireland. Photographer unknown, *c.* 1920s.

Irish agriculture after 1850 changed
from tillage to pasture. The shift
to grazing was encouraged both by
depopulation and the high demand for
livestock. Here, calves are being sold at
market. One of the consequences was the
emergence of a strong farming class who
were able to take advantage of inefficient
landlords. Photographer T.H. Mason,
late 1920s.

Immense quantities of foodstuffs
were exported from Ireland to Britain
throughout the nineteenth century, a trade
that continued even during the Famine
years. After Ireland achieved a measure
of political independence in 1921, trade
links with Britain remained strong. These
labourers were photographed on the quays
in Kilronan, Aran Islands by T.H. Mason
in the late 1920s.

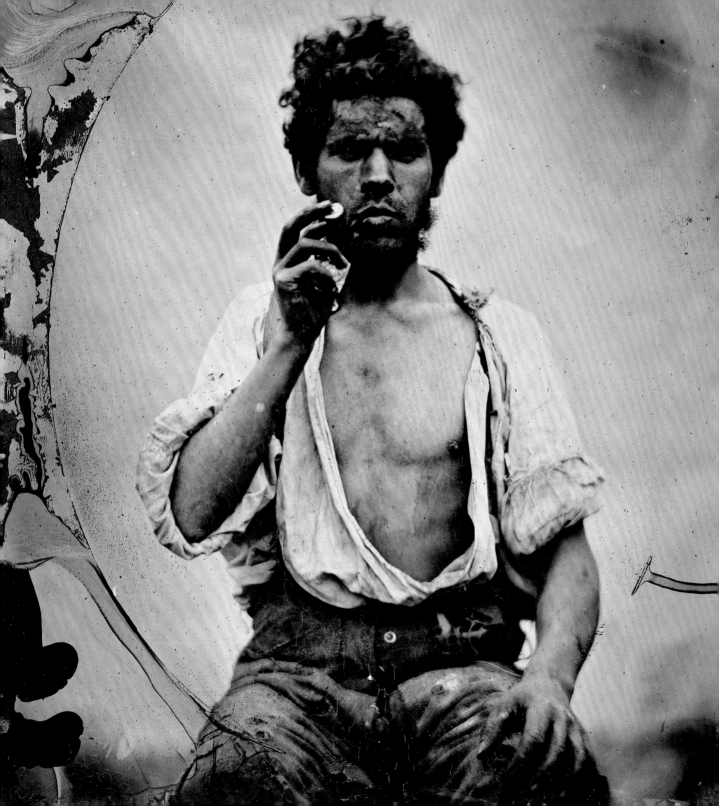

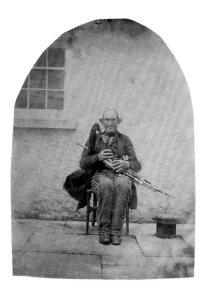

The suffering of the Famine is not
recorded in any photographs, but the
harshness of life for the poor is etched
on the faces of these workers who had
survived the tragedy. Opposite: this
image of a labourer is extremely rare.
In the early years of photography, the
cost of a photograph was equivalent to
up to a year's income of such a worker.
Photographer unknown, *c.* 1858.
Above: early study of a piper from
an album compiled in County Cork.
Photographer unknown, *c.* 1861. Right:
a group of workers. Although they all
have footwear, their overall demeanour
suggests poverty. Photographer
unknown, *c.* 1860.

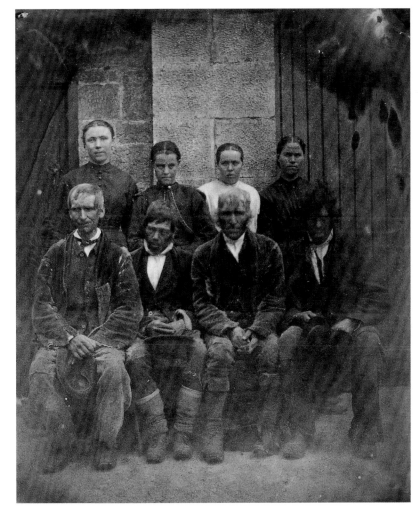

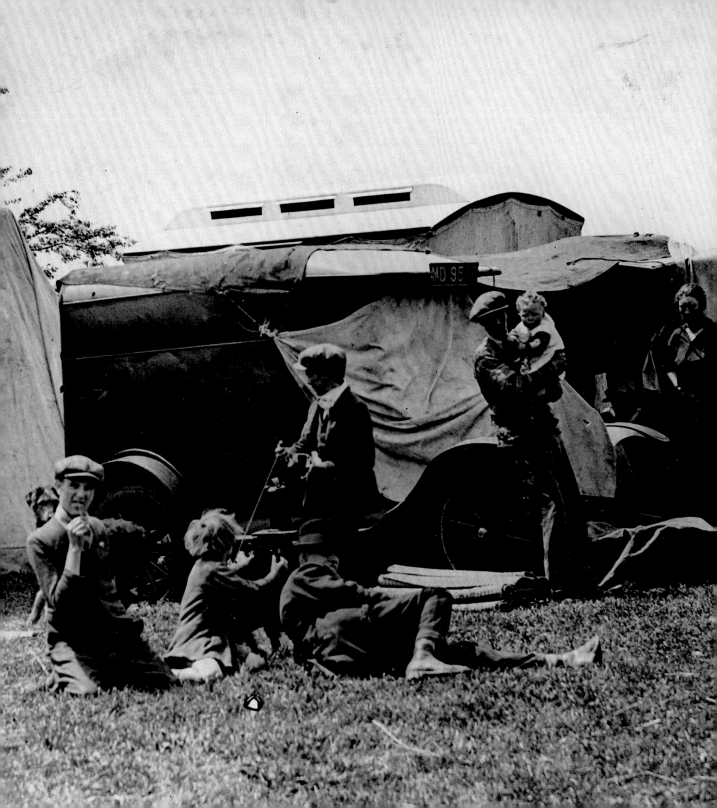

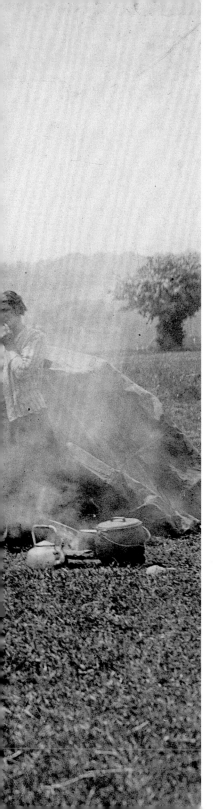

The origins and traditions of gypsies and tinkers were different, although these groups have sometimes been confused. Early photographs of either are rare. Left: Gypsies on the Epsom Downs, a week prior to the Derby horse race. Photographed for Special Press, 31 May 1930. Below: this photograph of an Irish tinker at work was taken in Scotland, reflecting the itinerant nature of this lifestyle. The tinker was a survivor of a tradition of travelling craftsmen whose skills were valuable in a dispersed rural society. Nonetheless, tinkers were generally looked down upon by the settled population. Photographer W. Reid, *c.* 1909.

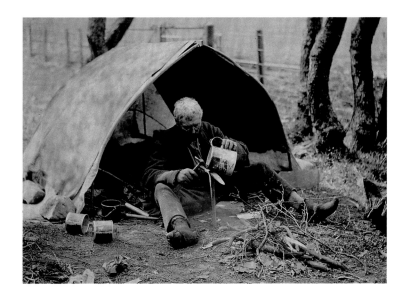

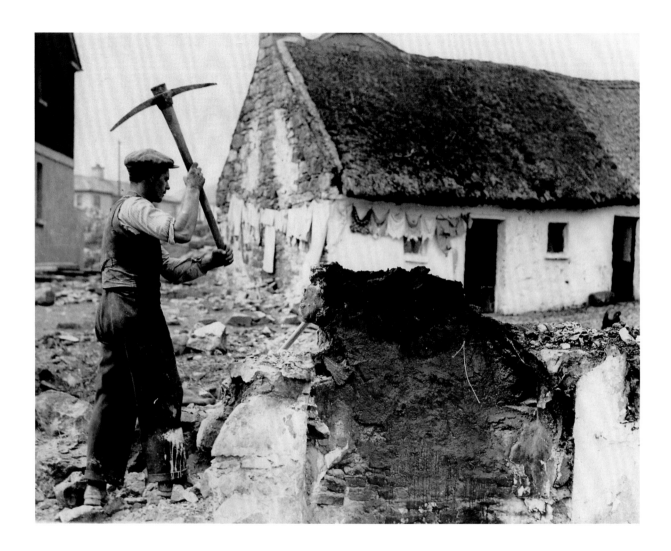

The Claddagh was an independent
fishing community that originally lay
beyond the city walls of Galway. Many of
the cabins, which had thatched roofs and
mud walls, were pulled down in the 1930s
as part of an extensive programme of
rebuilding. World Wide Photos, c. 1930.

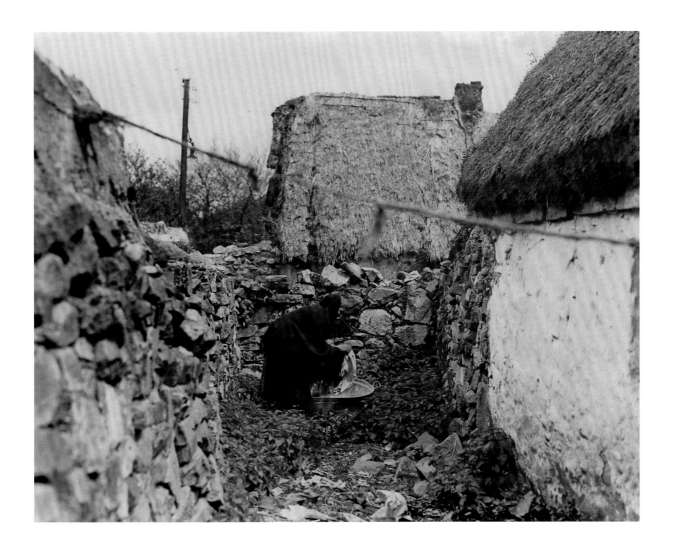

The inhabitants of the Claddagh
were Irish-speaking. The community
was traditionally governed by a 'king'
or 'mayor', the last of whom died in
1954. This woman is washing clothes
in the open air with rainwater. World
Wide Photos, *c.* 1930.

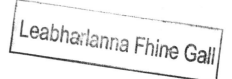

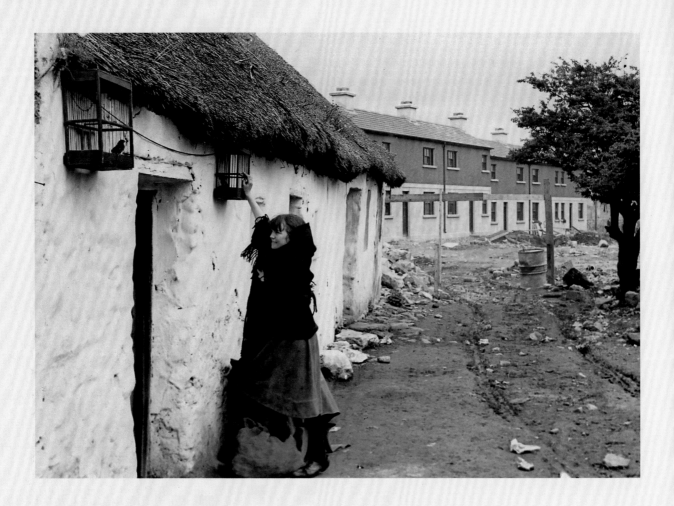

Birds were sometimes kept as pets
in the Claddagh, living here in cages
outside the cottage. The area also
had its own traditions and customs,
including a distinctive betrothal ring
that was often handed down from
mother to daughter. World Wide
Photos, *c.* 1930.

The name Claddagh (*An Cladach*) means 'flat, stony shore'. The children above are barefoot, even though this photograph was taken in the 1920s. The thatched cottages in the background were all knocked down (the last one in 1938) as part of Galway Corporation's redevelopment programme. World Wide Photos, 1920s.

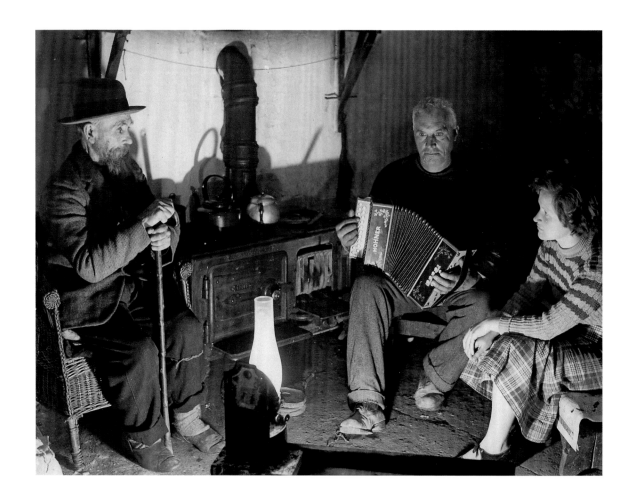

Strong traditions of music and storytelling
survived in the Claddagh into the twentieth
century. The modern clothes worn by the young
girl contrast with the traditional surroundings,
and were probably sent by relatives in America.
World Wide Photos, *c*. 1930.

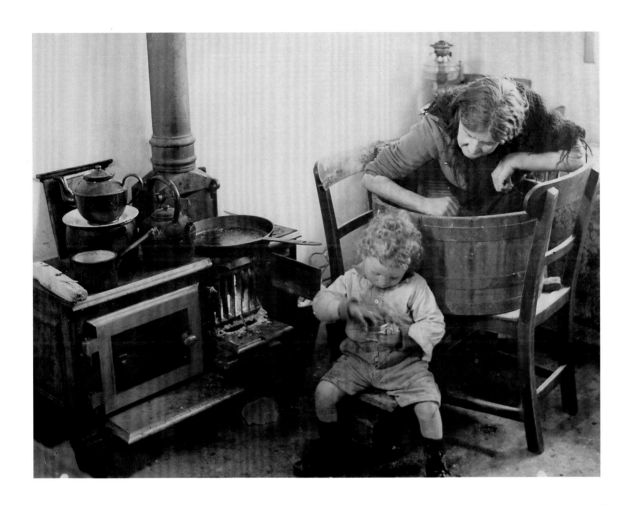

The cooking range was a common feature of Irish kitchens and often was the focal point of the social life of the home, as in this Claddagh cottage. World Wide Photos, *c.* 1930.

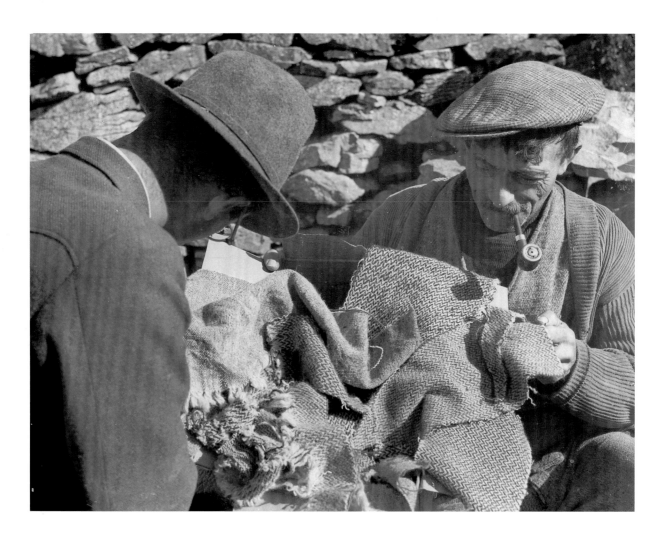

Men examining tweeds. Although buying and selling was a serious business, it could be carried out in informal surroundings. World Wide Photos, *c.* 1930. Opposite: the face of an old woman in the Claddagh. World Wide Photos, *c.* 1930.

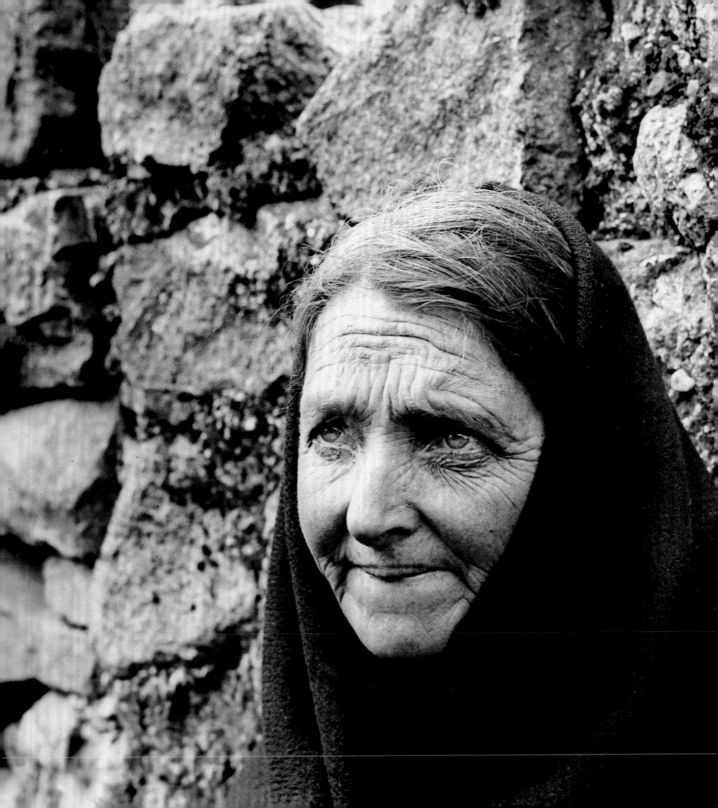

chapter 3

from union to partition

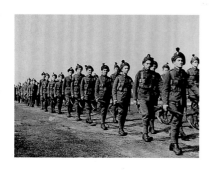

Irishmen accounted for approximately forty per cent of the British army in 1830, falling to ten per cent in 1914. Above: the London Irish Rifles, created in 1908, distinguished themselves at the Battle of Loos in 1915 by being the first troops to reach the German trenches, allegedly kicking a football on the way. Photographer unknown, 1930s. Opposite: hunger striker in 1917 (see p. 153).

The late nineteenth and early twentieth centuries saw great polarities in Ireland; rich and poor, landlord and tenant, Catholic and Protestant, nationalist and unionist, native and settler. Identity was also divided, with Irish, Anglo-Irish, Ulster-Scots and British being used variously to define both national origins and political or religious allegiance. The revival of the Irish language at the end of the nineteenth century coincided with a wider Irish cultural revival, but as this increasingly came to mean Gaelic culture, so language too became a signifier of division. Inevitably, the non-sectarian vision of the radicals who had led the uprisings in 1798 and 1848 evaporated as nationalist and Catholic, and unionist and Protestant became increasingly synonymous.

Moreover, political division found a geographic expression as Protestants in Ulster increasingly depicted themselves as being different from, and superior to, the people in the rest of the country.

One of the paradoxes of Irish history after 1800, however, was that while Ireland was a colony, she was also part of the British Empire and in the latter capacity supplied the Empire with numerous settlers, administrators and soldiers. Irish people from all classes made an important contribution to the growth and defence of the Empire. Ironically, being an Irish nationalist did not necessarily always mean being opposed to British imperialism. For the Ascendancy class, involvement in the Empire – particularly in the

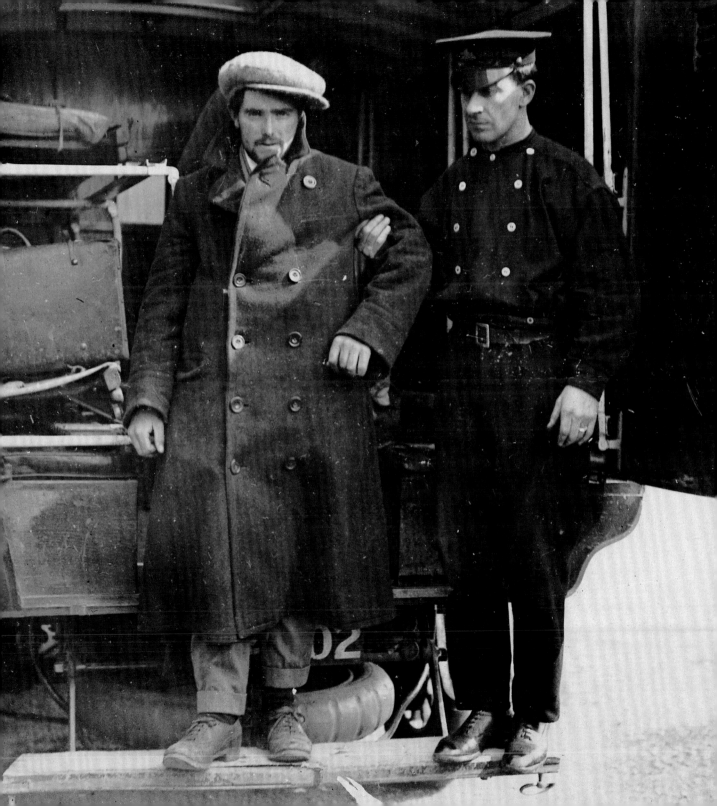

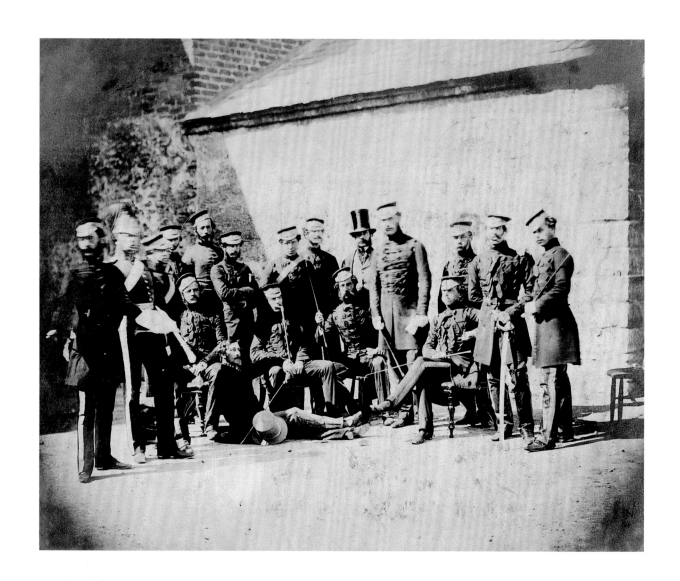

The officer ranks of the British army were frequently photographed, although the image of the 7th Dragoon Guards (opposite) is unusual. Photographer Sir Robert Shaw, 1855. Above: Field Marshall Viscount Gough (1779–1869) was one of the many Irish-born officers in the British army in the nineteenth century. During the Napoleonic Wars, he had commanded the Irish Fusiliers in the Spanish Peninsula. In 1843, he was appointed Commander-in-Chief in India. Photographer Camille Silvy, 5 February 1861.

military and civil service – had clear advantages. But it was not just the upper and middle class Protestants who participated in the Empire. The rising Catholic middle classes increasingly partook of its fruits: in the 1850s less than ten per cent of the Indian civil service who were Irish were Catholic; by 1914 this had risen to thirty per cent. For the poorer classes the Empire also provided opportunities for emigration, for men and women equally.

The role of the Ascendancy classes in the officer ranks of the army was particularly significant and, in the second half of the nineteenth century, eighteen per cent of all British officers were Irish-born. Irish enlistment in the officer ranks remained high as late as the Second World War. The Irish officers in the British army were almost exclusively drawn from the Anglo-Irish Ascendancy – or later from the unionist classes – and they rarely communicated their Irish identities, especially when Irishness became linked with opposition to British rule. Their presence is recalled in some First World War doggerel, which charted Irish involvement in imperial warfare at the highest levels:

> Sir John French from Galway,
> Good old Roberts too,
> Kitchener from Kerry,
> All Irish through and through.
> There was a man named Wellington
> Who fought at Waterloo;
> So never let yourself forget
> That you are Irish too.

For the poorer classes in Ireland, the British army provided a major source of employment for men. For the British authorities, in turn, Ireland offered a valuable reservoir of manpower. As a consequence, the role of Irishmen employed in imperial defence was disproportionate to the size of the population. This was emphasized by the fact that, for security reasons, Irish battalions were not deployed in Ireland and therefore were over-represented in other parts of the Empire. In the first half of the nineteenth century, the British army contained more Irishmen than Englishmen. This is all the more remarkable given that the Penal Laws had prevented Irish Catholics from joining the British army, and that this restriction had only been removed at the end of the eighteenth century. In the 1830s, over forty per cent of non-commissioned soldiers were Irish-born, although Ireland accounted for just over thirty per cent of the population of the United Kingdom. Irish recruitment declined after the Famine, mirroring the concurrent decline in the population, but it remained high. In 1878, Irishmen still accounted for twenty per cent of all recruits to the British army. Despite Dublin's associations with militant nationalism, recruitment was consistently higher there than in Belfast prior to the First World War, suggesting that economic rather than political motives were the main reasons for enlistment. However, the response to the First World War indicated that politics had now come to affect recruitment to the army. Not only did enlistment fall, but in March 1916

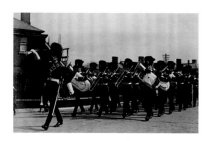

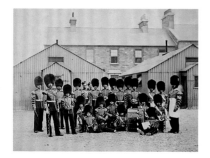

The shamrock presented to Irish regiments on St Patrick's Day was a tradition begun by Queen Victoria in the 1890s. Above top: marching band of 2nd Inniskilling Fusiliers, *c.* 1905. Above: 3rd Battalion Grenadier Guards, photographed at Beggar's Bush Barracks, Dublin, in October 1868. Note the youth of some of the soldiers in the front of this image. Opposite: Royal Irish Fusiliers on St Patrick's Day *c.* 1910. It was the general practice not to identify army photographers.

the government decided not to extend conscription to Ireland. The war also split opinion in Ireland, not only along the traditional unionist and nationalist divide, but also within the nationalist movement.

Paradoxically, while involvement in the British army was a prominent feature of Irish life, the maintenance of the Act of Union could only be guaranteed by the presence in Ireland of a large military force, an armed police force (after 1814) and the intermittent introduction of repressive legislation, known as the Coercion Acts. The British government regarded the population of Ireland as the most unruly and lawless within the United Kingdom. As Earl Grey admitted to the British House of Lords in 1846, 'we had military occupation of Ireland, but…in no other sense could it be said to be governed; …it was occupied by troops, not governed like England'. The dependence on force to maintain rule in Ireland did not change. In the late nineteenth century agrarian conflict was augmented by an increase in urban, sectarian conflict, which became a major source of disorder and led to Belfast becoming the most policed part of the United Kingdom. Given the central role of the military and the police, it is no surprise to find that they feature strongly in any collection of historic photographs. However, many of the surviving images show the officers at recreation – playing cards, cricket or hunting. They provide a strong contrast to photographs of their role in evictions, such as those in Chapter 2.

The campaign to achieve Home Rule in the final two decades of the nineteenth century further polarized political opinion in Ireland into nationalist and unionist camps. The attempt by the British Prime Minister, William Gladstone, to introduce a Home Rule bill into the British parliament in 1886 led to the foundation of the Irish Unionist Party. The party brought together Protestants of diverse social classes and political shades, united in their opposition to Home Rule, or 'Rome Rule', as they feared Catholic-majority rule would become. Largely due to the continuing support of William Gladstone, a second Home Rule bill was introduced in 1893, but was also defeated. A third Home Rule bill was passed in the House of Commons in 1912, and was due to be implemented in 1914. By 1912, however, it was obvious that violent confrontation would be the probable outcome of attempting to establish an independent parliament in Dublin. In the intervening period unionists, with the support of leading members of the Conservative Party, had organized agitation. In 1912 over 218,000 Protestants signed a Covenant that made it clear that they were willing to use physical force if necessary to stop Home Rule. The Ulster Volunteers were established in January 1913 and were armed by gun-running from Germany. If Home Rule was introduced into Ireland a civil war appeared inevitable. The onset of the First World War, therefore, provided a drastic but (to British politicians) welcome solution to this political impasse.

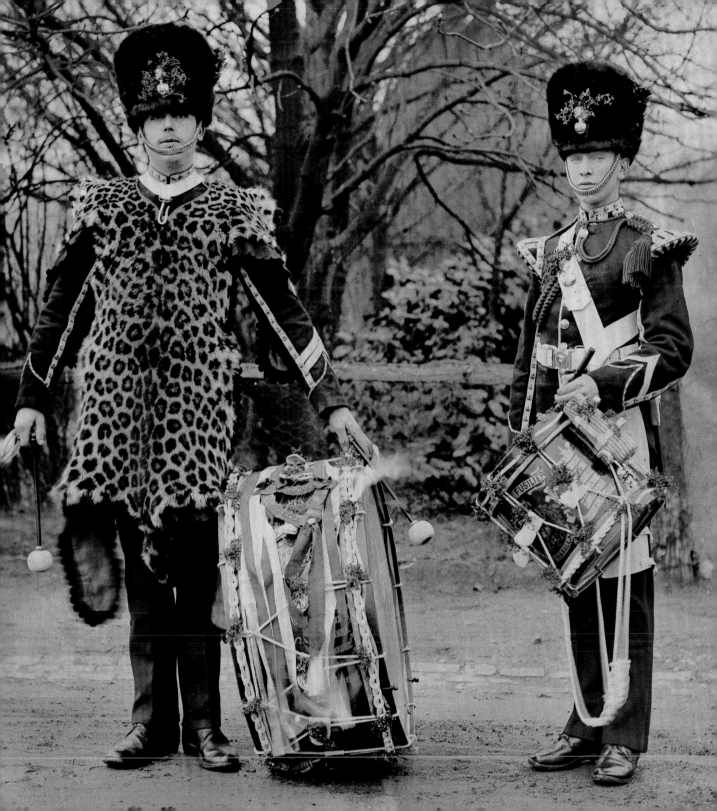

The 1912 Home Rule Bill never did reach the statute books. It was shelved by the British government for the duration of the war; but after the events of Easter 1916 they believed that the granting of Home Rule, as envisaged in 1912, was no longer possible. The Easter Rising in 1916, led by the Irish Republican Brotherhood and the Irish Volunteers, was regarded in Britain as an act of betrayal and treachery. In the same year, Protestant troops from Ulster suffered particularly high losses at the Battle of the Somme. Over 5,500 men from the specially constituted 36th (Ulster) Division, which had been created at the request of Lord Kitchener, were killed or injured in the first two days of battle. These losses became embedded in unionist memory and commemorative tradition. More significantly, the Protestant losses at the Somme were contrasted with the disloyal actions of nationalists in Dublin during the Easter Rising in 1916, helping to turn the British government against the nationalist cause. Following the ending of the First World War, a political 'solution' was imposed from outside by the Prime Minister, Lloyd George. He had promised the British Conservative Party that he would not introduce any policy that would result in 'the forcible submission of the six counties of Ulster to a Home Rule Parliament against their will'.

The solution to the political impasse was provided in the form of the Government of Ireland Act of 1920 which created a new six-county area to be known as Northern Ireland.

However, the legislation showed little sensitivity to the demands of the nationalists, and it also ignored the fact that in the General Election in December 1918, Sinn Féin had won 73 out of the total 105 Irish seats in parliament. Sinn Féin thus had a decisive majority in Ireland, which they believed gave them a mandate for self-government. One of the successful Sinn Féin candidates, Countess Markievicz, was the first woman ever to be elected to the British House of Commons though, in keeping with party policy, she never took her seat. The British government ignored the outcome of the election. The 1920 Government of Ireland Act partitioned Ireland and created two new states – the Irish Free State and Northern Ireland. As it turned out, Partition was not only the first stage in the dismemberment of the United Kingdom, but it also marked an early, significant step in the break-up of the British Empire. However, it was a solution that had neither precedent nor popular support in Ireland.

Partition provided a pragmatic if harsh solution to the conflicting aspirations of various, apparently irreconcilable, groups. The actual legislation was a crude amalgam of the earlier Home Rule bills and even took some unionists by surprise. It also disappointed Protestants residing outside the six counties of Northern Ireland. In 1921, 121 years after the Act of Union had been passed with the intention of creating a unitary political system, three parliaments existed within the former United Kingdom.

Irish regiments were generally stationed outside Ireland, serving in other parts of the British Empire and fighting in the numerous conflicts of the nineteenth century. Below: an Irish regiment in Canada. Photographer unknown, *c.* 1870. Bottom: sergeants of the Royal Inniskilling Fusiliers, one of the oldest Irish regiments in the British army. Like a number of early regiments, they are associated with the town of Enniskillen in County Fermanagh. Their origins lie in the wars between James II and William of Orange between 1688 and 1690, when they contributed to the defeat of the Jacobite army. Photographer unknown, *c.* 1900.

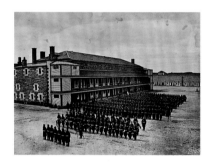

The Partition of Ireland did not mark an end to civil unrest or violence. Divisions within the nationalist movement over the terms of the Anglo-Irish Treaty resulted in a period of civil war in the new Free State, which pitted Catholic against Catholic and comrade against comrade. The conflict also spilled over into the six northern counties and resulted in sectarian violence more vicious than anything witnessed in the nineteenth century. The Partition of Ireland had created two new states in Ireland, but the old problems of sectarian and religious conflicts remained unresolved, while new divisions and uncertainties had emerged.

Both new parliaments in Ireland remained tied to the United Kingdom and the British Empire. In the case of the new Free State, this affiliation had been imposed by the Anglo-Irish Treaty. By the 1930s, the government of the Free State felt assured enough to start to dismantle some of the more offensive clauses of the Treaty. This culminated in the new Irish Constitution of 1937 which declared Ireland to be a 'sovereign, independent, democratic state'. From this point the Free State, or Éire as it was referred to in the Constitution, also ceased on paper to be a member of the Commonwealth. While the new Constitution may have satisfied nationalists, its pronouncements on social issues, especially on the role of the Catholic Church and the position of women, made it a deeply conservative document. But each measure that affirmed the independence of Ireland served to confirm unionist determination to remain a Protestant state within the United Kingdom.

The Constitution, therefore, not only codified the distance between the Free State and the United Kingdom, it also served to deepen divisions between the governments of the south and the north of Ireland. In 1949, the year that Éire declared itself to be a Republic and officially left the Commonwealth, legislation was passed in Britain that confirmed that Northern Ireland would remain as part of the United Kingdom. When Lloyd George consented to the partition of Ireland he viewed it as a temporary solution to a difficult problem, but within decades the division of Ireland had become deeply embedded in Irish political life.

In theory the new Northern Ireland government had little independent power. The 1920 Act stated that 'the supreme authority of the Parliament of the United Kingdom shall remain unaffected and undiminished over all persons, matters and things'. In practice, Westminster remained aloof and did not exert its authority until forced to do so in 1972 when direct rule from Westminster was reimposed. Northern Ireland was the first attempt at devolution in the United Kingdom, but it only survived for fifty years, and during that period was blighted by internal political and sectarian divisions. Moreover, the partition of the country, rather than solving Ireland's political problems, created new ones which appear to be just as intractable.

The social differences between officers and other recruits were evident even during leisure activities. Above: the cricket eleven of the Royal Irish Rifles. Photographer unknown, 1907. Opposite: D. Company football team of the Royal Irish Rifles. Photographer unknown, *c.* 1895. The Royal Irish Rifles distinguished themselves in the Boer War of 1899–1902, suffering heavy losses.

Sectarian conflict caused Belfast to become the most policed town in the United Kingdom in the second half of the nineteenth century. A high military presence was also maintained, especially at times of political tension. Opposite: British army officers in Belfast. Photographer unknown, 1902. Right: two images of the Royal Irish Rangers with field artillery, Ballinkinler, County Down. Ballinkinler was used as a training camp at the outbreak of the First World War and subsequently became a detention centre for political prisoners. Photographer unknown, 1903.

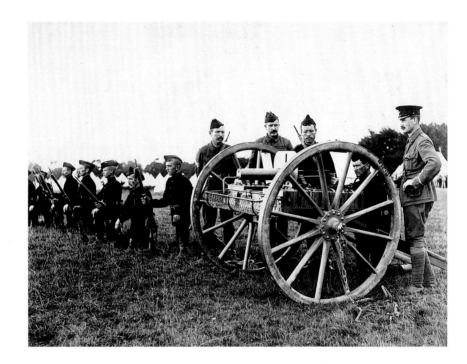

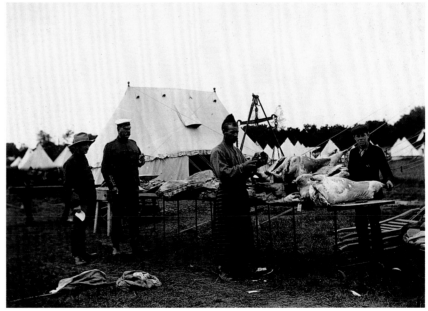

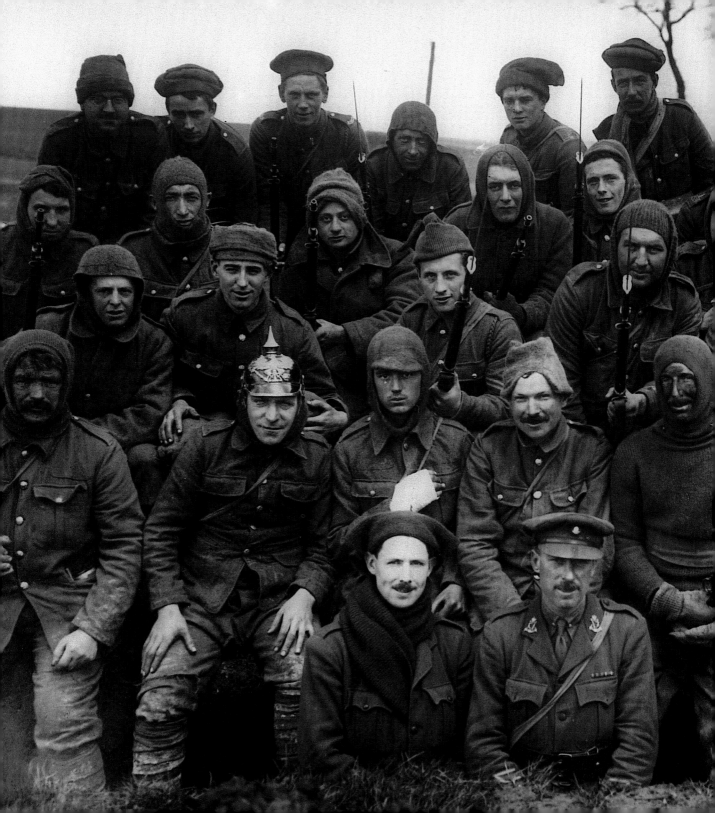

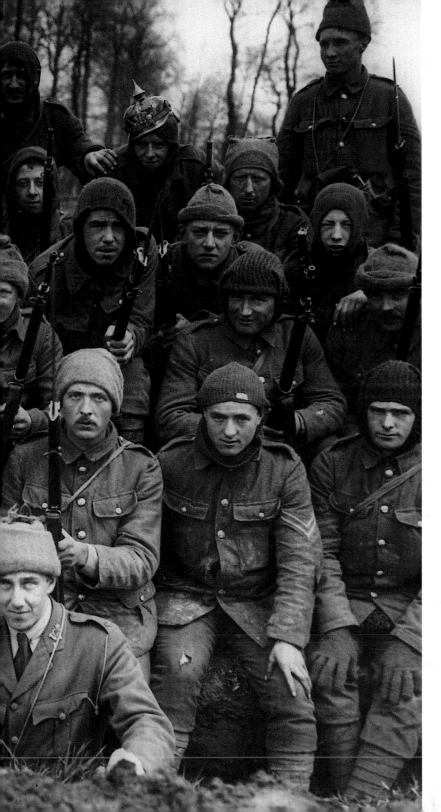

The First World War split nationalist opinion in Ireland. Catholics who participated were subsequently regarded as traitors, even though at the start of hostilities John Redmond (leader of the Irish Parliamentary Party) as well as Edward Carson (leader of the Unionist Party) both pledged to support Britain in the war effort. A small minority of nationalists rejected the call. This raiding party of the 8th Irish King's Liverpool Regiment at Wailly, photographed on the morning of 18 April 1916, bear the mementos of their night raid. The helmets are clearly German. Photographer unknown.

from union to partition 133

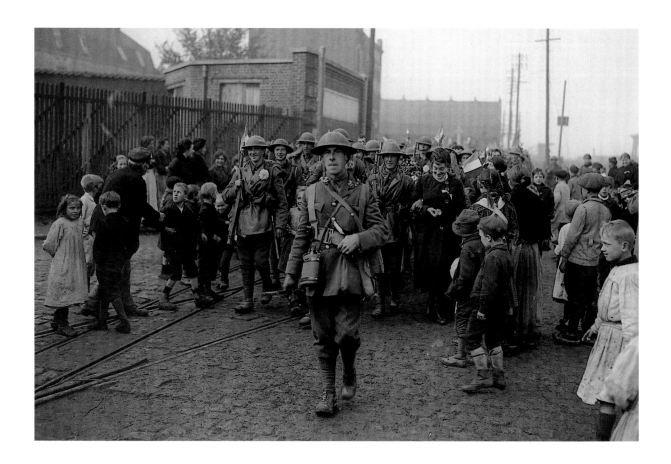

Despite opposition to the war by some
nationalists and socialists, including James
Connolly, an estimated 250,000 Irishmen
fought for the British Crown, many joining
up outside Ireland. The British government
responded to the fall in recruitment throughout
the United Kingdom by introducing
conscription in March 1916, although it was
not extended to Ireland. These photographs
show the 8th Liverpool Irish (57th and 59th
divisions) entering liberated Lille, France, on
18 October 1918, to the evident delight of local
children. Photographer unknown.

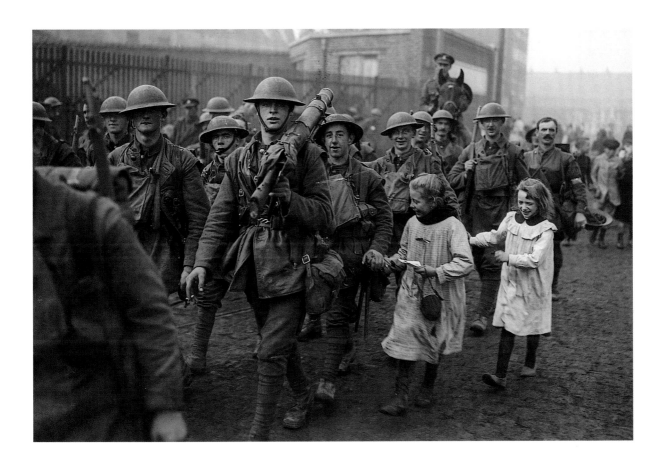

British royalty showed little interest in Ireland after 1800, despite the creation of the United Kingdom. During Queen Victoria's long reign (1837–1901) she visited Ireland only three times. Below: Queen Victoria outside Kate Kearney's Cottage in Killarney, County Kerry in 1861. She visited Killarney to convalesce in the aftermath of her mother's death. Although she admired the beauty of the lakes, she found the climate oppressive. Photographer unknown. Below right: Prince Edward of Saxe-Weimar (1823–1902) visiting Dublin. Photographer unknown, 1868.

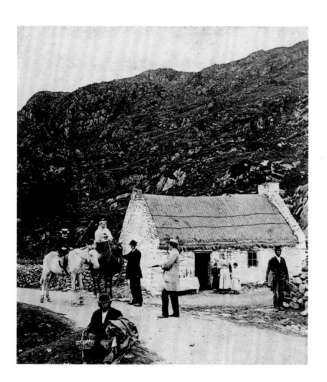

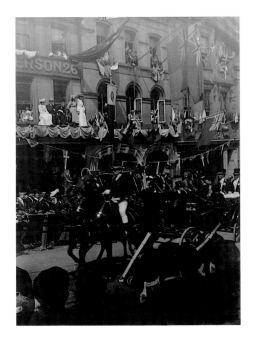
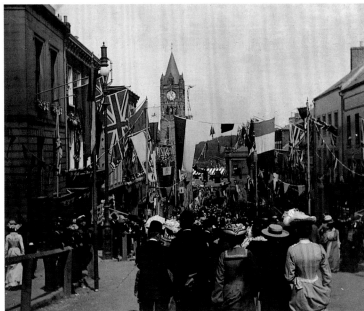

Edward VII (1841–1910) was the
second child of Queen Victoria.
He was sixty when he acceded
to the throne in 1901. He visited
Ireland in 1903, and was warmly
welcomed by Unionists in Belfast
and Londonderry, who used his
tour to reaffirm their loyalty to the
monarchy and to the union with
Britain. Photographer unknown,
1903.

Court life was revitalized when the monarch visited Ireland. These debutantes were presented to King Edward VII during his visit to Ireland in 1903. Photographer unknown.

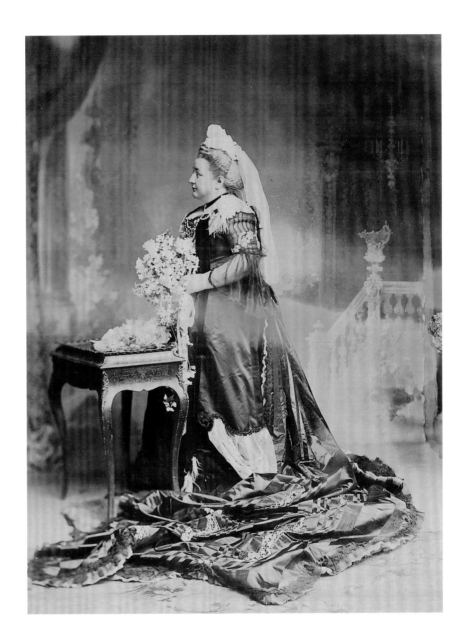

James Joyce (1882–1941) was one of the greatest writers of the twentieth century. He was born in Dublin, where he received a traditional Catholic education. After 1901, he lived and worked abroad, visiting Ireland for the last time in 1912 to arrange the publication of *Dubliners*, a collection of short stories. In 1922, *Ulysses* was published in Paris. Although it came to be regarded as a masterpiece, it was banned in both the United States and Britain until 1936. Photographer Berenice Abbott, 1928.

The Nobel Prize for Literature was won
by William Butler Yeats (1865–1939)
in 1923 and George Bernard Shaw
(1856–1950) in 1925. Both men were
born in Dublin. Above: Senator W.B.
Yeats. Photographer Lafayette, *c.* 1922.
Right: G.B. Shaw. Photographer Marcel
Sternberger, *c.* 1925.

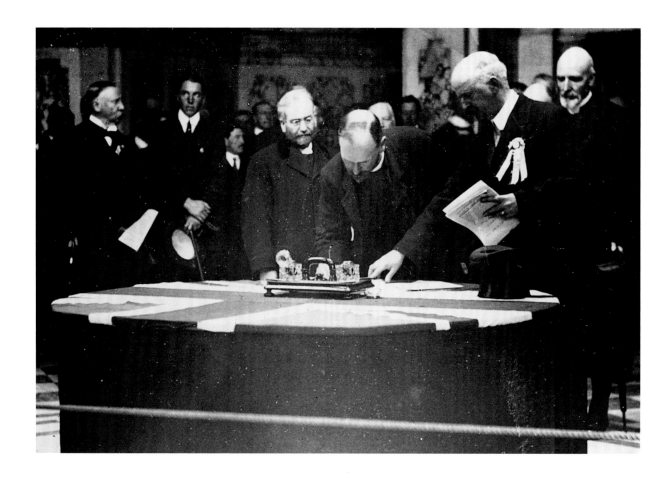

The Home Rule bill of 1912 provoked intense Unionist opposition, with over 218,000 signing a 'Solemn League and Covenant' against it. Above: clergymen signing the Covenant. Photographer Alexander Hogg, 28 September 1912. Opposite left: the first page of the Covenant, including the signature of Unionist leader Edward Carson. Photographer Alexander Hogg. Opposite above: retired Field Marshall Lord Roberts, who was Irish-born, was one of a number of senior military figures who voiced sympathy for the Unionists. Photographer unknown, *c.* 1908. Opposite below: Edward Carson meeting nurses at Ballyclare, County Antrim. Photographer unknown, *c.* 1912.

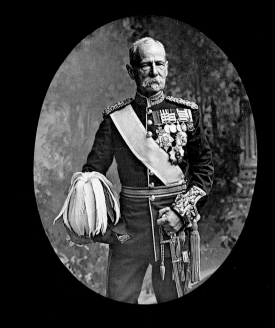

The Easter Rising was a failed attempt to establish a republic in Ireland. It began on Easter Monday 1916, taking everybody by surprise, including the Crown forces. Within twenty-four hours, British reinforcements had arrived in Dublin from the Curragh, Belfast and England. The republicans were greatly outnumbered and inadequately armed, after weapons from Germany failed to arrive. The strategy of the British troops was to create a cordon around the insurgents and close in on them. Right and opposite: British army barricades in Easter 1916. Right below: additional artillery arriving for the British forces during the Easter Rising. Photographers unknown, 1916.

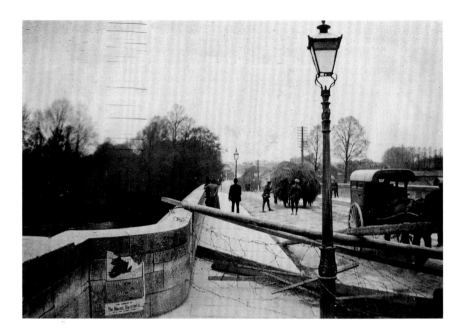

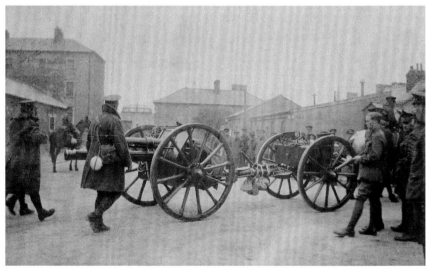

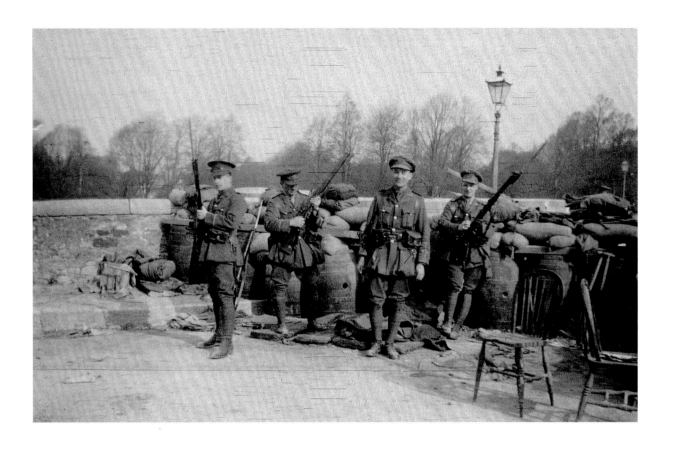

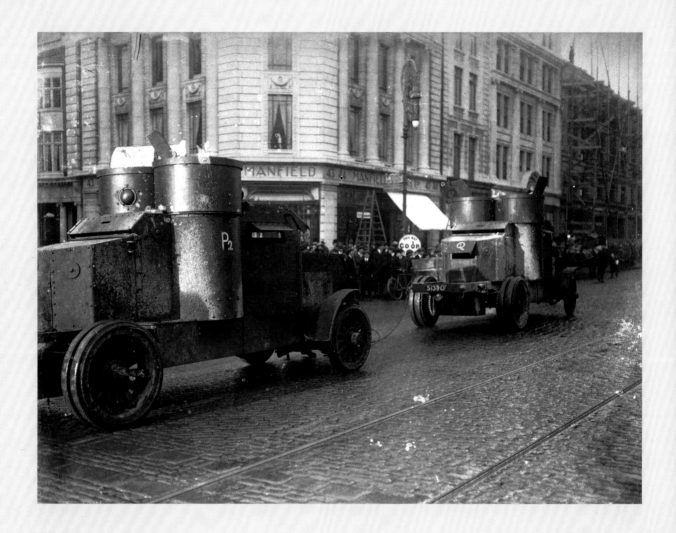

Political unrest meant that both police and military presence in Ireland was high at the beginning of the twentieth century. These British military vehicles, one towing the other, were photographed in Dublin during the Easter Rising. Photographer unknown, 1916.

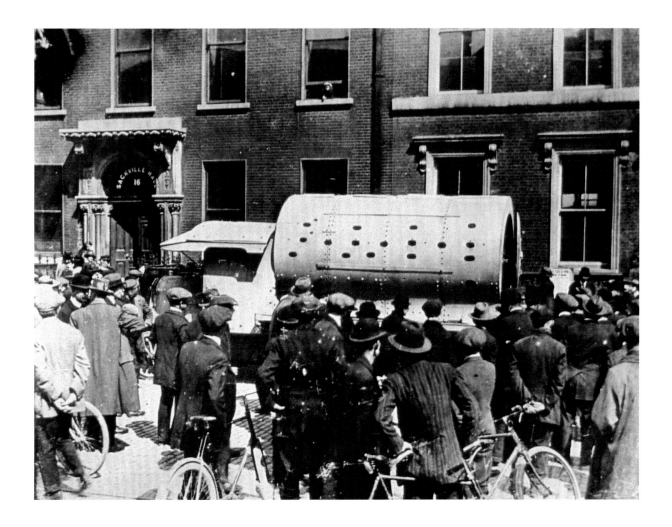

In response to the Easter Rising the British
army patrolled the streets of Dublin in a variety
of military vehicles. This armoured car was
converted from a lorry. To confuse snipers,
some of the peepholes are genuine, some
bogus. Photographer Joseph Cashman, 1916.

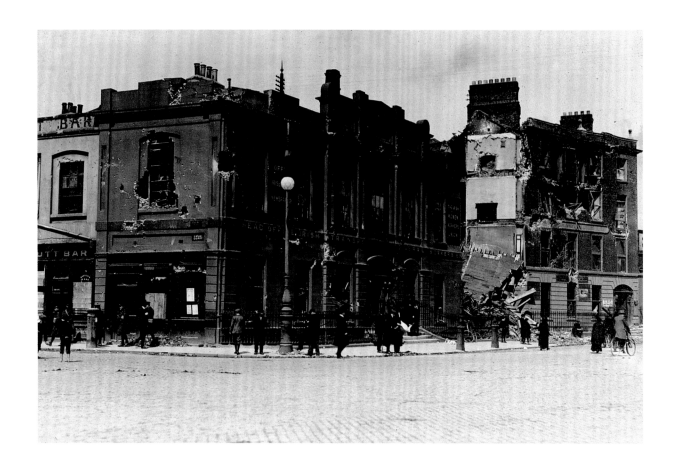

The Easter Rising lasted less than a week, but in that time much of the centre of Dublin was destroyed or damaged. Two days after the fighting started, the British gunboat *Helga* arrived on the Liffey and bombarded Liberty Hall (headquarters of the Irish Transport and General Workers' Union), leaving the building in ruins. Photographer Mr Chancellor, 1916.

In addition to damage to property, 132 members of the British crown forces, 64 insurgents and 230 civilians were killed during the Rising. Its fifteen republican leaders were executed in Ireland while Sir Roger Casement, who had attempted to bring arms into the country, was tried for treason and hanged in London. Two survivors of the Rising, Eamon de Valera and Michael Collins, became key figures in a reinvigorated nationalist movement after 1916. Right: the damaged YMCA (Young Men's Christian Association) building after the Easter Rising. Photographer unknown, 1916.

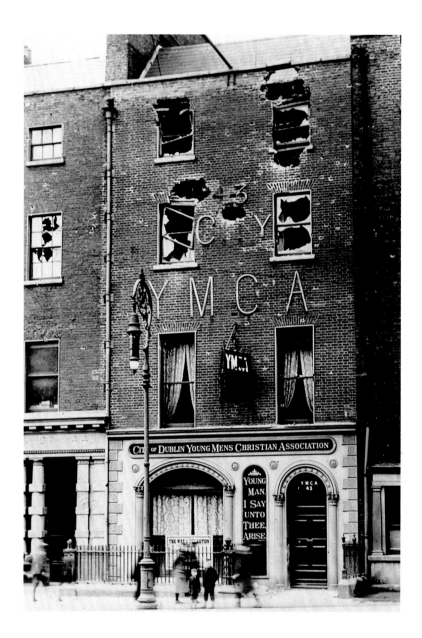

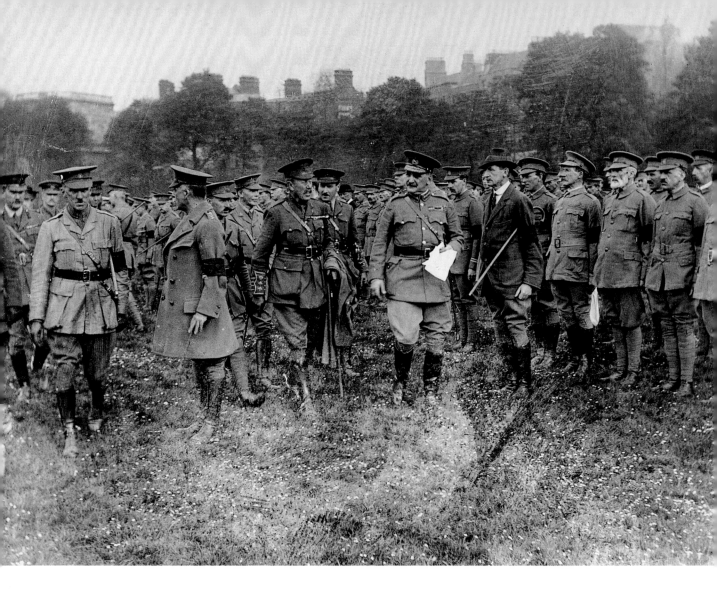

150 from union to partition

The Easter Rising began with the seizure of several important buildings in Dublin and the reading of a Proclamation of Independence on behalf of the provisional government of the Irish Republic. Con Colbert, right, was bodyguard to Thomas Clarke, the first signatory of the Proclamation. Colbert was born in County Limerick in 1896. He became a drill instructor at Patrick Pearse's school in Dublin and joined the Irish Volunteers. Colbert was executed in Kilmainham Jail on 8 May 1916 for his role in the Rising. Photographer unknown, *c.* 1915. Opposite: General Maxwell inspecting troops. Maxwell, just back from defending the Suez Canal against the Turks, went to Ireland to lead the British forces against the Rising. Photographer unknown. *c.* 1916.

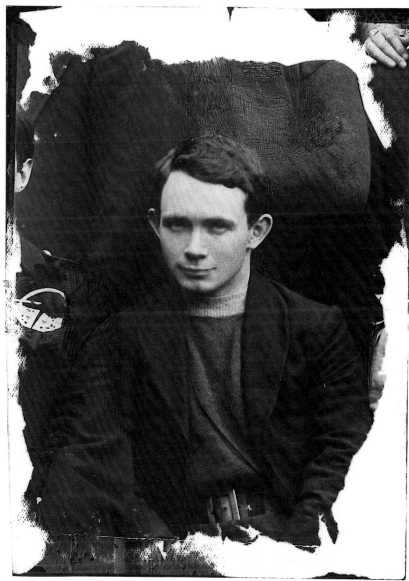

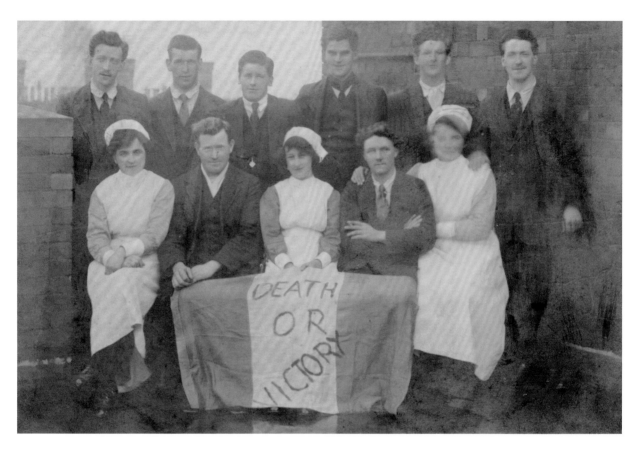

The Partition resulted in an upsurge in violence in Northern Ireland. The Unionist government responded by interning over seven hundred republicans. Above: a number of internees went on hunger strike, including these prisoners on the prison ship *Argenta*, 1923. Right: One of the original *Argenta* hunger strikers, Séamus (James) Connolly, interned again in Londonderry Prison in 1940. Photographers unknown.

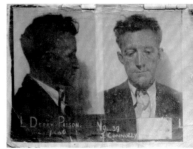

The origin of hunger strikes as a protest strategy is unknown. In September 1917, a group of republican prisoners in Mountjoy Jail went on hunger strike. The leader, Thomas Ashe (1885–1917), died a few days later while being forcibly fed. In 1920 a second hunger strike took place, which resulted in the death of Terence MacSwiney, the Lord Mayor of Cork, and two other prisoners. Right: these two prisoners joined the wave of protest hunger strikes in 1917. Photographer unknown.

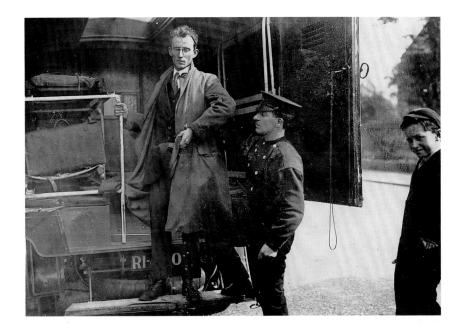

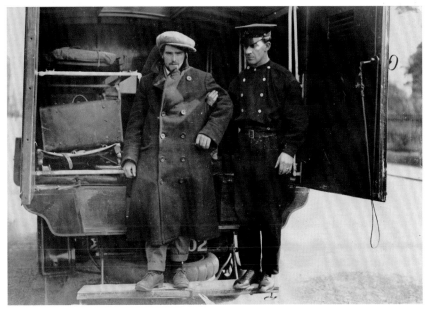

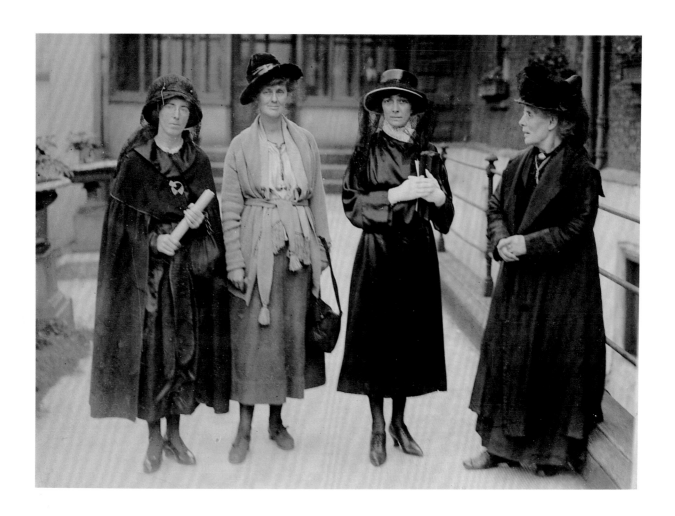

Women's contribution to the nationalist movement was considerable. These women were elected in 1921 to the first Free State parliament. They are (left to right) Mrs Clarke, Countess Markievicz, Kate O'Callaghan and Margaret Pearse. Photographer unknown, *c.* 1924.

Countess Markievicz (1868–1927)
was one of the most romantic political
figures of the twentieth century. She
gained her name and title from her
brief marriage to a Polish count.
Through her involvement with
Inghinidhe na hÉireann ('daughters
of Ireland') she campaigned for both
women's suffrage and the national
struggle. In the 1916 Rising, she
served as a Commandant, her gender
saving her from the death sentence.
Although in 1918 Markievicz was the
first woman ever elected to the British
House of Commons, as a Sinn Féin
representative she refused to take her
seat. Instead, she sat in the first Irish
Dáil in 1919. Markievicz opposed the
Anglo-Irish Treaty. She died in poverty
in 1927. Photographer unknown,
c. 1910.

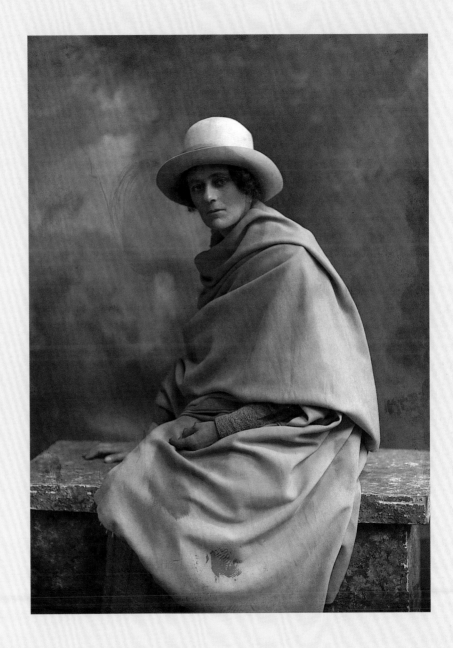

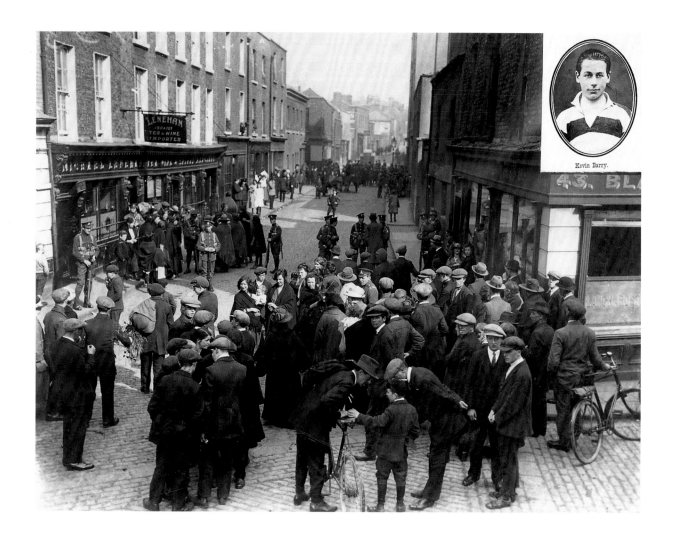

Kevin Barry.

A British soldier was killed during an ambush
by republicans in Church Street, Dublin, in
September 1920. Kevin Barry (1902–20), a
medical student, was sentenced to death for his
part in the incident. This was the street scene
following the ambush, inset with a portrait of
Barry. Photographer Joseph Cashman, 1920.

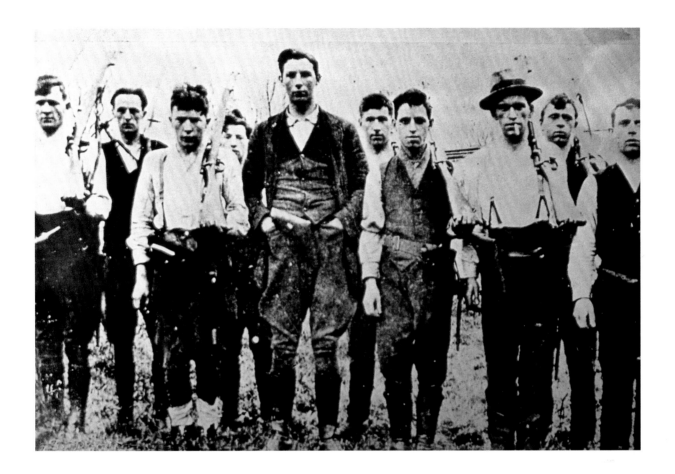

Guerrilla techniques were widely used in
County Cork by the IRA, particularly ambushes,
bombings and assassination. The Fourth
Battalion of the IRA posed for this photograph
while training for an attack on a British troop
train at Cobh Junction, fixed for 22 February
1921. Photographer unknown, 1921.

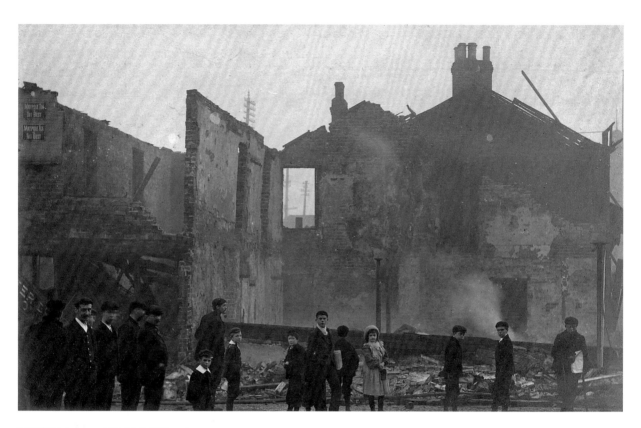

The Anglo-Irish War, from January 1919 to the Truce of July 1921, was marked by increasing savagery on both sides. The newly created Black and Tans, British recruits taken on to reinforce the Royal Irish Constabulary, particularly acquired a reputation for ruthlessness. Left: Black and Tans. Photographer unknown, 1920. Above and opposite: the sacking and burning of Cork by the Black and Tans in December 1920 caused public outrage, not just in Ireland but internationally. Photographer unknown, 1920.

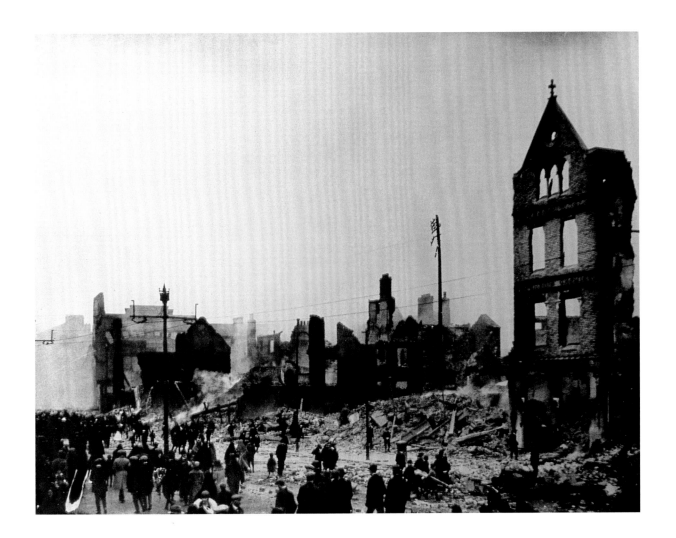

The failure of Eamon de Valera, the president of the Dáil, and David Lloyd George, the British Prime Minister, to agree on a political settlement for Ireland resulted in a conference being held in London. De Valera did not attend. The Irish delegation was led by (from the left) Arthur Griffith (1871–1922), Robert Barton (1881–1975) and Michael Collins (1890–1922). The Treaty they signed sowed the seeds for the Irish Civil War. Photographer P.L. Kjeldsen, 1921. Opposite: British troops leaving Ireland. Photographer unknown, 1922.

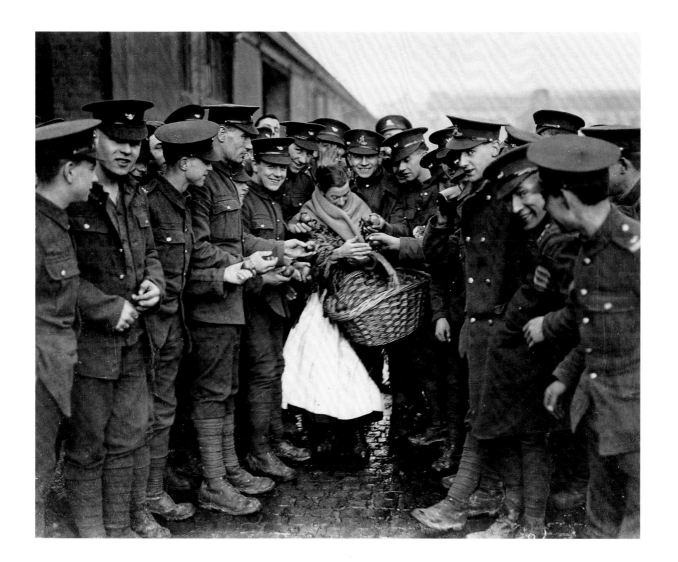

The signing of the Anglo-Irish Treaty on 6 December 1921 marked an end to the Anglo-Irish War. It also established the Irish Free State as a self-governing dominion within the British Commonwealth. Although British troops were withdrawn from Ireland, control over a number of 'treaty ports' was retained by Britain. De Valera and a number of other Sinn Féin leaders rejected the Treaty. The division was the basis for the Irish Civil War that followed. These British troops on the Dublin docks are about to leave Ireland. Photographer unknown, 1922.

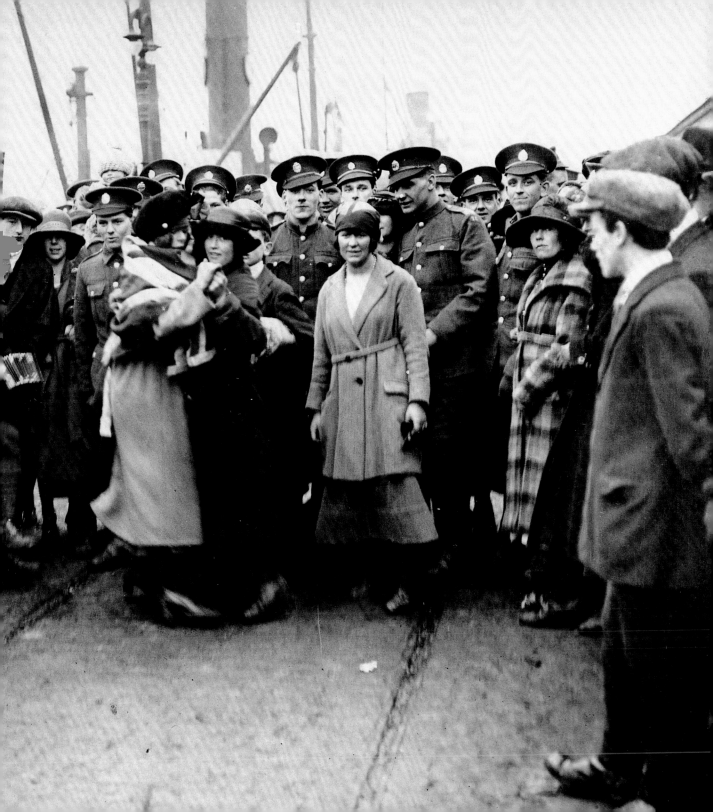

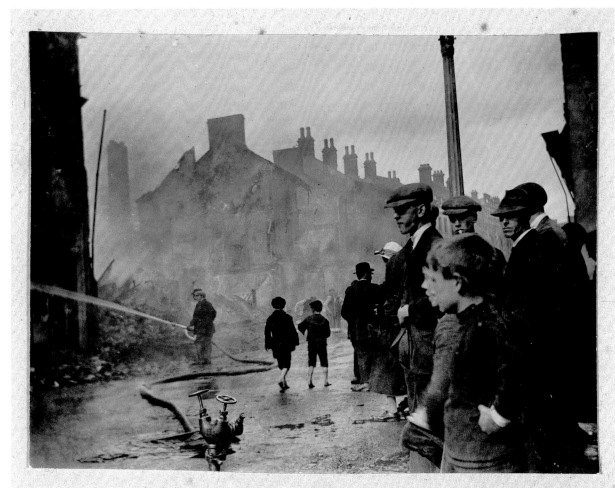

Bow St Lisburn

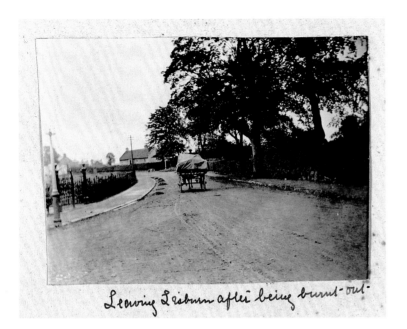

Leaving Lisburn after being burnt-out

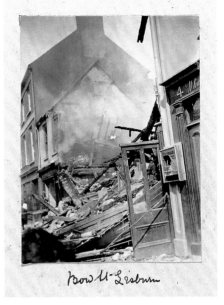

Bow St. Lisburn

The Partition did not end sectarian violence in Northern Ireland. Vicious fighting broke out in Lisburn following the shooting of District Inspector Swanzy in August 1920, and Catholic homes and business premises were attacked and burned. Nearly all of the Catholic population of Lisburn fled as a result of the attacks. Photographer unknown, 1920.

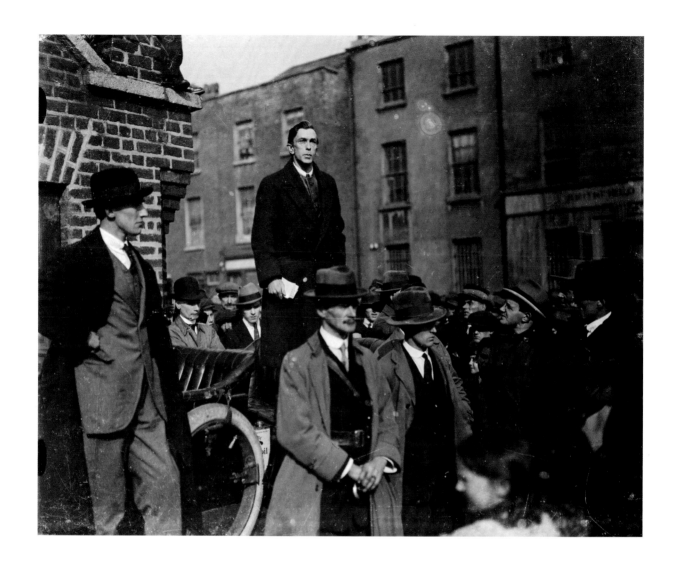

The republican activist Rory O'Connor
(1883–1922) was wounded during the Easter
Rising. He opposed the Treaty and was executed
on 8 December 1922 on the order of Kevin
O'Higgins, at whose wedding O'Connor had
been best man. He is seen here giving a speech
the year that he died. Photographer unknown.

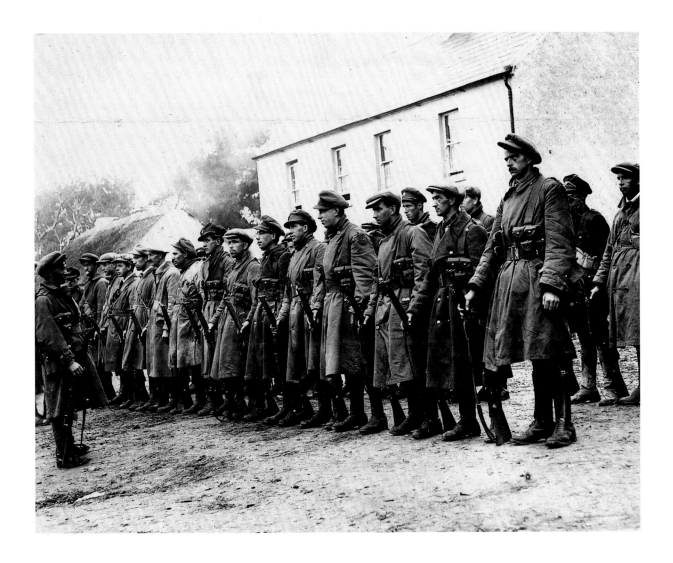

The Anglo-Irish Treaty split the nationalist movement and precipitated a civil war. Those who opposed the Treaty, including the majority of the IRA, became known as the Irregulars. Here, Free State troops are preparing to attack Irregulars near Bunduff and Cliffoney, County Sligo. Photographer unknown, 26 September 1922.

Fighting between the pro- and anti-Treaty forces broke out in June 1922 when the former, led by Michael Collins, attacked the headquarters of the Irregulars in the Four Courts in Dublin. Within two weeks, the pro-treaty groups had control of Dublin and the conflict moved to the countryside where the Irregulars resorted to the same guerrilla methods they had used during the Anglo-Irish War, including wrecking the railway system. These images show a derailed train being recovered during the Civil War. Photographer unknown, 1922.

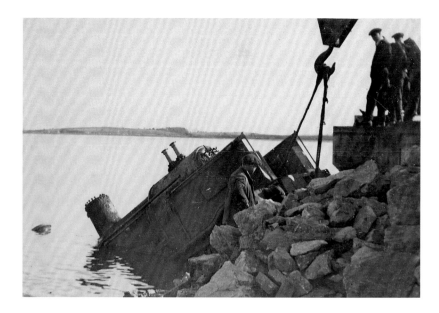

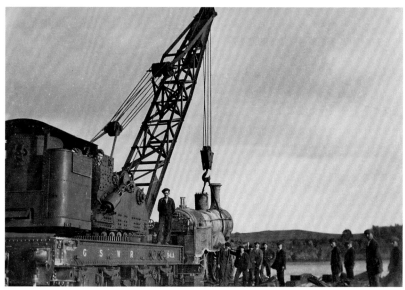

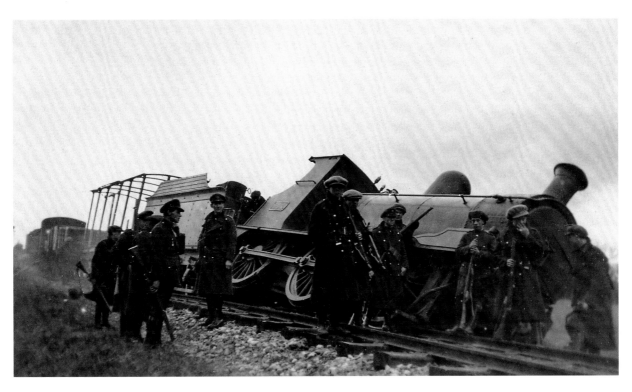

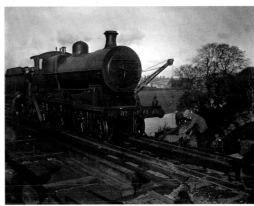

Disrupting transport was a tactic used by the Irregulars during the Civil War. Above: a derailed train in County Tipperary, another victim of Irregular guerrilla tactics. Right: repairing the track after damage. Photographer unknown, 1922.

The Irish Civil War ended with the calling of a ceasefire by the anti-Treaty Irregulars on 30 April 1923. Almost one thousand people had been killed during the hostilities, including Michael Collins who was ambushed in August 1922 at Beal na Blath in County Cork. The war's legacy of bitterness and division lasted for decades. These images show James Quirke, allegedly the last man shot in the Civil War, before and after embalming. Photographer E. Leslie, 1923.

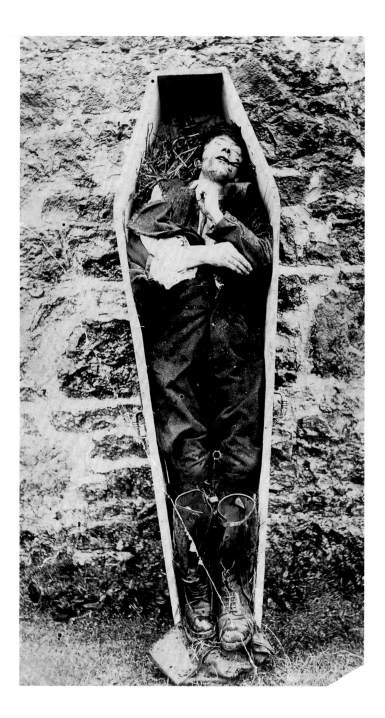

chapter 4

towards a modern ireland

Shipbuilding in Ireland was concentrated in Belfast from the 1850s, where it was dominated by two companies, Harland and Wolff, and Workman, Clark and Company. Above: the rotor for the *Argentine* at Harland and Wolff. Photographer Robert Welch, *c.* 1912. Opposite: work on a portion of a turbine casing for the *Olympic*, sister ship of the more famous *Titanic*. Photographer Robert Welch, *c.* 1909.

The Act of Union of 1800 not only established a political union, but it also created an economic union between Britain and Ireland, bringing free trade within the United Kingdom and the gradual integration of economic institutions. But even after 1800, the economic development of the countries remained deeply unequal. At the time of the Union, Britain was one of the leading industrialized nations in Europe; by 1851, she was the acknowledged workshop of the world. The Great Exhibition, held in London that year, advertised her economic and industrial supremacy.

The Irish economy, in contrast, remained overwhelmingly agricultural. In the early nineteenth century, Ireland was judged by British officials to be backward, economically underdeveloped and overpopulated. They attributed this to a number of factors including the high dependence on the potato, which had allowed the extensive subdivision of land, making agricultural improvements impossible; and Irish landlords (many of whom regarded themselves as Anglo-Irish), who were believed to lack both the capital and initiative required to modernize their estates. Although the Famine reduced the population dramatically and resulted in both the surrender of thousands of smallholdings and the sale of many large estates, Irish agriculture did not modernize in the way that had been envisaged. The Famine did not end the high dependence of the peasantry on potatoes, although there was a change from tillage to pasture in large-scale agricultural production. Landlords were accused of replacing their

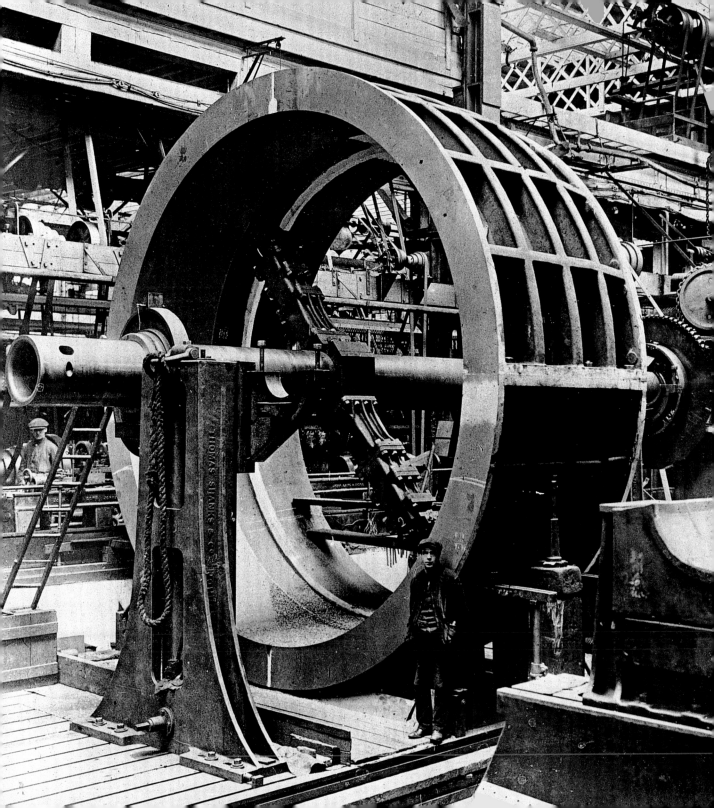

The mechanization of agricultural production increased after 1850. Nonetheless, harvest time still brought men, women and children together in preparing the crop for both commercial sale and personal consumption. Harvest was also a time of festivity, with pagan festivals such as *Lughnasa* incorporated into the Christian calendar. Below: threshing machine. Photographer unknown, *c.* 1860. Below: steam engine for threshing machine. Photographer unknown, *c.* 1885. Opposite: railway coaling stage at Inchicore, Dublin. Photographer P. Kennedy, *c.* 1920.

tenants with sheep as a way of maximizing the income from their estates. In the late nineteenth century, nationalists blamed both landlords and the Union for Ireland's economic decline and the high levels of poverty and emigration. They believed that political independence would help Ireland to achieve economic prosperity.

In addition to agriculture, there was significant industrial and manufacturing activity in Ireland, especially in and around the towns of Cork, Dublin and Belfast. Cork and Dublin, as well as being busy ports, were sites of shipbuilding, textile production, glass-making, biscuit production, distilling and brewing. One of the most successful companies in Dublin was the brewing company, Guinness. Arthur Guinness had begun brewing in 1756 and three years later had moved his business to St James's Gate in Dublin. Initially, it produced ale and porter (which later became known as Guinness) for the Dublin market, but from the 1820s became a major exporter to Britain. By the beginning of the twentieth century, Guinness was one of the largest companies in the world. Its fortunes, however, were closely tied to the development of Dublin. Its success fostered the growth of a number of support industries in the city such as barrel-making. The family were noted benefactors and they built artisan-dwellings for their employees. They were also involved in political life: Arthur Guinness the younger, although a member of the Anglican Church, supported Catholic Emancipation in the

1820s, and two of his descendants were Conservative members of the British parliament in the late nineteenth century. The success of the Guinness dynasty contradicts the image of nineteenth-century Ireland as lacking entrepreneurs and businessmen. Moreover, the photographic record provides ample evidence of the vibrancy of street life, not only in Dublin but throughout Ireland, north and south, at the beginning of the twentieth century. Street markets, numerous pedlars, and well-stocked shop fronts attest to the wide range of economic activity.

Nonetheless, in the late nineteenth century it was Belfast that was regarded as the flagship of Ireland's industrial advancement, especially since many of its industries were integrated into the economy of Britain and the wider Empire. It was therefore regarded, in the words of one travel writer in the 1840s, as an 'UnIrish' town. In the post-Famine decades, both the population and economy of Belfast grew rapidly in tandem with the expansion of the local linen industry, shipbuilding and associated activities such as rope-making. Linen, however, was the most important manufacturing industry in Ireland in the nineteenth century. In the years following the Act of Union, Belfast had been a successful centre of cotton production, but after the 1820s linen became the major local textile industry. Initially linen cloth had been produced in people's homes as part of a successful cottage industry. Many people

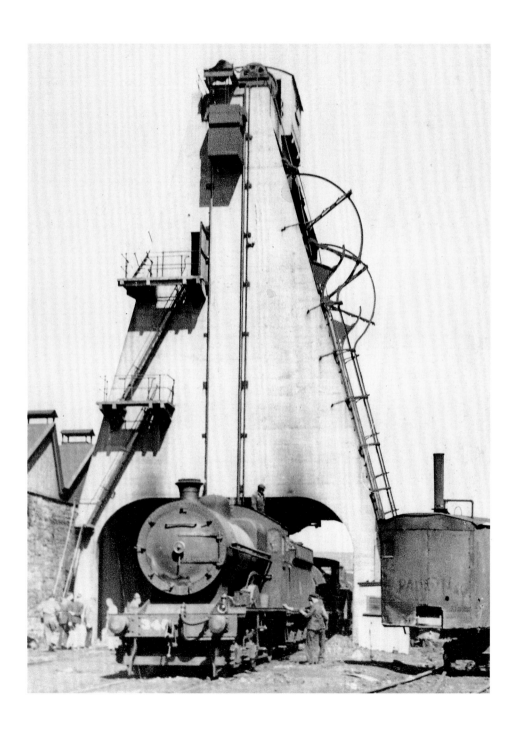

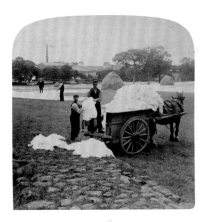

Linen was the most important manufacturing industry in Ireland in the eighteenth and nineteenth centuries. Production was concentrated in Ulster, and from the 1820s, with increased mechanization, it moved to towns such as Belfast. Above: bleaching linen in Lisburn. Photographers Underwood and Underwood, *c.* 1903. Opposite: linen manufacture in Belfast. Photographer unknown, *c.* 1900.

who lived in Ulster described themselves as half-handloom weaver and half-farmer. As a result of technological changes after 1820, however, linen production increasingly moved from the domestic sphere into factories. As the century progressed, production also became more concentrated into large towns such as Belfast. By 1850, Belfast was the largest centre of linen manufacturing in the world. The textile industry, especially shirt-making, was also an important employer in the west of Ulster, notably in Counties Derry, Donegal and Tyrone. Initially, as with linen, production had taken place in the home, but with mechanization it moved into workshops and factories. Many of the workforce employed in this industry were women and they tended to be poorly paid, with wages based on piece-work. Shirt-making in these localities started to decline at the beginning of the twentieth century, largely due to changes in fashion.

The concentration of textile production in a small number of towns in Ulster in the nineteenth century had contributed to economic decline in other parts of the country, especially in areas where domestic production of linen was widespread. The move to mechanization had a serious impact on counties Mayo, Sligo, Leitrim and Roscommon, all of which had been active in domestic textile manufacture before 1830. For some families, the loss of income from weaving led directly to an increased dependence on potato production, which in turn increased their vulnerability when the potato crop failed after 1845.

As early as 1841 (the year of the last census before the Famine), Belfast had been the most important shipbuilding centre in Ireland. In the second half of the nineteenth century, the growth of two shipbuilding companies – Harland and Wolff, and Workman, Clark and Company – contributed to the rapid economic development of the town. Harland and Wolff was founded in 1861, and achieved world renown under the leadership of William Pirrie, who had joined the company as an apprentice in 1862. One of his main concerns was with passenger comfort and his vision led to the building of luxury liners such as the *Olympic* and the *Titanic.* When the *Titanic* was launched in 1912, she was the largest ship in the world. By the beginning of the twentieth century, Harland and Wolff was not merely one of the most successful companies in the United Kingdom, it was one of the largest shipbuilders in the world. The economic success of Belfast, however, did not ease sectarian tensions, with large companies such as Harland and Wolff favouring Protestants over Catholics in their recruitment. Religious differences were reinforced by the economic divisions this fostered. The resplendent Orange Hall in Belfast (page 21) provides an insight into the importance of political and religious identity of ordinary working-class Protestants. Moreover, Protestants of all social classes regarded the Union with Britain as essential to their continued economic success.

Industrial development depended on good transport links both within Ireland and with

Britain. The expansion of roads and railways in the late nineteenth century changed the pattern of Irish rural life. Apart from increasing contact with some of the most remote parts of the country and encouraging commercial farming, they also facilitated the depopulation of the rural landscape, by making emigration and the import of foreign produce cheaper and easier. The network of communications also altered the rural landscape, as many photographs demonstrate. Much of the road building in the late nineteenth century came about through employment schemes set up to act as a test of destitution during the intermittent periods of poor crop harvests. The extensive road network in some of the most isolated parts of Ireland is therefore a testimony to Ireland's past poverty rather than prosperity. As well as employing local labour, roads and walls were generally constructed from material gathered from surrounding fields.

The development of a transport infrastructure within Ireland was crucial for the movement of food, goods and people. Although a system of horse-drawn carriages ran between Dublin and some of the major towns, it was expensive and did not serve people who wanted to travel between provincial towns. The first internal system of transport accessible to the poorer social groups was introduced by an Italian immigrant Carlo Bianconi, who had moved to Ireland in 1802. In 1815 he started a service that ran between Clonmel and Cahir in County Tipperary carrying people, goods and

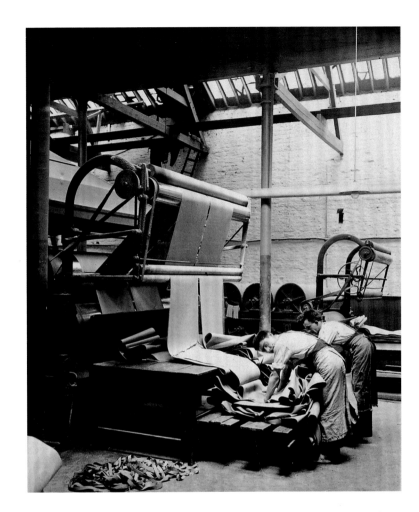

mail. He was able to keep costs down, while maximizing carriage space, by using open-topped cars. Some of his larger carriages could carry up to twenty people, generally sitting back to back. By the 1840s, Bianconi's business had expanded and was covering 3,000 miles of road each day. The tardiness of the railway system in reaching parts of the west of Ireland meant that Bianconi's cars remained an important means of moving goods and people into the late nineteenth century.

The first railway was opened in Ireland in 1834, running from Dublin to Kingstown (Dun Laoghaire). This route was chosen because it provided a link between Dublin and the boat service from Holyhead which, in turn, was linked with London. The London to Dublin link allowed politicians, mail and troops to move quickly from one capital to another. Despite the success of this line, railways were slow to develop in the rest of Ireland, partly due to a reluctance to invest. In the northeast of the country, however, the Ulster Railway Company established a line in 1842 between Belfast, Lisburn and Portadown (the so-called 'linen triangle') to facilitate the rapid movement of goods to Belfast, from where they could be forwarded to any part of the British Empire. During the Famine, the leader of the Conservative Party, George Bentinck, had suggested that a massive public works programme of railway building should be undertaken as a means of both providing short-term relief and helping the longer term industrial development of Ireland, but this idea was rejected in parliament.

By 1860 the major railway routes had been completed and thirty companies were operating 324 locomotives. The railways allowed large numbers of people and goods to cross Ireland, and onwards to Britain, quickly. Increasingly also, railways brought tourists to the west of Ireland, thereby stimulating the hotel trade. Many railway companies also owned hotels, so further increasing their income. By the beginning

Harland and Wolff was one of the most successful shipping companies in the world at the beginning of the twentieth century. Robert Welch was the company's official photographer. Right: part of the *Argentine*. Photographer Robert Welch, *c.* 1912. Opposite: part of the engine room of the *Olympic*. Photographer Robert Welch, 1909.

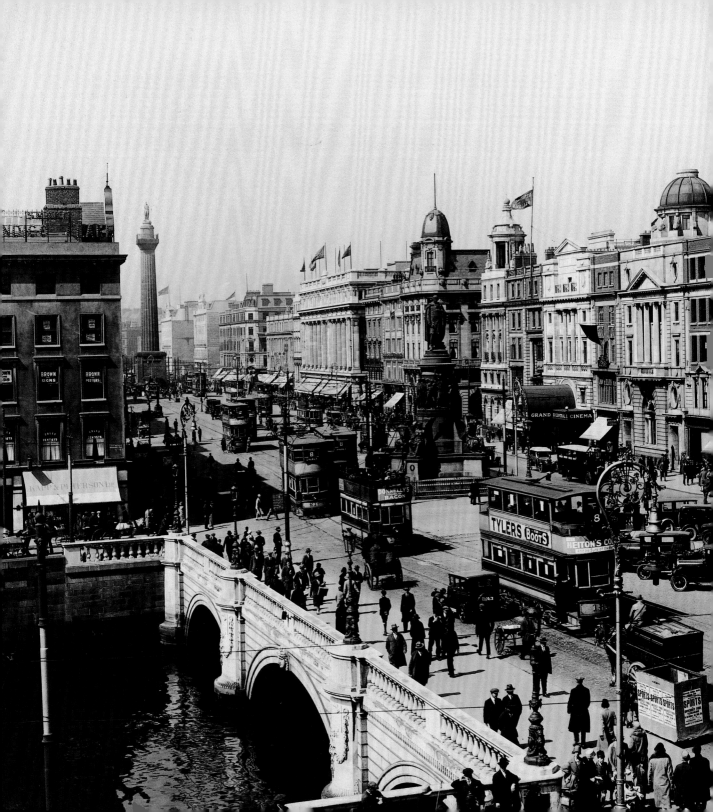

Daniel O'Connell and Eamon de Valera dominated Irish politics in the nineteenth and twentieth centuries respectively. A monument to Daniel O'Connell (1775–1847) was unveiled in Sackville Street in the centre of Dublin in 1882, which then became popularly known as O'Connell Street. Opposite: O'Connell Bridge. Photographer unknown, 1920s. Below: Eamon de Valera (1882–1975) with two sons at the funeral of his son Brian, killed in a riding accident in Dublin. Fox Photos, 12 February 1936.

of the twentieth century, therefore, Ireland was supplied with a good transportation infrastructure. Lack of investment, however, had left many roads in poor condition. The ongoing decline in population numbers made the extensive transport system increasingly uneconomical. As a consequence, in the first decades of the twentieth century the system was rationalized. After 1923 a number of railway lines were closed, with the highest number of closures taking place in the new state of Northern Ireland. As public transport declined, private transport in the form of the motor car and motorcycle grew. The increase in privately owned vehicles pointed to the emergence of an affluent middle class, but it also contributed to the closure of even more railway routes.

The Act of Union in 1800 had created a free-trade zone across the United Kingdom, but Partition meant that on the island of Ireland two separate governments and economies now coexisted. Partition was followed by two decades of economic depression on both sides of the border. In Northern Ireland, the recession was exacerbated by a decline in staple industries such as shipbuilding and engineering upon which Ulster had built her economic success. The linen industry (which in 1924 employed over fifty-one per cent of the workforce in Northern Ireland) also declined, as fashions changed and clothes became shorter and less formal. The 1920s and 1930s, therefore, were characterized by high unemployment and endemic poverty as well as disease in the new northern state. Although

there was initially some cooperation between unemployed Catholics and Protestants, the overall impact of the economic uncertainty was to forge new divisions as competition for employment intensified. The Second World War helped short-term economic recovery in the province.

Despite achieving political independence after 1921, the Free State's links with Britain continued, for a time at least, especially in relation to the economy and defence. Britain's strategic interest in the twenty-six counties had been codified in the defence clauses of the 1921 Treaty, and it was not until 1938 that its authority over the 'treaty' ports was given up. Economically also, the Free State's economy remained dependent on that of Britain, despite De Valera's overt attempts at economic self-sufficiency in the 1930s. A trade agreement in 1938 provided for the free movement of certain goods between Britain and Éire, thus marking a softening of the economic war that De Valera's policies had initiated between the two respective governments. Despite a policy of neutrality, the Second World War was a difficult time for Éire, which experienced food shortages and an increase in unemployment and emigration. High levels of emigration continued into the 1970s. In the short term, political independence had not brought prosperity or closed the gates to emigration from Ireland. It was not until the end of the twentieth century, with membership of the European Union, the start of the Peace Process and the rapid growth of the Irish economy, that the situation was to reverse.

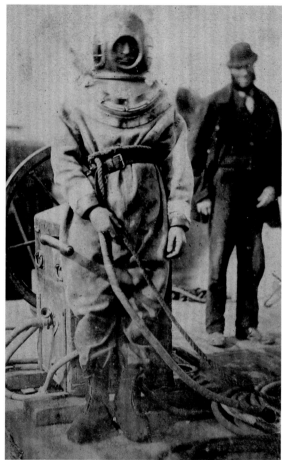

The sea has always played a significant role in Irish history. Above: an early image of a sailor. Photographer Augustuvus Darcy, *c.* 1863. Above right: a deep sea diver, working on the cable link between Valentia Island, County Kerry and Newfoundland that brought the electric telegraph to Ireland. Photographer Augustuvus Darcy, October 1864. Opposite: *The Eilander* of County Down near the Tyne after a gale. Photographer unknown, 1 March 1933.

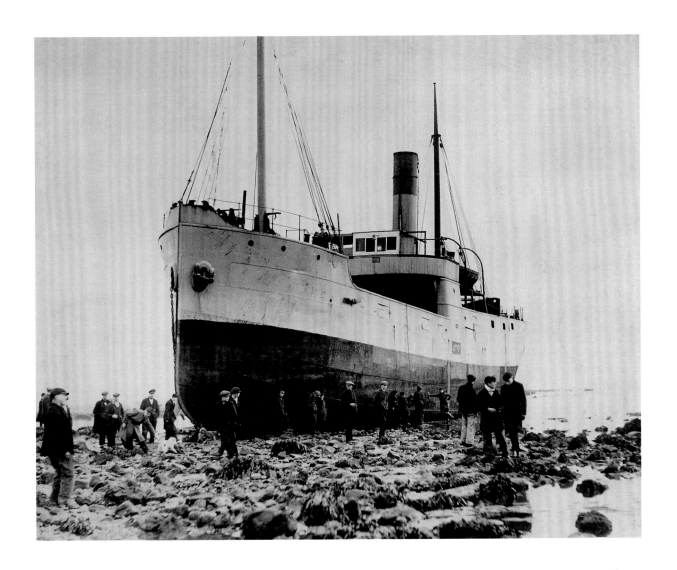

Public works, especially road building, were a preferred form of providing short-term welfare in the nineteenth century. In 1831 a Board of Works was established to encourage the construction of roads, harbours and piers in poor areas, such as Kingstown Harbour. Public works were the main form of relief after 1846, but the policy was ultimately disastrous – the wages were low, the system was bureaucratic, and such hard physical labour was inappropriate for weak, hungry people. Right: road building in County Cork or Kerry. Photographer unknown, *c*. 1860. Right below: steam engine in Waterford. Photographer unknown, 1900. Below: people in a train carriage travelling to Blarney, County Cork. Photographer unknown, *c*. 1914.

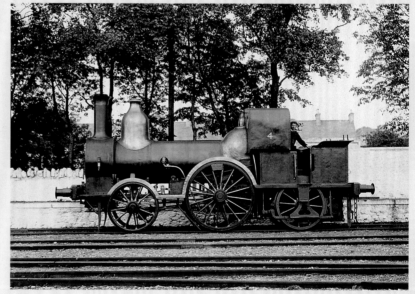

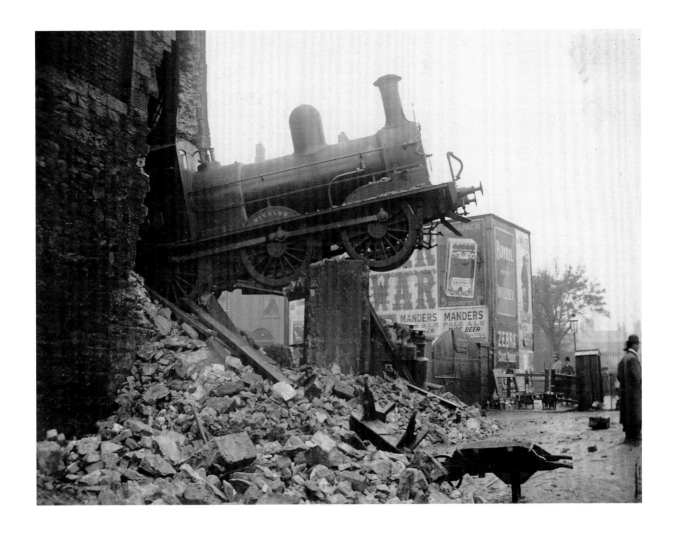

The first railway in Ireland linked Dublin and
Kingstown (Dun Laoghaire) in 1834; within a few
decades the whole country was linked by a railway
network. Accidents were not unknown. This
train derailed Harcourt Street Station, Dublin.
Photographer unknown, 14 February 1900.

The popular perception of navvies
was that they were unskilled Irish
labourers. In fact, many of the
men who built the canals, railways,
tunnels and roads of Britain were
skilled and physically strong. The
extensive use of explosives made the
work highly dangerous. The most
famous Irish navvy was Patrick
MacGill (1891–1963), who was born
in County Donegal. He left school
at ten and was largely self-taught.
His first publication, *Gleanings
from a Navvy's Scrapbook* (1911)
was widely acclaimed, as was his
first novel, *Children of the Dead End*
(1914). Right: Irish workers in the
East Midlands, England, using an
early version of the pneumatic drill.
Photographer unknown, *c.* 1934.
Opposite: constructing Thackley
Tunnel, near Leeds, England.
Photographer unknown, *c.* 1900.

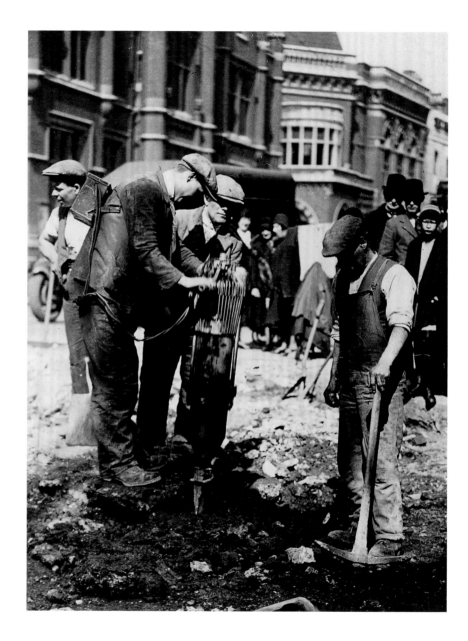

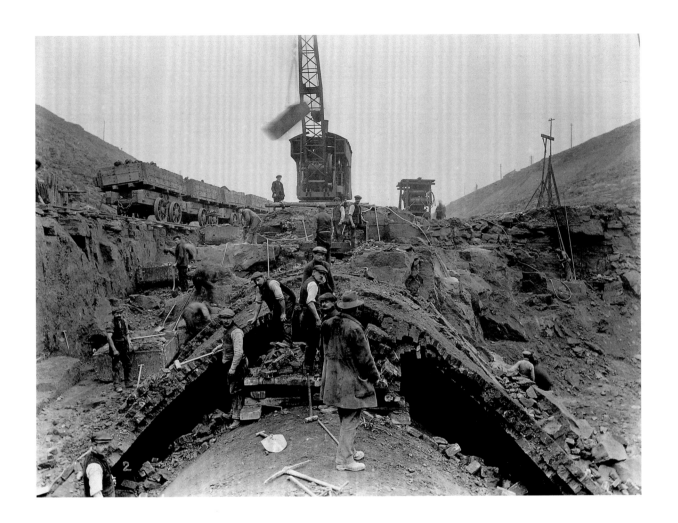

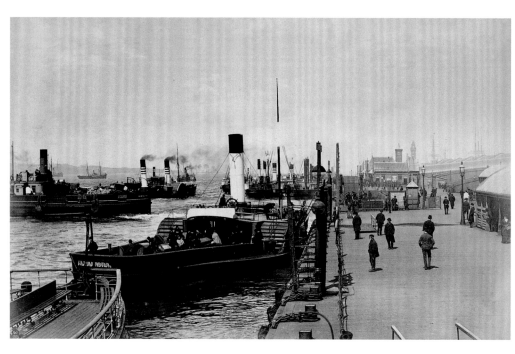

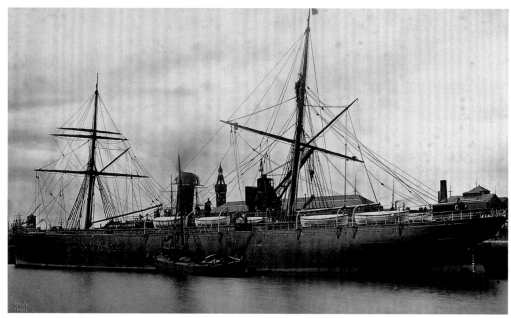

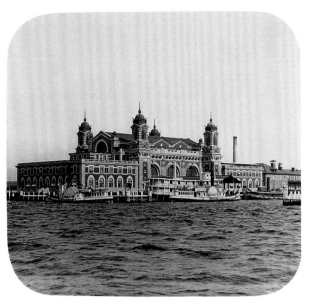
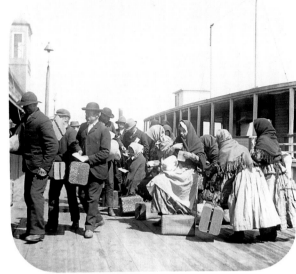

The immigration station at Ellis Island, New York was opened in 1892 to monitor immigration into New York. The first immigrant to enter through the station was a fifteen-year old Irish girl, Annie Moore from County Cork, accompanied by her two brothers. Following inspection, they were declared to be 'physically and morally fit for America'. In commemoration of this, Annie was given a $10 gold piece. Many Irish emigrants to America sailed via Liverpool, which was the main transatlantic port. Opposite above: St George's landing stage at Liverpool. Photographer James Valentine, *c.* 1890. Opposite below: an American liner in Liverpool. Photographed for the Frith Series, *c.* 1880. Above left and right: Ellis Island, and immigrants waiting to enter America at Ellis Island. Photographer T. McAllister, *c.* 1900.

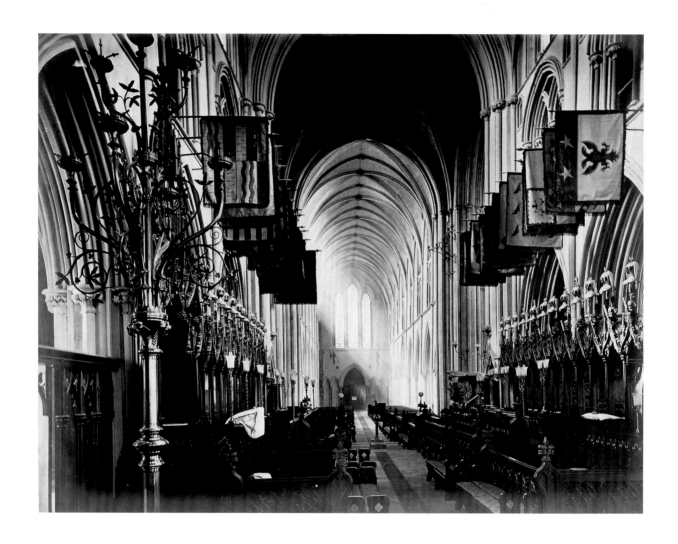

St Patrick's Cathedral in Dublin is the largest
Protestant church in Ireland. It was located
on a well where St Patrick baptized converts
to Christianity. The brewer Sir Benjamin
Guinness paid for it to be restored in the
1860s. Photographer Robert French, *c.* 1880.

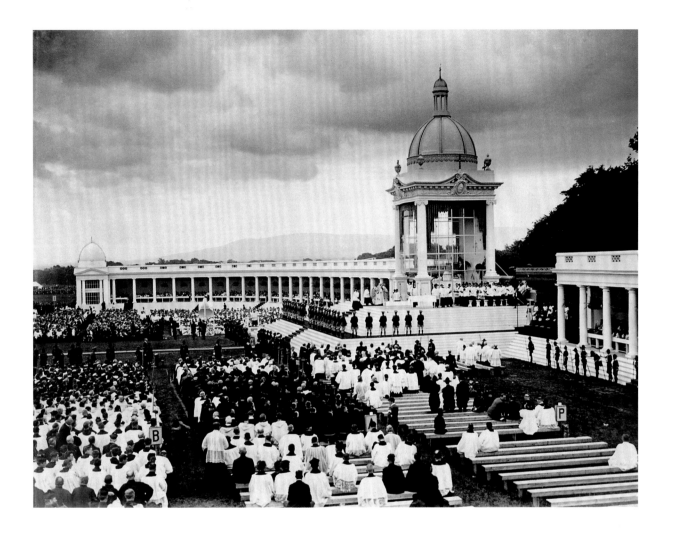

Eucharistic Congresses were organized by
the Catholic Church for the celebration of the
Blessed Sacrament. The 31st Congress was
held in Dublin, with mass being celebrated in
Phoenix Park, attended by over one million
people. Photographer unknown, 1932.

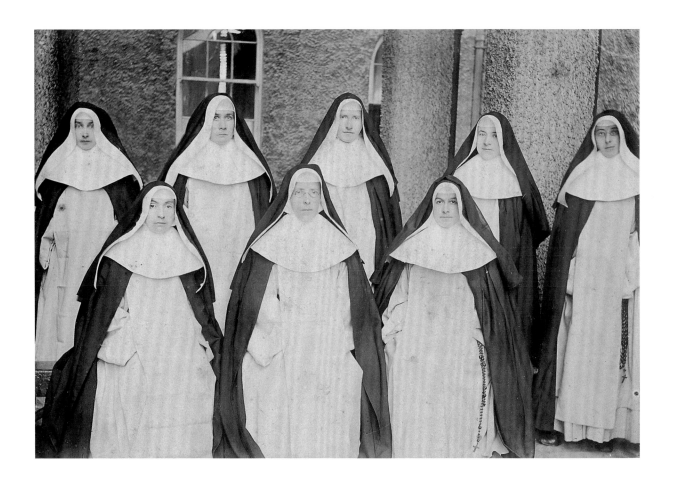

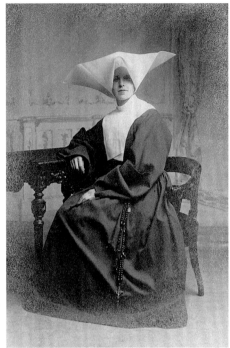

The number of women joining religious orders in Ireland increased after the Famine. The nineteenth century also saw the development of nursing as a female profession. Opposite: nuns from the Dominican Convent in Dublin. The Dominican Order arrived in Ireland in 1224, but it was only in the nineteenth century that women were allowed to become Sisters. Their role became associated with teaching and the care of orphans. Photographer unknown, *c.* 1900. Above: two nurses. Photographed by Castle Studio, Belfast, *c.* 1912. Above right: portrait of a nun. Photographer J. Stanley, *c.* 1912.

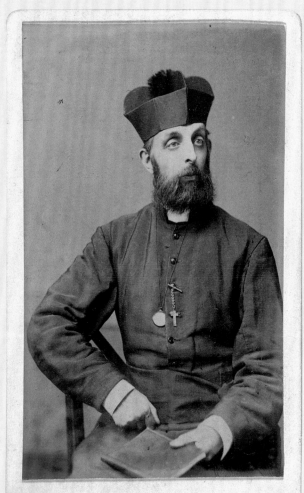

WILLIAM LAWRENCE, 5, 6 & 7. Upper Sackville St. DUBLIN.

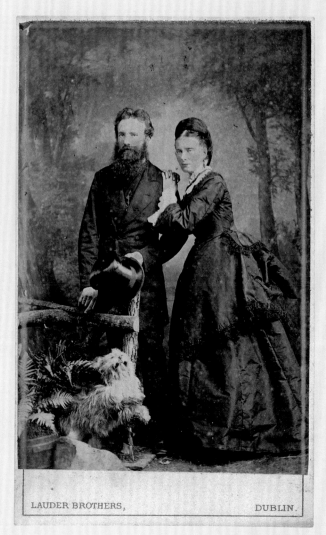

LAUDER BROTHERS, DUBLIN.

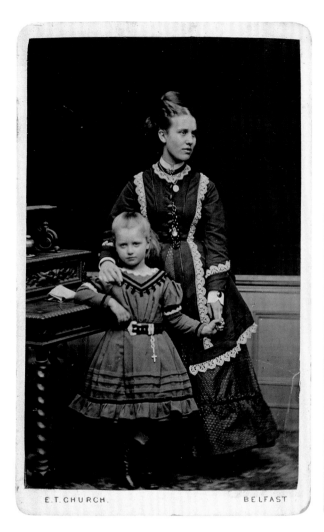

E.T.CHURCH. BELFAST

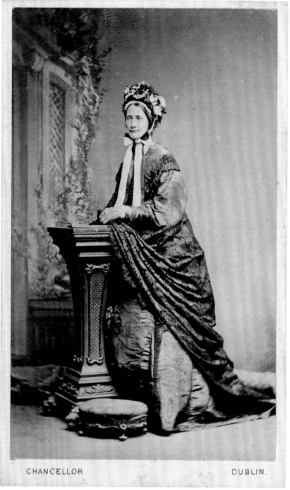

CHANCELLOR. DUBLIN.

The popularization of photography was helped by a fall in overhead costs. These studio portraits were taken between 1860 and 1895. Opposite left: a priest. Photographed by Lawrence Studio. Opposite right: a couple. Photographed by Lauder Brothers. Above: woman and child. Photographer E.T. Church. Above right: a woman. Photographer Mr Chancellor.

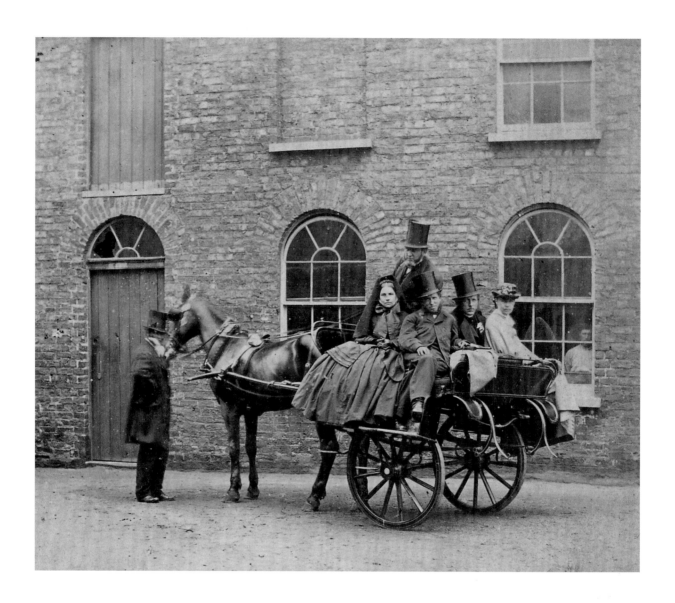

Horse-drawn transport remained commonplace well into the twentieth century. Open-topped cars provided an important link between provincial towns, even after the development of railways. They are associated with Carlo Bianconi, who started his service in 1815. Opposite: a side car in Belfast. Photographer James Magi. *c.* 1870. Above: a milk delivery boy. Photographer unknown, 1920s.

 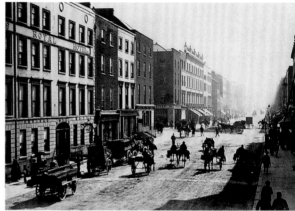

Living standards rose following the Famine,
helped by both the depopulation of the
country and the tradition of emigrants
sending remittances to those left behind
(often referred to as 'American letters'). The
spread of railways and road improvements
also made rural Ireland accessible, which
facilitated trade while helping to reduce
prices. Fairs and market days continued
to be an important way of doing business.
Above: market day in The Square, Thurles,
County Tipperary. Photographer W. Ritchie,
c. 1900. Above right: George's Street,
Limerick. Photographer Robert French,
c. 1880. Opposite: street market in Cork.
Photographer W. Ritchie, *c.* 1905.

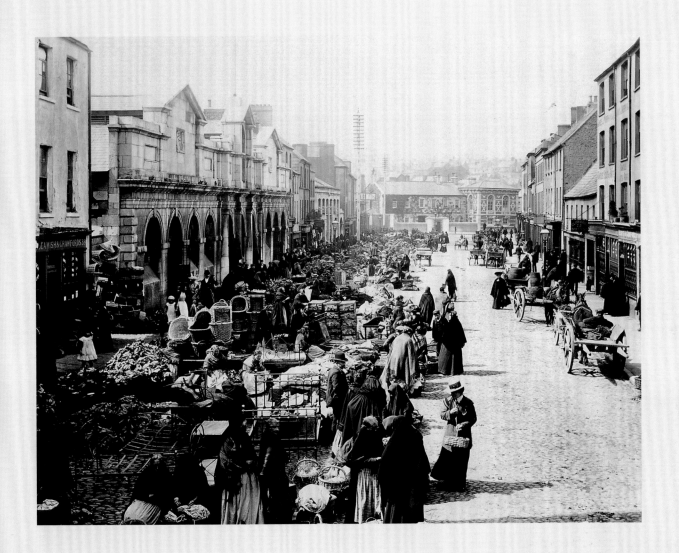

The majority of the population at the turn of the century lived in the countryside, but towns and villages played an important part in Ireland's development. In the nineteenth century Dublin declined in relative economic importance, which writers such as James Joyce believed was reflected in its social and cultural paralysis. In contrast, towns in Ulster were bolstered by the success of some industries such as textile production and shipbuilding. Below: street in Rathfarnham, Dublin. Photographer unknown, 1920s. Right: Scotch Street, Armagh. Photographer W. Ritchie, c. 1900.

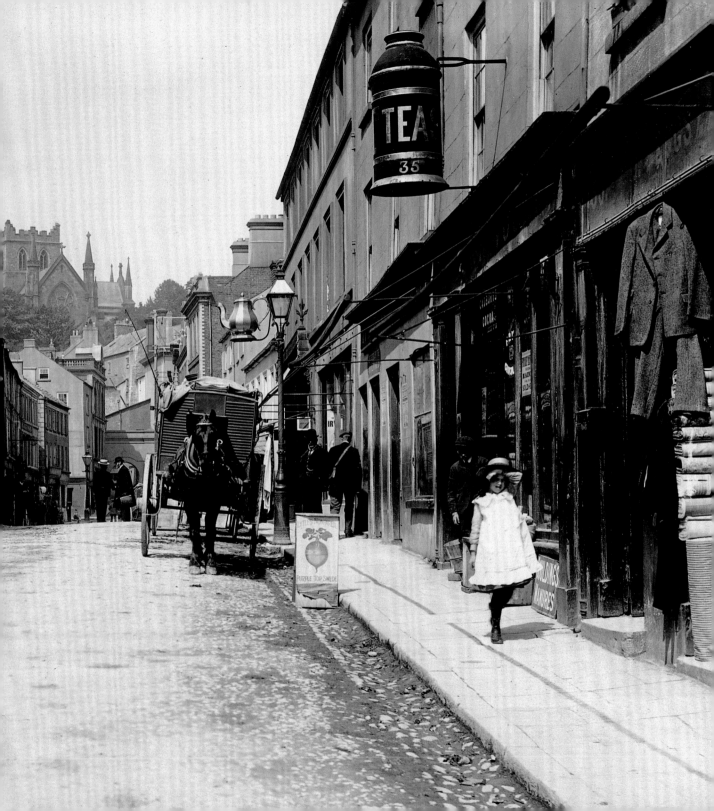

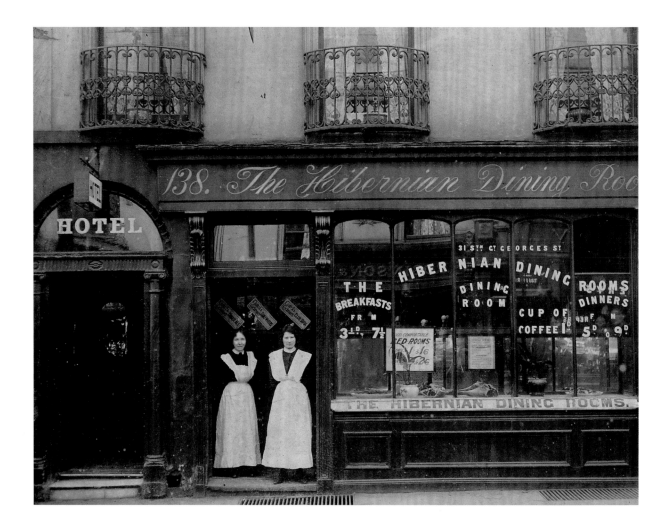

While life for the poor was harsh, an increasing range of leisure activities, such as dining out, was available to the middle classes. The spread of eating establishments also provided employment opportunities for women, such as these workers at the Hibernian Dining Rooms in Dublin. Photographer unknown, *c.* 1895.

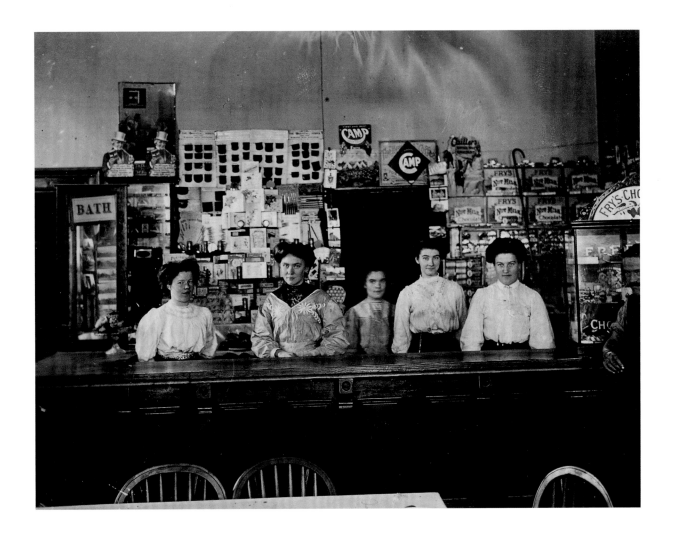

The number of women employed in shops increased greatly at the end of the nineteenth century. Shop girls regarded themselves as socially superior to women employed in factories or domestic service. This shop was in the Curragh, County Kildare. Photographer Philip G. Hunt, *c.* 1903.

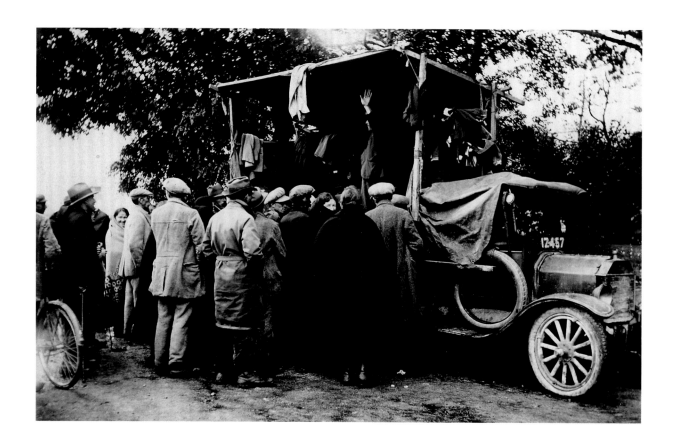

Itinerant traders played an important role in bringing goods to remote parts of the country, despite the increase in shops in Irish towns. The availability of motor vehicles speeded up the process, as for this travelling hawker. Photographer T.H. Mason, 1920s.

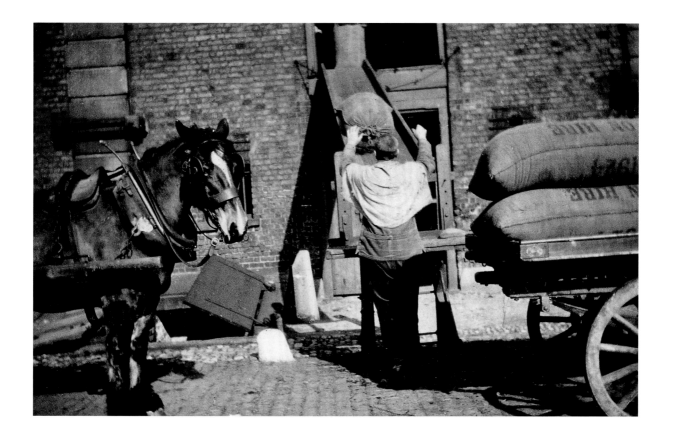

Grain being taken out of a warehouse owned by Dublin Port and Docks Board. Regardless of the political turmoil endured by the Dublin people in the years after the 1916 Rising, some aspects of life changed little. Photographer unknown, 1920s.

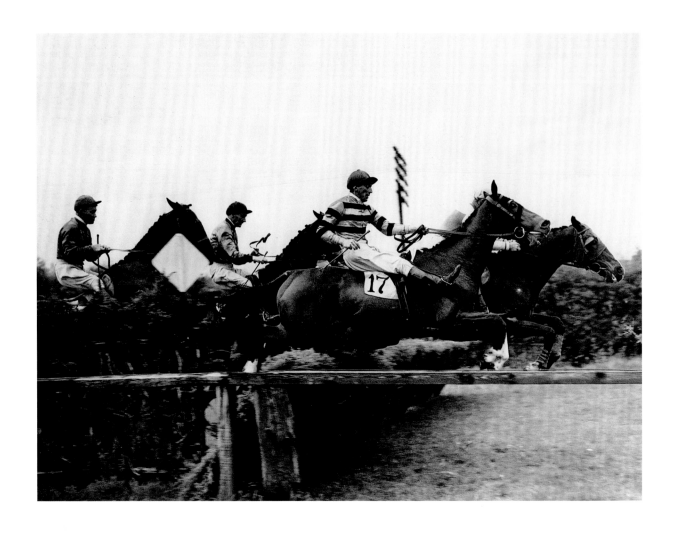

Steeplechasing originated in Tipperary in the eighteenth century, but it was largely confined to the gentry. Popular interest increased greatly after the First World War, helped by the success of Irish-bred horses in both Irish and English racing. The Farmleigh Handicap, shown here, was held at Phoenix Park, Dublin. Photographer unknown, 1930s.

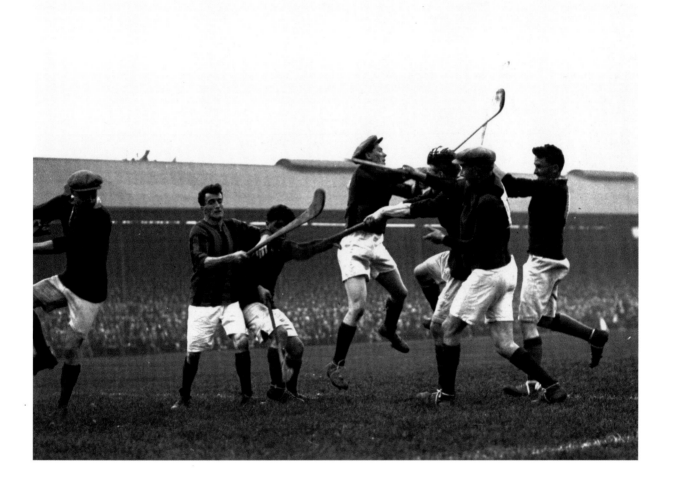

The origins of hurling are uncertain, but a
version of the game was played in medieval
Ireland. The Gaelic Athletic Association
fostered the revival of hurling in the 1880s.
This photograph was shot from the Kilkenny
goalmouth during the All Ireland Hurling
Final of 1931, in which Cork beat Kilkenny.
Photographer unknown, 1931.

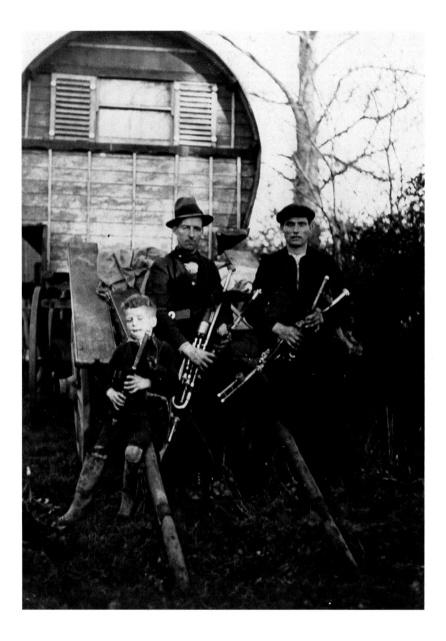

The uilleann pipe player Johnny Doran (1908–50, right) belonged to the famous Doran family of travelling pipers, who played at fairs, horse races, hurling games and other sporting events. The uilleann pipes evolved from the simple bagpipe in the 1700s. In 1947 Johnny Doran was recorded by the Folklore Commission, and this formed the basis of his album *Bunch of Keys*. He was fatally injured when a wall fell on his caravan home in Dublin. Photographer unknown, *c.* 1940.

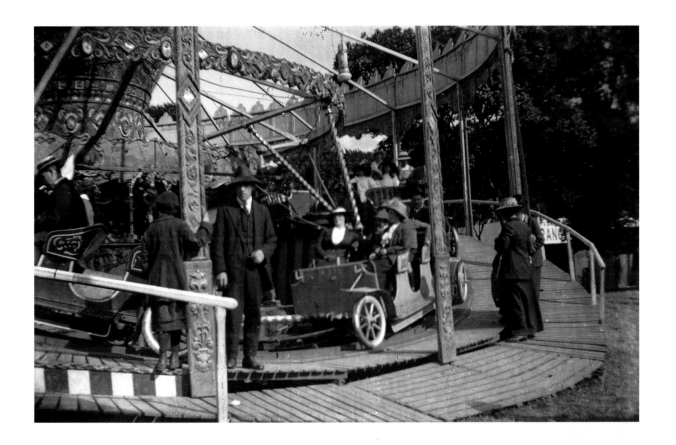

Leisure time increased for most
workers at the end of the nineteenth
century. Fairgrounds provided low-cost
entertainment. They were also widely
accessible, as they often travelled around
the country. Above: a merry-go-round in
Dublin. Photographer unknown, 1920s.

Transport and recreation were transformed in the first decades of the twentieth century, at least for the upper classes. Motoring spread quickly in Ireland, with the Irish Automobile Club being established in 1901. Left: the Ards Circuit, County Down. C.J.P. Dodson, driving an M.G. Magnette, won the 1934 Ards Circuit from a field of forty-one international cars. The race was 478 miles long. Photographer unknown, 2 September 1934. Left below: woman driving a seventeen horsepower Maudslay Car. Photographer unknown, c. 1912. Below: a racing cyclist. Photographer D'Arcy, 13 June 1902. Opposite: Charles McGonegal, an armless pilot. Photographed by Underwood and Underwood in the USA, 5 March 1930.

A boating trip in Ashleagh, County Carlow. Little is known about the origins of this photograph, and both the subjects and the photographer remain unidentified. Nonetheless, the serenity of the image, especially the composure of the woman, is in contrast to the agitation in Ireland at the time it was taken, *c.* 1912. Overleaf: the billboards in Galway in the 1920s illustrate how the modern world and traditional Ireland coexisted.

chronology

1798 United Irishmen lead uprisings in various parts of Ireland that are put down by government forces with high casualties. A French invasion in support of the United Irishmen is defeated.

1800 The Act of Union, which creates the United Kingdom of Great Britain and Ireland, is passed. The Irish parliament meets for the last time. Only Protestant MPs can sit in the British parliament.

1829 Catholic Emancipation is granted, allowing Catholics throughout the United Kingdom to sit in parliament.

1834 The first railway, between Dublin and Kingstown (formerly Dun Laoghaire) is opened.

1839 Louis Daguerre in France, and William Fox-Talbot in England, each announce different methods of recording permanent images through the aperture of a camera

1840 Rapid Portrait Lens invented by Petzval in Vienna making portrait photography possible.

1841 The first photographic studio is opened in Dublin.

1845 A potato blight appears in Ireland that triggers the onset of the Great Hunger.

1847 Death of Daniel O'Connell.

1848 Young Ireland uprising in County Tipperary is easily defeated. Leaders are convicted of high treason but this is commuted to transportation for life.

1851 Frederick Scott-Archer announces the collodion wet plate process.

1854 Dublin Photographic Society founded. (Renamed the Photographic Society of Ireland in 1858.)

1858 James Stephens founds the Irish Republican Brotherhood (IRB) in Dublin • Work begins on the laying of the transatlantic telegraphic cable between Newfoundland and Valentia Island, to be completed in 1866.

1859 The Fenians (the American equivalent of the IRB) are founded in New York.

1860 Poor harvest • Evictions in Partry, County Mayo.

1861 The Glenveigh evictions in County Donegal take place following the murder of the landlord's agent • Census records 101 professional photographers in Ireland (62 in Leinster, 19 in Ulster, 17 in Munster, 3 in Connaught) • The Harland and Wolff shipyard opens in Belfast.

1864 Work begins on building the O'Connell monument in Sackville Street, Dublin, but is followed by two weeks of sectarian rioting in Belfast • Walter Bentley Woodbury announces the Woodbury-type process.

1865 William Mervin Lawrence extends his brother's photographic studio in Sackville Street in Dublin.

1866 Eight hundred Fenians invade Canada from the US (April–June). Withdraw after a skirmish at Lime Ridgeway • The Irish Constabulary begin photographing suspected Fenians, for systematic surveillance of nationalists • First aplanatic lens invented by Adolph Steinheil.

1867 Fenian uprisings in Ireland and parts of England are unsuccessful • Execution of Allen, Larkin and O'Brien (the Manchester Martyrs) for killing a policeman.

1869 The Irish Church Act means that the Church of Ireland is no longer the state church.

1870 The Home Rule Association (later, League) is formed by Isaac Butt • Michael Davitt sentenced to 15 years penal servitude for his political activities.

1871 Fenian invasion of Canada (5 October) • Prevention of Crime Act makes it a legal requirement that arrested criminals have their photographs taken.

1876 The IRB splits with the Home Rule League.

1877 Charles Stewart Parnell takes over leadership of the Home Rule League.

1878 Michael Davitt and John Devoy link land reform to the nationalist movement in the 'New Departure' • The first successful dry plates go on the market, making photographic equipment more transportable.

1879 Michael Davitt founds the Mayo Land League (August) which is followed by the formation of the Irish National Land League marking the beginning of the Land War, the purpose of which is to secure the 'Three Fs' (fair rent, fixity of tenure and free sale) • Very heavy rainfall results in a poor harvest in many parts of the west.

1880 Parnell tours America and addresses the House of Representatives. Following the success of the Land League supporters in the General Election, Parnell is elected the head of the Irish Parliamentary Party • The 'boycotting' of Captain C. Boycott in County Mayo takes place.

1881 Gladstone's Land Act legalizes the Three Fs.

1882 Chief Secretary Frederick Cavendish and Under Secretary Thomas Henry Burke are murdered by 'The Invincibles' in the Phoenix Park.

1884 The IRB begin a 'Dynamite Campaign'; Thomas James Clarke and three others are sentenced to life imprisonment • The Gaelic Athletic Association is founded.

1885 In the General Election, the Irish Party wins 85 seats (out of the 105 Irish seats) in the United Kingdom parliament • Gladstone declares his support for Home Rule • The Irish Loyal and Patriotic Union is

formed to defeat Home Rule • The Fenians bomb parts of London • George Eastman develops a roll holder for use with a standard plate camera.

1886 Gladstone introduces a Home Rule bill, but it is defeated • The Irish Unionist Party is founded.

1887 Twenty-eight families are evicted in Bodyke, Co. Clare.

1888 Circular from Catholic Church in Rome condemning various political activities including boycotting • The Kodak box camera, a portable hand camera, is launched.

1889 Captain O'Shea cites Parnell as co-respondent when he files for divorce against Kitty O'Shea • Dr Paul Rudolph's calculations lead to the invention of the anastigmat lens.

1890 Captain O'Shea divorces his wife and the verdict is against Parnell • Parnell is re-elected as leader of Irish Parliamentary Party, but Gladstone states that Home Rule is impossible if he remains as leader.

1891 The Balfour Act provides money for land purchase by tenants • Parnell dies months after marrying Kitty O'Shea.

1892 Professor John Joly, a lecturer in Trinity College, Dublin, invents a colour photographic process.

1893 Gladstone's second Home Rule bill is defeated. The Gaelic League is established.

1896 James Connolly founds the Irish Republican Socialist Party • 1,500 bankrupt estates are made available for purchase by tenants.

1898 As a result of the Local Government Act, some women get the vote for the first time in local elections.

1904 The Abbey Theatre opens in Dublin • The first mechanically produced photographs invented by Dr Mertens are reproduced in the newspaper *Der Tag*.

1905 Arthur Griffith founds Sinn Féin • The Ulster Unionist Council is founded, which strengthens the links between the Unionist Party and the Orange Order.

1907 Marconi begins his transatlantic wireless service between Clifden, County Galway and Canada.

1910 Sir Edward Carson elected leader of the Unionist Party • The *Olympic* is launched at Harland and Wolff in Belfast.

1911 The Census shows that the population has halved since 1841 • The *Titanic*, sister ship of the *Olympic*, is launched at Harland and Wolff • Work begins on the Parnell Monument in Sackville Street.

1912 The third Home Rule bill is introduced • Unionists organize an 'Ulster Day' that includes the signing of the Solemn League and Covenant • D.W. Corbett makes the first aeroplane crossing over the Irish sea.

1913 The Ulster Volunteer Force (UVF) is formed in Belfast • The Irish Volunteers are established.

1914 Britain declares war on Germany • The Nationalist leader, John Redmond, asks the Volunteers to serve with the British Armed Forces, but this leads to a split within the Volunteers • The Supreme Council of the IRB decides on an insurrection before the end of the war.

1916 The Easter Rising takes place with the occupation of the General Post Office in Dublin. Fifteen of the leaders are executed and Eamon de Valera, Michael Collins and Countess Markievicz are interned in England. Roger Casement is tried in England and sentenced to death • Lloyd George attempts to negotiate a Home Rule agreement excluding six Ulster counties, but this is rejected by John Redmond • At the Battle of the Somme, the 36th (Ulster) Division suffers over 5,000 casualties • The 16th (Irish) Division suffers 4,500 losses at Ginchy.

1917 The Easter Rising internees are released from prison • Eamon de Valera wins a by-election in County Clare. He is elected President of Sinn Féin. The Irish Volunteers select him as their leader • Thomas Ashe dies as a result of a hunger strike in Mountjoy Gaol.

1918 Representation of People Act extends the vote to men over 21 and women over 30 with property. Women also allowed to sit in the House of Commons • The Military Service Act introduces conscription to Ireland but it is abandoned due to widespread opposition • Sinn Féin candidates win 73 seats in General Election; the Home Rule Party 6; and Unionist candidates 26. Countess Markievicz, a Sinn Féin candidate, is the first woman ever elected to the House of Commons.

1919 Sinn Féin convenes the first Dáil Éireann (parliament) which issues a Declaration of Independence • The War of Independence begins following the murder of two RIC men • Eamon de Valera escapes from Lincoln Jail and is elected President of Dáil Éireann.

1920 Black and Tans arrive in Ireland to support the police • Disturbances in Derry and Belfast. Catholics are expelled from the shipyards • The Irish Republican Army (IRA) attacks police barracks • The Mayor of Cork, Terence MacSwiney, dies on hunger strike in Brixton Prison • Kevin Barry, aged 18, is the youngest IRA man to be executed during the war • The United Kingdom parliament passes the Act for the Better Government of Ireland, which leads to Partition • The Royal Ulster Constabulary and Ulster Special Constabulary are established.

1921 Sir James Craig replaces Edward Carson as leader of the Unionist Party • Elections are held for the new Northern Ireland parliament, which was formally opened by George V • The new parliament in Dublin is boycotted by Sinn Féin and adjourns • Truce between IRA and British army (9 July) • Sinn Féin sends a delegation to London, led by Michael Collins and Arthur Griffith, which signs the Anglo-Irish Treaty on 6 December. Eamon de Valera rejects the Treaty.

1922 The Anglo-Irish Treaty is ratified in the Dáil by 64 to 57 votes. De Valera resigns as President of Sinn Féin and leaves the Dáil with other members opposed to the Treaty • Michael Collins is appointed Chairman of the Provisional Government. Dublin Castle is officially handed over and British rule in Ireland ends • The Irish Civil War begins in June • Sectarian riots in Belfast with over 400 people killed in Belfast alone • Michael Collins is killed in an ambush in County Cork • The Free State government executes Erskine Childers.

1923 Civil War ends in May • William Cosgrave is elected head of the Free State government; Sinn Féin abstains.

1924 The Irish Film censor bans 104 films.

1925 The IRA breaks with Eamon de Valera and forms an independent Army Council.

1926 Eamon de Valera breaks with Sinn Féin and forms Fianna Fáil.

1928 The first east–west transatlantic air crossing is made from Baldonnell Airport to Greely Island, Labrador.

1929 The Northern Ireland government abolishes proportional representation.

1931 The Free State government establishes a Military Tribunal to try political crimes. Twelve organizations are banned including the IRA.

1932 Eamon de Valera forms a Fianna Fáil Government • De Valera abolishes the Parliamentary Oath of Allegiance • The Northern Ireland parliament moves to a new building at Stormont, which is opened by the Prince of Wales.

1936 The IRA is declared an illegal organization by the Free State government.

1937 Eamon de Valera's Constitution comes into effect on 29 December.

1938 Douglas Hyde is elected the first President of Éire under the new Constitution.

1939 The Second World War begins • The Dáil passes a bill declaring Éire's neutrality • The United Kingdom government decides not to extend conscription to Northern Ireland.

further reading

F.H.A. Aalen, Kevin Whelan and Matthew Stout (eds), *Atlas of the Irish Rural Landscape* (Cork, 1997)

Jonathan Bardon, *A History of Ulster* (Belfast, 1992)

Ronald H. Bayor and Timothy J. Meagher (eds), *The New York Irish* (Maryland, 1996)

Mark Bence-Jones, *A Guide to Irish Country Houses* (London, 1978)

A.E.C. Bredin, *A History of the Irish Soldier* (Belfast, 1987)

Brian de Breffny and Rosemary ffolliott, *The Houses of Ireland* (London, 1975)

C.E.B. Brett, *Buildings of Belfast 1700–1914* (Belfast, 1985)

Dominic Bryan, *Orange Parades. The Politics of Ritual, Tradition and Control* (London, 2000)

Edward Chandler, *Photography in Ireland. The Nineteenth Century* (Dublin, 2001)

Concise Dictionary of National Biography (Oxford, 1992)

David Power Conyngham, *The Irish Brigade and its Campaigns* (New York, 1994)

Tim Pat Coogan and George Morrison, *The Irish Civil War* (London, 1998)

Ultan Cowley, *The Men Who Built Britain. A Celebration of the Irish Navvy* (Dublin, 2001)

Liz Curtis, *The Cause of Ireland. From the United Irishmen to Partition* (Belfast, 1994)

Richard Doherty and David Truesdale, *Irish Winners of the Victorian Cross* (Dublin, 2000)

Joseph Maria Eder, *History of Photography*, (Columbia, first pub. 1945)

E. Estyn Evans, *Irish Folkways* (London, 1957)

Alan Gailey, *Rural Houses of the North of Ireland* (Edinburgh, 1984)

Helmut and Alison Gernsheim, *A History of Photography* (London, second ed., 1969)

Maria Hamburg and Pierre Apraxine, *The Waking Dream: Photography's First Century* (New York, 1993)

Peter Hart, *The I.R.A. and its Enemies. Violence and Community in Cork 1916–1923* (Oxford, 1998)

Anne Haverty, *Countess Markievicz. An Independent Life* (London, 1988)

Keith Jeffrey, *An Irish Empire? Aspects of Ireland and the British Empire* (Manchester, 1996)

John S. Kelly, *The Bodyke Evictions* (Clare, 1987)

Liam Kennedy and Philip Ollerenshaw, *An Economic History of Ulster 1820–1939* (Manchester, 1985)

Declan Kiberd, *1916 Rebellion Handbook* (first pub. 1916 by *Irish Weekly News*; Dublin, 1998)

Christine Kinealy, *A Disunited Kingdom. England, Ireland, Scotland and Wales 1800–1949* (Cambridge, 1999)

Christine Kinealy, *The Great Irish Famine. Impact, Ideology and Rebellion* (Basingstoke, 2001)

Claudia Kinmouth, *Irish Country Furniture 1700–1950* (New Haven and London, 1993)

J.J. Lee, *Ireland 1912–75* (Cambridge, 1980)

Elizabeth Longford, *Victoria R.I.* (London, 1964)

Ben Maddow, *Faces. A Narrative History of the Portrait in Photography* (New York, 1977)

Gerard P. Moran, *The Mayo Evictions of 1860* (Westport, 1986)

Noel J. Mulqueen, *The Vandeleur Evictions in Kilrush, 1888. The Plan of Campaign* (Kilrush, 1988)

Cormac Ó'Gráda, *Ireland. A New Economic History, 1780–1939* (Oxford, 1994)

Sean Sexton, *Ireland. Photographs* (London, 1994)

Patrick and Maura Shaffrey, *Buildings of Irish Towns. Treasures of Everyday Architecture* (Dublin, 1983)

Mike Weaver, *The Art of Photography 1839–1989* (New Haven and London, 1989)

list of illustrations

a – above, *l* – left, *r* – right, *b* – below, *c* – centre

p. 1 Portrait of a boy, Teelin, County Donegal. *c.* 1865. Photographer unknown. Albumen print.
pp. 2–3 Irish vagrants in Scotland. *c.* 1909. W. Reid. Gelatine silver developed out paper.
p. 5*al* St John's Church. *c.* 1858. E. King-Tenison. Albumen print.
p. 5*ac* Kilronan Castle, County Roscommon. *c.* 1858. E. King-Tenison. Albumen print.
p. 5*ar* Fishwives on the Claddagh, Galway. *c.* 1905. Philip G. Hunt. Gelatine silver printing out paper.
p. 5*bl* Free State troops before attacking Irregulars between the villages of Bunduff and Cliffoney, County Sligo.
26 Sept ember1922. Photographer unknown. Gelatine silver print.
p. 5*bc* Steam engine in Waterford. 1900. Photographer unknown. Gold-toned gelatine silver printing out paper.
p. 5*br* Killarney, County Kerry. *c.* 1870. Photographer unknown. Gold-toned albumen print.
p. 6 Belfry of Aghadoe, County Kerry. 1864–69. Mr Mercer. Autotype.
p. 7 Kilmalkedar Church, west doorway. 1864–69. Mr Mercer. Autotype.
p. 9 Aghadoe Military Tower, County Kerry. 1864–69. Mr Mercer. Autotype.
p. 10 Belfry of Dysert O'Dea, County Clare. 1864–69. Mr Mercer. Autotype.
p. 11 Belfry of Iniscealtra, County Clare. 1864–69. Mr Mercer. Autotype.
p. 12 Group of women. *c.* 1850. Photographer unknown. Hand-coloured daguerreotype.
p. 13*l* Young men in suits. *c.* 1857. Robinson. Hand-coloured wet collodion positive on glass.
p. 13*r* Two women. *c.* 1858. Robinson. Hand-coloured wet collodion positive on glass.
p. 14*a* Newspaper sellers breaking for dinner. 1909. Christine Chichester. Gelatine silver printing out paper.
p. 14*b* Street in Belfast. *c.* 1900. Photographer unknown. Gelatine silver printing out paper.
p. 15 The Parliament building at Stormont in Belfast. *c.* 1945. Photographer unknown. Gelatine silver print.
p. 16*l* Lord Abercorn with family. *c.* 1868. Alex Ayton. Gold-toned albumen print.

p. 16*r* Police mug shots of Fenian prisoners: James Donahy, Henry Hughes, Hugh McGrishin. 1865–66. Photographer unknown. Albumen prints.
p. 17*l* Jeremiah O'Donovan Rossa. *c.* 1860. Photographer unknown. Albumen print.
p. 17*r* The Rising Sun public house in London after a Fenian bomb. 1884. B. Lemere. Gelatine silver printing out paper. Reproduced by permission of English Heritage. NMR
p. 18*l* General Sheridan. *c.* 1862. Matthew Brady. Albumen print.
p. 18*r* Guarding the suspension bridge at Niagara Falls, Canada against Fenian raid. 1866. George Barker. Collodion printing out paper.
p. 19*l* William O'Brien MP. 11 October 1889. Photographer unknown. Collodion printing out paper.
p. 19*c* Michael Davitt. *c.* 1886. Photographer unknown. Albumen print.
p. 19*r* Charles Stuart Parnell. *c.* 1878. Photographer unknown. Albumen print.
p. 20 Queen's College, Belfast. *c.* 1880. Robert French. Albumen print.
p. 21 The Orange Hall in Belfast. *c.* 1890. Photographer unknown. Albumen print.
p. 22*l* Mass at Ballintubber Abbey, County Mayo. *c.* 1872. Thomas Wynne. Albumen print.
p. 22*r* The Mission Colony, Achill Island, County Mayo. *c.* 1885. Robert French. Albumen print.
p. 23*l* J.A. Froude *c.* 1870. H.J. Whitlock. Albumen print.
p. 23*c* Thomas Carlyle. 1870s. Charles Watkins. Woodbury type.
p. 23*r* Mark Lemon. *c.* 1868. D. Everest. Gold-toned albumen print.
p. 24 Giant's Causeway, County Antrim. *c.* 1865. Photographer unknown. Gold-toned albumen print.
p. 25 Tarmon, County Leitrim. 1864–69. Mr Mercer. Autotype.
p. 26 Urchins in foliage. *c.* 1860. Attributed to Humphrey Haines. Gold-toned albumen print.
p.27 Dolmen (neolithic burial chamber). *c.* 1895. Unknown photographer. Gelatine silver transparency.
pp. 28–29 Nude studies. 1892–1911. Louis Jacob. Gold-toned gelatine silver printing out paper.
p. 30 Ladies from landed classes outside Rockingham House. *c.* 1858. Taken from an album titled, in gilt, 'Photographs'. Lady Augusta Crofton. Gold-toned albumen print.

p. 31a Lady Augusta Crofton writing at a table. *c.* 1865. Photographer unknown. Albumen print.

p. 31b The Tighe family. *c.* 1865. From a photographic album titled 'Georgina Harriet Tighe'. Attributed to Lady Augusta Crofton. Hand-coloured albumen print.

p. 32 Lady Louisa King-Tenison. *c.* 1863. Attributed to Edward King-Tenison. Albumen print.

p. 33 Gentry getting into a landau. *c.* 1863. From an album compiled by Georgina Tighe. Albumen print.

p. 35 Women and girls standing in front of ivy-clad house. *c.* 1860. From an album compiled in County Cork. Gold-toned albumen print.

p. 36l The Earl of Clarendon. *c.* 1864. Watkins. Albumen print.

p. 36r Charles Edward Trevelyan. *c.* 1865. Photographer unknown. Albumen print.

p. 37l Lord John Russell. *c.* 1865. J.E. Mayall. Albumen print.

p. 37c Sir George Grey. *c.* 1865. Photographer unknown. Albumen print.

p. 37r Sir Charles Wood. *c.* 1870. Attributed to W. Walker. Albumen print.

p. 38 Ruin. *c.* 1860. Photographer unknown. From an album compiled in County Cork.

p. 40 Kenmare (Killarney) House, County Kerry. *c.* 1890. Robert French. Albumen print.

p. 41 Lady Charles Beresford. *c.* 1890. Photographer unknown. Woodburytype.

p. 42 Beaters at Muckross House, County Kerry. *c.* 1857. From an album compiled by Arthur Vivian. Albumen print.

p. 43 Huntsman with dead game. *c.* 1865. Attributed to Lady Augusta Crofton. Albumen print.

p. 44 Huntsman at Kilronan. *c.* 1865. Page from an album. Gold-toned albumen print.

p. 45 Servants at Kilronan or Rockingham. *c.* 1860. Probably by E. King-Tenison. Gold-toned albumen print.

p. 46 Water Carriers. May 1855. Francis Edmund Currey. Gold-toned albumen print.

p. 47 Workers and cart on the Lismore Estate, County Waterford. *c.* 1855. Francis Edmund Currey. Albumen print.

p. 48a Kilronan Castle, County Roscommon. *c.* 1858. E. King-Tenison. Albumen print.

p. 48b Clifden Castle, County Galway. *c.* 1872. Thomas Wynne. Albumen print.

p. 49 Lismore Castle, County Waterford. *c.* 1890. Robert French. Albumen print.

p. 50, p. 51al Views of Bantry House, County Cork. *c.* 1880. Robert French. Albumen print.

p. 51ar Interior of Bantry House. *c.* 1880. Robert French. Albumen print.

p. 51br View from Bantry House. *c.* 1890. Robert French. Albumen print.

p. 52 The Great Telescope at Birr, King's County (later County Offaly). *c.* 1900. Eason and Son. Gelatine silver printing out paper.

p. 53 Infirmary, County Roscommon. *c.* 1858. E. King-Tenison. Gold-toned albumen print.

p. 54 Mrs Osborne with book. *c.* 1858. William Despard Hemphill. Hand-coloured wet collodion on glass.

p. 55al Image of dead man. 1840s. Photographer unknown. Daguerreotype.

p. 55r Young girl. *c.* 1860. From album compiled in Cork. Gold-toned albumen print.

p. 56 Portrait of a woman. *c.* 1860. Simonton and Millard. Hand-coloured wet collodion positive on glass.

p. 57 Portrait of two boys. *c.* 1860. Simonton and Millard. Hand-coloured wet collodion positive on glass.

p. 58 Gentry resting. April 1888. Photographer unknown. Gelatine silver printing out paper.

p. 59 Mrs Osborne. *c.* 1860. John Lawrence. Albumen print.

p. 60 Young boy. *c.* 1855. Simonton and Millard. Hand-coloured wet collodion positive on glass.

p. 61 Lord Anson, the Honourable George Anson and Lord Henry Anson. *c.* 1865. Page from an album. Gold-toned albumen print.

p. 62 Group of children. *c.* 1855. Lord Otho Fitzgerald. Salt paper print signed in the negative.

p. 63l Portrait of two children. *c.* 1865. From an album entitled in gilt, 'Georgina Harriet Tighe'. Gold-toned albumen print.

p. 63ar Woman and girl. *c.* 1880. W. and D. Downey. Albumen print.

p. 63br Young Oscar Wilde. *c.* 1872. A.J. Melhuish. Albumen print.

p. 64 Women and children indoors. *c.* 1858. Humphrey Haines. Wet collodion on glass.

p. 65 Mary Fitzgerald with a bandaged arm. *c.* 1853. Francis Edmund Currey. Salted paper print.

p. 66 Group of young men. *c.* 1858. James Robinson. Hand-tinted wet collodion positive on glass.

p. 67 Two portraits. *c.* 1865. Sir Robert Shaw. Gold-toned albumen print.

p. 68 Maghera thatched cottages, Ardara, County Donegal. *c.* 1920. Photographer unknown. Gelatine silver developed out print.

p. 69 Women with creels gathering seaweed. *c.* 1910. Detail of photograph on p. 92.

p. 70a Cottages in Falcarragh, County Donegal. 1888. Robert Banks. Albumen print.

p. 70b Mick McQuaid's Cabin. *c.* 1895. Robert Welch. Gelatine silver transparency.

p. 71 Farm in Lough Dan, County Wicklow. *c.* 1865. Photographer unknown. Gold-toned albumen print.

pp. 72–73 Washing blankets. *c.* 1910. Philip G. Hunt. Gelatine silver out paper.

p. 74 Ross Mahon, land agent. *c.* 1865. Attributed to Lady Augusta Crofton. Albumen print.

p. 75 Cabin near Roundstone, Connemara. *c.* 1895. Photographer unknown. Toned gelatine silver transparency.

p. 76 Woman breastfeeding baby. *c.* 1890. Photographer unknown. Albumen print.

p. 77 Woman spinning. *c.* 1900. Photographer unknown. Gelatine silver transparency.

p. 78 Gweedore inhabitants, County Donegal. *c.* 1890. Robert French. Albumen print.

p. 79 Poteen-making in Connemara. *c.* 1890. Robert Welch. Platinum print.

p. 80l Eviction at Falcarragh, County Donegal. 1888. Robert Banks. Albumen print.

p. 80r A battering ram. 1888. Robert French. Hand-coloured gelatine silver transparency.

p. 81 Widow Quirk's Cottages at Coomasaharn, County Kerry, after eviction. 1888. Francis Guy. Collodion silver printing out paper.

p. 82a Eviction at Michael Cleary's house entitled *Attacking the Breach.* 1888. Robert French. Albumen print.

p. 82b Cleary's house following evictions on the Vandeleur Estate, Kilrush, County Clare. 1888. Robert French. Albumen print.

p. 83 Michael Cleary and family outside temporary accommodation following eviction. 1888. Robert French. Albumen print.

pp. 84–85 Destroyed cabins and evicted families, Glenbeigh, County Kerry. 1888. Francis Guy. Collodion silver printing out paper.

p. 86al Cutting corn, County Donegal. 1920s. T.H. Mason. Gelatine silver developed out print.

p. 86ar A blacksmith. *c.* 1910. Philip G. Hunt. Gelatine silver printing out paper.

p. 86b Thatching. 1920s. T.H. Mason. Gelatine silver developed out print.

p. 87 Ballycopeland Mill, Millisle, County Down. *c.* 1910. J. Johnson. Gold-toned gelatine silver printing out paper.

p. 88 Reaping corn in the Clogher Valley, County Tyrone. *c.* 1912. Rose Shaw. Gelatine silver developed out print.

p. 89 Sheep shearing, Gleninagh, Connemara. *c.* 1895. Photographer unknown. Toned gelatine silver transparency.

p. 90a Boy loading up turf. 1920s. T.H. Mason. Gelatine silver developed out print.

p. 90b Bringing home turf. *c.* 1910. Philip G. Hunt. Gelatine silver developed out print.

p. 91 Footing turf. *c.* 1910. Philip G. Hunt. Gelatine silver developed out print.

p. 92 Women with creels gathering seaweed. *c.* 1910. Philip G. Hunt. Gelatine silver out print.

p. 93 Fishwives on the Claddagh, Galway. *c.* 1905. Philip G. Hunt. Gelatine silver printing out paper.

p. 94 Two images of sea fishing off the coast of County Down. *c.* 1938. S.M. Baliance. Gelatine silver developed out print.

p. 95 Gutting the fish on the quayside. *c.* 1938. S.M. Baliance. Gelatine silver developed out print.

p. 96al Fishwives at Castletownshend, County Cork. *c.* 1892. Louisa Warenne. Matt gelatine silver developed out print.

p. 96ar Curing mackerel at Castletownshend, County Cork. *c.* 1892. Louisa Warenne. Platinum print.

p. 96b Curing mackerel at Castletownshend, County Cork. *c.* 1892. Louisa Warenne. Matt gelatine silver developed out print.

p. 97 Four portraits. *c.* 1892. Louisa Warenne. Platinum prints.

p. 98a *Horse and Rider in the Aran Islands. c.* 1910. Christine Chichester. Sulphur-toned gelatine silver print.

p. 98b *Activities at the Shore. c.* 1910. Christine Chichester. Sulphur-toned gelatine silver print.

p. 99 *Alexandra Hotel, Killarney, County Kerry. c.* 1905. Christine Chichester. Gelatine silver printing out paper.

p. 100 *Mrs Griffin of Cahirciveen Selling Apples at Valencia Regatta, County Kerry. c.* 1910. Christine Chichester. Gelatine silver printing out paper.

p. 101 *Dancing, with no Accompanying Music, on Aran Island. c.* 1910. Christine Chichester. Sulphur-toned gelatine silver print.

p. 102l Market at Kilronan, Aran Islands. *c.* 1912. T.H. Mason. Gelatine silver developed out print.

p. 102r Turf for market, Galway. 1920s. Photographer unknown. Gelatine silver transparency.

p. 103 Accident at Thurles. *c.* 1900. W. Ritchie. Gold-toned gelatine silver printing out paper.

p. 104 Street scene in Galway. *c.* 1895. Photographer unknown. Toned gelatine silver positive on glass.

p. 105 Livestock market. 1920s. Photographer unknown. Gelatine silver transparency.

p. 106 Selling calves at market. Late 1920s. T.H. Mason. Gelatine silver developed out paper.

p. 107 On the quays in Kilronan, Aran Islands. Late 1920s. T.H. Mason. Gelatine silver developed out print.

p. 108 Study of labourer. *c.* 1858. Photographer unknown. Collodion positive.

p. 109l Study of piper. *c.* 1861. From an album compiled in County Cork. Albumen print.

p. 109r Group of workers. *c.* 1860. From album partly compiled in Cork. Photographer unknown. Gold-toned albumen print.

pp. 110–11 Gypsies on the Epsom Downs, a week prior to the Derby. 31 May 1930. Special Press. Toned gelatine silver developed out paper.

p. 111 An Irish tinker at work. *c.* 1909. W. Reid. Gelatine silver developed out print.

p. 112 Man with a pickaxe. *c.* 1930. World Wide Photos. Gelatine silver printing out paper.

p. 113 Washing clothes. *c.* 1930. World Wide Photos. Gelatine silver printing out paper.

p. 114 Girl feeding pet birds. *c.* 1930. World Wide Photos. Sulphur-toned gelatine silver printing out paper.

p. 115 Children in the Claddagh. 1920s. World Wide Photos. Gelatine silver printing out paper.

p. 116 Listening to music by lamplight. *c.* 1930. World Wide Photos. Gelatine silver printing out paper.

p. 117 Interior of Claddagh cottage. *c.* 1930. World Wide Photos. Sulphur-toned gelatine silver developed out paper.

p. 118 Men examining tweeds. *c.* 1930. World Wide Photos. Sulphur-toned gelatine printing out paper.

p. 119 Face of old woman. *c.* 1930. World Wide Photos. Sulphur-toned gelatine silver printing out paper.

p. 120 London Irish Rifles. 1930s. Photographer unknown. Gelatine silver printing out paper.

p. 121 Hunger striker. 1917. Detail of lower photograph, p. 153.

p. 122 7th Dragoon Guards. 1855. Sir Robert Shaw. Albumen print.

p. 123 Field Marshall Viscount Gough. 5 February 1861. Camille Silvy. Albumen print.

p. 124a Army marching band, 2nd Inniskilling Fusiliers. *c.* 1905. Photographer unknown. Gelatine silver printing out paper.

p. 124b 3rd Battalion Grenadier Guards, taken at Beggar's Bush Barracks in Dublin. October 1868. Photographer unknown. Albumen print.

p. 125 Royal Irish Fusiliers. *c.* 1910. Photographer unknown. Gelatine silver developed out print on blue-dyed paper.

p. 127a Irish regiment in Canada. *c.* 1870. Photographer unknown. Albumen print.

p. 127b Sergeants of the Inniskilling Fusiliers. *c.* 1900. Photographer unknown. Gelatine silver printing out paper.

p. 128 Royal Irish Rifles cricket eleven. 1907. Photographer unknown. Matt gelatine silver printing out paper.

p. 129 D. Company football team, Royal Irish Rifles. *c.* 1895. Photographer unknown. Albumen print.

p. 130 British Army officers in Belfast. 1902. Photographer unknown. Albumen print.

p. 131 Two images of the Royal Irish Rangers with field artillery, Ballinkiler, County Down. 1903. Photographer unknown. Gold-toned gelatine silver printing out paper.

pp. 132–33 A raiding party of the 8th Irish King's Liverpool Regiment at Wailly. 18 April 1916. Photographer unknown. Gelatine silver negative. Imperial War Museum Q.510.

pp. 134–35 Two images of the 8th Liverpool Irish (57th division) entering Lille, France. 18 October 1918. Photographer unknown. Gelatine silver negative. Imperial War Museum Q.9572, Q.9579.

p. 136l Queen Victoria at Kate Kearney's Cottage, Killarney, County Kerry. 1861. Photographer unknown. Albumen print.

p. 136r Prince Edward of Saxe-Weimar, Dublin. 1868. Photographer unknown. Gold-toned albumen print.

p. 137 Two images of the visit of King Edward VII to Ireland. 1903. Photographer unknown. Matt gelatine silver printing out paper.

pp. 138–139 Debutantes presented to King Edward VII during his visit to Ireland. 1903. Photographer unknown. Gelatine silver print.

p. 140 James Joyce in Paris. 1928. Berenice Abbott / Commerce Graphics Ltd, Inc. Platinum print.

p. 141l Senator W.B. Yeats. *c.* 1922. Lafayette. Gelatine silver print.

p. 141r George Bernard Shaw *c.* 1925. Marcel Sternberger. Gelatine silver developed out print.

p. 142 Clergymen signing the Ulster Covenant. 28 September 1912. Alexander Hogg. Gelatine silver transparency.

p. 143l First page of the Ulster Covenant. 28 September 1912. Alexander Hogg. Gelatine silver transparency.

p. 143ar Field Marshall Lord Roberts. *c.* 1908. Photographer unknown. Gelatine silver transparency.

p. 143br Sir Edward Carson with nurses at Ballyclare, County Antrim. *c.* 1912. Photographer unknown. Gelatine silver transparency.

pp. 144a, 145 British Army barricades in 1916. Photographer unknown. Gelatine silver print.

p. 144b Additional artillery arriving during the Easter Rising. 1916. Photographer unknown. Gelatine silver print.

p. 146 Military vehicles used by the British forces in Dublin during the Easter Rising. 1916. Photographer unknown. Gelatine silver negative.

p. 147 Armoured car. 1916. Joseph Cashman. Gelatine silver print. Photograph courtesy Cork City Hall.

p. 148 The ruins of Liberty Hall. 1916. Mr Chancellor. Gelatine silver printing out paper.

p. 149 The damaged YMCA (Young Men's Christian Association) after the Easter Rising. 1916. Photographer unknown. Gelatine silver transparency.

p. 150 General Maxwell inspecting troops. *c.* 1916. Photographer unknown. Gelatine silver transparency.

p. 151 Con Colbert. *c.* 1915. Photographer unknown. From a gelatine silver negative. Photograph courtesy the National Photographic Archive of Ireland.

p. 152a Group of hunger strikers interned on the *Argenta*. 1923. Photographer unknown. Toned gelatine silver printing out paper. Photograph courtesy of Máire Connolly.

p. 152b Hunger striker, Séamus (James) Connolly, Londonderry Prison. 1940. Photographer unknown. Gelatine silver printing out paper. Photograph courtesy of Máire Connolly.

p. 153 Two hunger strikers. 1917. Photographer unknown. Gelatine silver developed out paper.

p. 154 Mrs Thomas Clarke, Countess Markievicz, Kate O'Callaghan, Margaret Pearse. *c.* 1924. Independent Newspapers. Photographer unknown. Gelatine silver developed out paper.

p. 155 Countess Markievicz. *c.* 1910. Photographer unknown. Black and white transparency from gelatine silver negative. Photograph courtesy the National Photographic Archive of Ireland.

p. 156 Street scene following an ambush in Dublin during which a British soldier was killed. September 1920. Joseph Cashman. Gelatine silver print.

p. 157 Men of the Fourth Battalion Column. Cork Number 1 Brigade preparing for an attack on a British troop train at Cobh Junction, fixed for 22 February 1921. 1921. Photographer unknown. Gelatine silver print. Photograph courtesy Cork City Hall.

pp. 158a, 159 The burning of Cork. 1920. Photographer unknown. Gelatine silver print. Photograph courtesy Cork City Hall.

p. 158b Black and Tans. 1920. Photographer unknown. Gelatine silver negative.

p. 160 Arthur Griffith, Robert Barton and Michael Collins at the London negotiations of the Anglo–Irish Treaty. 1921. P.L. Kjeldsen. Gelatine silver prints.

p. 161 British troops leaving Ireland. 1922. Photographer unknown. Gelatine silver printing out paper.

pp. 162–63 British troops on the Dublin docks leaving Ireland. 1922. Photographer unknown. Gelatine silver developed out paper.

pp. 164–65 Three images of anti-Catholic pogroms in Lisburn. 1920. Photographer unknown. Gelatine silver print.

p. 166 Rory O'Connor giving a speech. 1922. Photographer unknown. Gelatine silver negative.

p. 167 Free State troops before attacking Irregulars between the villages of Bunduff and Cliffoney, County Sligo. 26 September 1922. Photographer unknown. Gelatine silver print.

p. 168 Two images of a train derailed during the Civil War. 1922. Photographer unknown. Gelatine silver developed out paper.

p. 169a Derailed train in County Tipperary. 1922. Photographer unknown. Gelatine silver print.

p. 169b Repairing the track after damage. 1922. Photographer unknown. Gelatine silver negative.

pp. 170–71 James Quirke, allegedly the last man shot in the Civil War, before and after embalming. 1923. E. Leslie. Gelatine silver developed out paper.

p. 172 Rotor for the *Argentine*. *c.* 1912. Robert Welch. Gelatine silver developed printing out paper.

p. 173 Portion of turbine casing for the *Olympic* being bored. *c.* 1909. Robert Welch. Toned gelatine silver transparency.

p. 174a Threshing machine. *c.* 1860. From a County Cork album. Albumen print.

National Photographic Archive of Ireland.

p. 174b Steam engine for threshing machine. *c.* 1885. From a County Carlow album. Platinum print.

p. 175 Railway coaling stage, Inchicore, Dublin. *c.* 1920. P. Kennedy. Gelatine silver print.

p. 176 Bleaching linen in Lisburn *c.* 1903. Underwood and Underwood. Gelatine silver printing out paper.

p. 177 Linen manufacture in Belfast. *c.* 1900. Photographer unknown. Gelatine silver printing out paper.

p. 178 Part of the *Argentine*. *c.* 1912. Robert Welch. Gelatine silver developing out paper.

p. 179 Part of the engine room of the *Olympic*, built by Harland and Wolff. *c.* 1909. Robert Welch. Toned gelatine silver transparency.

p. 180 O'Connell Bridge. 1920s. Photographer unknown. Gelatine silver print.

p. 181 Eamon de Valera with two sons at the funeral of his son, Brian. 12 February 1936. Fox Photos. Gelatine silver developed out print.

p. 182l Sailor. *c.* 1863. Augustuvus Darcy. Gold-toned albumen print.

p. 182r Deep sea diver. October 1864. Augustuvus Darcy. Gold-toned albumen print.

p. 183 *The Eilander* of County Down on the rocks near the Tyne after a great gale. 1 March 1933. Photographer unknown. Gelatine silver developed printing out paper.

p. 184l Informal study of people in train carriage travelling to Blarney, County Cork. *c.* 1914. Photographer unknown. Toned gelatine silver transparency.

p. 184ar Early road building in County Cork or Kerry. *c.* 1860. Photographer unknown. Gold-toned albumen print.

p. 184br Steam engine in Waterford. 1900. Photographer unknown. Gold-toned gelatine silver printing out paper.

p. 185 Train crash, Westmoreland Street, Dublin. 14 February 1900. Photographer unknown. Gelatine silver printing out paper.

p. 186 Irish workers in East Midlands using an early version of the pneumatic drill. *c.* 1934. Photographer unknown. Gelatine silver print.

p. 187 Thackley Tunnel near Leeds, England. *c.* 1900. Photographer unknown. Gelatine silver.

p. 188a St George's landing stage at Liverpool. *c.* 1890. James Valentine. Albumen Print.

p. 188b An American liner in Liverpool. *c.* 1880. Frith Series. Gold-toned albumen print.

p. 189*l* Ellis Island, New York. *c.* 1900. T. McAllister. Gelatine silver transparency.

p. 189r Emigrants waiting to enter America at Ellis Island, New York. *c.* 1900. T. McAllister. Gelatine silver transparency.

p. 190 Interior of St Patrick's Cathedral, Dublin. *c.* 1880. Robert French. Albumen print.

p. 191 Eucharistic Congress at the Phoenix Park. 1932. Photographer unknown. Gelatine silver negative.

p. 192 Irish nuns. *c.* 1900. Photographer unknown. Toned gelatine silver printing out paper.

p. 193*l* Two nurses. *c.* 1912. Castle Studio, Belfast. Gelatine silver print.

p. 193r Portrait of a nun. *c.* 1912. J. Stanley. Gelatine silver print.

pp. 194–95 Studio portraits taken between 1860 and 1895: priest by Lawrence Studio; couple by Lauder Brothers; woman and child by E.T. Church; woman by Chancellor. Collodion and albumen prints.

p. 196 Side car in Belfast. *c.* 1870. James Magi. Albumen print.

p. 197 Milk delivery boy. 1920s. Photographer unknown. Gelatine silver printing out paper.

p. 198*l* Market day, the square, Thurles, County Tipperary. *c.* 1900. W. Ritchie. Gelatine silver printing out paper.

p. 198r George's Street, Limerick. *c.* 1870. Robert French. Albumen print.

p. 199 Street market in Cork. *c.* 1905. W. Ritchie. Gold-toned silver printing out paper.

p. 200*l* Street in Rathfarnham, Dublin. 1920s. Gelatine silver printing out paper.

pp. 200–1 Scotch Street, Armagh. *c.* 1900. W. Ritchie. Gold-toned gelatine silver printing out paper.

p. 202 Hibernian Dining Rooms, Dublin. *c.* 1895. Photographer unknown. Albumen print.

p. 203 Shop interior, the Curragh, Kildare. *c.* 1903. Philip G. Hunt. Gelatine silver developed printing out paper.

p. 204 A travelling auctioneer. 1920s. T.H. Mason. Gelatine silver developed out paper.

p. 205 Grain being taken out of warehouse owned by Dublin Port and Docks Board. 1920s. Photographer unknown. Gelatine silver printing out paper.

p. 206 Farmleigh Handicap, Phoenix Park, Dublin. 1930s. Photographer unknown. Gelatine silver printing out paper.

p. 207 Kilkenny goalmouth, All Ireland Hurling Final (Cork v. Kilkenny). 1931. Photographer unknown. Photograph courtesy Irish Examiner.

p. 208 Johnny Doran Playing the Uilleann Pipes. *c.* 1940. Photographer unknown. Gelatine silver developed out paper. Photograph courtesy Na. Píobairí Uilleann.

p. 209 Merry-go-round, Dublin. 1920s. Photographer unknown. Gelatine silver negative.

p. 210*a* Motor racing over the Ards Circuit, County Down. 2 September 1934. Photographer unknown. Gelatine silver print.

p. 210*bl* Seventeen horsepower Maudslay car driven by a woman. *c.* 1912. Photographer unknown. Gelatine silver printing out paper.

p. 210r Racing cyclist. 13 June 1902. Signed D'Arcy. Platinum print.

p. 211 Charles McGonegal, armless pilot. 5 March 1930. Underwood and Underwood. Toned gelatine silver print.

pp. 212–13 A boating trip in Ashleagh, County Carlow. *c.* 1912. Photographer unknown. Gelatine silver printed out paper.

p. 214 Billboards in Galway. 1920s. Photographer unknown. Gelatine silver transparency.

acknowledgments

Process identification was by Nicholas Burnett, Museum Conservation Services. Photography was by Clarissa Bruce. Additional thanks to: Eamon Browne; Edward Chandler; Cork City Hall; Michael Farelly; Claire Freestone, National Portrait Gallery, London; Philippe Garner; John Grey; Vincent Hehir; Alan and Mary Hobart; Michael Holland; Tom Kenny; Robert Langford; Tom Lawlor; Ian Leith; Murray MacKinnon; Gráinne McLaughlin; Liam McNulty; Terence Pepper, National Portrait Gallery, London; Muiris Ó Róchain; John O'Sullivan; Owen Rodgers; Laurie Tyrer; Peter Walshe; and John Young.

index

Abercorn, Duke of 16
absenteeism 34–36
Achill, Co. Mayo 27
Act for the Better Government of Ireland (1920) 127
Act of Union (1800): introduction of the 8, 126, 172; effects of the 11, 15, 21, 31, 36, 124, 181; repeal of the 8, 16, 20
Aghadoe, Co. Kerry 11
agrarian 'outrages' 74; conflict 124
agriculture: before the Famine 34; commercialization of 68–70, 177; crises 34, 73; employment in 14; technological developments and mechanization 34, 41, 79, 86, 172, 174, 176; change from tillage to pasture after the Famine 106, 172
American Civil War 18
Anglican Church 21
Anglo-Irish Treaty (1921) 14, 127, 155, 160, 162, 166, 167, 168, 181
Anglo-Irish War (1919–21) 14, 158, 162, 168; Truce of July 1921 158
Aran Islands 102, 107
Argenta prison ship 152
Argentine 172, 178
Armagh 200
Ascendancy class, the 11, 17, 21, 32, 41, 120–23
Ashe, Thomas 153
Balfour, Arthur 41
Ballinkinler, Co. Down 131
Ballintubber Abbey 22
Ballycopeland Mill, Millisle, Co. Down 87
Bantry House, Co. Cork 51
Bantry, Earl of 51
Barton, Robert 160
Belfast 14, 15, 174, 178; Catholic population of 15, 16; creation of parliament (1920) 20; housing 14, 15; industry 15, 174; linen manufacture 174–76; Orange Halls 21; policing 15, 124, 131; Protestant population of 15, 120; Queen's College 20; sectarian violence 15, 124, 126; shipbuilding industry 172, 176; Stormont 15; Ulster Hall 18

Bianconi, Carlo 177–78, 197
'Big Houses' 39, 41, 51
Birr Castle, King's Co. (Co. Offaly) 52
Black and Tans 158
Board of Works 184
boycott, strategy of 74–75
Boyne, Battle of the (1690) 20, 21
Britain: trade links with 15, 172 (*see also* export); Irish workers in 186
British army 123, 128, 131, 144, 146–47; and evictions 70; garrisons 11; Irishmen in the 120, 123–26; leaving Ireland 160, 162; leisure activities of 124, 128
British Commonwealth, the 31, 126, 127, 162
British Empire 15, 18, 120, 123, 126, 127, 178
British government 11, 16, 17, 18, 31, 41, 77, 124, 126, 134, 155
British Liberal Party 18–20, 34, 70
British monarchy: visits to Ireland 11, 20, 124, 136, 139
British Parliament, Westminster 8, 77, 127; House of Commons 124, 126; House of Lords 124
Carlyle, Thomas 23
cars *see* motoring
Carson, Edward 133, 142; statue 15
Casement, Sir Roger 149
castles: Birr, Queen's Co. (Co. Offaly) 53; Clifden 48; Kilronan 48; Lismore 47
Catholicism 20, 120: anti-Catholic pogroms 16, 164–65; Catholic Emancipation (1829) 8, 21, 174; discrimination against 15, 20, 21, 32, 34, 176; granted right to sit in British parliament 8; Catholic landowning class 11; Catholic Church in Ireland 20, 21–22, 32, 77, 126, 191; participation in the First World War 131; Catholic middle classes 123
cattle rearing 34, 39
Chichester, Christine 96, 100
Church of Ireland 20
Churchill, Lord Randolph 18
Churchill, Winston 31

Civil War, Irish (1922–23) 14, 167, 170
clachans 70
Claddagh, the 112–17
Clarendon, Fourth Earl of 36
Clarke, Thomas 151
Clifden 27, 48; Castle 48
clothing 59, 61, 78, 93, 102, 104, 109, 116, 118
Coercion Acts 124
Colbert, Con 151
Collins, Michael 149, 160, 168, 170
colonial system 32 *see also* British Empire
commemorations: of Empire Day (24 May) 27; of the Battle of Boyne (12 July) 27; of Covenant Day (28 Sept) 27; St Patrick's Day (17 March) 27, 124
Congested Districts Boards, creation of 41, 77–79
Connaught 74
Connemara 74, 79, 89; sheep-shearing in 89; a still in 79
Connolly, James 134
conscription 31, 124, 134
Conservative Party 18, 20, 34, 77, 124, 126, 174, 178
'constructive unionism' 77
Cork 158, 174, 198
cottage industry 174–76
cottages, stone-built 68, 80, 82, 86
cotton production 174
Covenant against Home Rule 124, 126
Craig, Sir James 15
Craigavon, Lord 31
Crofton, Lady Augusta 30
Currey, Francis Edmund 47
D'Arcy, John 48
Daguerre, Louis 8, 23
daguerreotypes 13, 23, 55, 57
Dáil, the 160
dancing 70; Irish step dancing 101
Darkest Dublin, collection of photographs 14
Davitt, Michael 17, 19, 74, 85
Derryveagh, Co. Donegal 73, 74
distilling 79; still in Connemara 79
Doran, Johnny 208
Dublin 11, 14, 136, 140, 141, 178, 200; Catholic population

of 14; destruction caused during Easter Rising 148, 149; creation of parliament (1920) 20; the Hibernian Dining Rooms 202; housing 14; industry 14, 174; Phoenix Park 191, 206; Photographic Society 30; population growth 14; poverty 15; recruitment for British Army 123; St Patrick's Cathedral 190; statue of Daniel O'Connell 11, 181; Trinity College 14
Dysert O'Dea, Co. Clare 11
Easter Rising (1916) 14, 126, 144–51, 155, 166, 205
Edward VII, King 139
Edward, Prince 136
Éire 31, 127, 181
Ellis Island, New York 189
emigration 8–11, 22, 30, 36, 37, 41, 70, 73, 123, 174, 177, 181; to North America 18, 24, 79, 105, 189, 198
Emmet, Robert 16
employment: in agriculture 14; in Britain 186–87; sectarian discrimination 15, 176
Encumbered Estates Act (1849) 39, 48
Enniskillen, Co. Fermanagh 127 *see also* Inniskilling Fusiliers
estates, clearance of 73
evictions 41, 70, 80, 85, 124; Bodyke evictions in east Clare (1887) 77; Vandeleur evictions, Co. Clare (1888) 82
export of foodstuffs 34, 36, 68–70, 87, 95, 107, 174
factories 176
Famine *see* Great Hunger
farming *see* agriculture
Fenianism 16, 17, 18, 19, 77
First World War 14, 79, 123, 124, 126, 131, 133, 206; Battle of the Somme 126; Catholic participation in 133
fishing 79, 94–95, 98, 112
Froude, James Anthony 23
Gaelic cultural revival 101, 120
Gaelic language 37, 70, 120
gentry 32, 39, 43, 44
Giant's Causeway, Co. Antrim 24
Gladstone, William 41, 77, 124
Gough, Field Marshall Viscount 123

Government of Ireland Act (1920) 126 see also Northern Ireland
Great Hunger 11, 14, 22, 34, 36–43, 47, 48, 53, 70–74, 79, 178; depopulation due to 37, 39, 70, 79, 89, 106, 123, 172, 198; evictions after 80; policy formation during 37–39; population growth after 174; survivors of 96, 109
Grenadier Guards, 3rd Battalion 124
Grey, Sir George 37, 39
Griffith, Arthur 160
Guinness: brewing company 174; family 59, 174, 190
Harland and Wolff (shipbuilding company) 172, 176, 178
harvests 73, 80, 86, 88, 172, 177
Home Rule 15, 18; bill 126; movement for 17, 20, 34, 77, 79, 124; shelving of Home Rule bill 142; protests against 124, 126
homelessness 37, 73
hunger strikes 120, 153
hurling 207, 208
imports: of coal 90; food after 1846 36; of foreign produce 177
industry 14, 15, 174; barrel-making 174; biscuit making 14, 174; brewing 14, 174; development 41, 77, 176; distilling 14, 174; engineering 15; glass-making 174; linen production 15, 174–76, 181; ropemaking 15; shipbuilding 15, 172, 174, 176, 181, 200; textiles 174–76, 200; tobacco 15
Iniscealtra, Co. Clare 11
Inniskilling Fusiliers: 2nd 124; Royal 127
Irish Free State 126, 127; Constitution (1937) 79, 126–27, 167; creation of 41, 79, 162; government 14–15, 22, 31, 39, 41, 126, 127; links with Britain 181
Irish King's Liverpool Regiment, 8th 133, 134
Irish language see Gaelic
Irish nationalism 11, 34, 39, 74, 120, 124, 126, 149, 167; opposition to participation in

First World War 133, 134; monuments to 11–14
Irish Parliamentary Party 133
Irish Republican Army (IRA) 157, 167
Irish Republican Brotherhood 126
Irish Volunteers 126
Irregulars, the 167, 168, 170
Jacob, Louis 29
James I of England and VI of Scotland 20
James II, King of England 20, 127
Joyce, James 140, 200
Kenmare (Killarney House), Co. Kerry 41
Kilmalkedar Church 4
Kilronan Castle, Co. Roscommon 32, 44, 48, 61
King-Tenison, Edward 32, 44, 48, 61
King-Tenison, Lady Louisa 32
Land Acts: of 1881 41, 77; of 1923 39
Land Commission 39, 41
Land League 41, 77, 79, 82, 85; foundation of (1879) 17, 19, 74, 80
land ownership 21, 32, 34, 39, 41
Land War (1879–82) 17, 43, 85
land: abandonment of 73; letting and subletting of 34; occupation of 36, 37; reform 74, 77, 79; subdivision of 68, 172; taxation on 73
landlord class 11, 17, 32–67, 70, 74, 79, 80, 106, 120; British 32; Catholic 11, 32–34; demise of 11, 39–41, 43; legal rights of 74; murders of 73; native Irish 34, 39, 70–73; Protestant 32, 39; replacing tenants with sheep 172–74; rise of 11; taxes imposed on 36 see also Ascendancy class
Lawrence Collection 51, 59
Lemon, Mark 23
Limerick 198; Castle Oliver 39
Lisburn: anti-Catholic violence in 165
Lismore Estate 47; Castle 47
Lloyd George, David 126, 127, 160
London Irish Rifles 120
MacGill, Patrick 186
McGonegal, Charles 210

MacSwiney, Terence 153
Mahon, Ross 74
markets 102, 105, 106, 174, 198
Markievicz, Countess Constance 126, 155
Maxwell, General 151
medical provision 52
military, the 70; presence of British 17, 124, 131, 146 see also British army
motoring 181, 197, 204, 210
music 70, 116
nationalism 16, 17, 18, 19, 74, 174
'navvies' 186
Northern Ireland 15, 126, 127
nuns 193
O'Brien, William 19
O'Connell, Daniel 16–17, 20, 21, 181; statue of 11, 181
O'Connor, Rory 166
O'Donovan Rossa, Jeremiah 16
O'Hanlon, Reverend W. 15
Olympic, the 172, 176, 178
Orange Order 20, 21; Orange Halls 21, 176
Parnell, Charles Stewart 17, 19, 74
Partition of Ireland 15, 20, 22, 31, 41, 126, 127, 152, 165, 181
Pearse, Patrick 16, 17, 151
peasantry class 68; collapse of 37
peat bogs 70, 79, 90; cutting peat 90–91, 102
Penal Laws 21, 32–34, 123
photography: albumen process 34; as an art form 24; consumer market, development of a 31, 195; cost of 24, 31, 109, 195; discovery of 8, 23; dry-plate process 24; early 11, 13, 23; photographic equipment 24, 30; photographic studios 24, 27; as a propaganda tool 24; influence of tourism 27; wet-collodion process 13, 24, 57
Pirrie, William 176
policing 11, 15, 70, 124, 124
population change: depopulation 8, 14, 15, 177, 181; population growth 34, 68, 174
potato 34, 79, 87: dependence on the 8, 34, 68, 172, 176; failure of crop 32, 176 see also Great Hunger

poteen 79
poverty 8, 15, 68–118, 174, 181; urban 14
press, the 74, 77, 82
Protestant Defence organizations 21 see also Orange Order
Protestantism 8, 14, 15, 17, 21, 120, 124, 126; and Ascendancy class 21; churches 190; evangelicals 22; Mission Colony on Achill Island, Co. Mayo 22; Orange Order 20; Protestants in the British Empire 123; plantations 20
Punch 23
Quarter Acre Clause 36–37, 73
railways: building of 186; closing of 178; coaling stage (Inchicore, Dublin) 174; development of the 15, 24, 27, 176–78, 197, 198; rail network 168, 169, 177–78, 184–85
Redmond, John 133
religion 20, 70; religious divisions 20–21 see also Catholicism and Protestantism
Republic of Ireland 31 see also Éire and Irish Free State
roads 176–77, 181, 184, 186, 198
Roberts, Field Marshall Lord 142
Roscommon Infirmary 53
Royal Irish Fusiliers 124
Royal Irish Rangers 131
rural population 27, 177, 200; work 27, 47, 73, 77, 89–92, 98, 102
Russell, Lord John 36, 37, 39
seaweed 92
Second World War 31, 123, 181
sectarian conflict 15–16, 124, 126, 165, 176, 131
Shaw, George Bernard 141
Shaw, Rose 30, 88
sheep-shearing 89
Sheridan, Philip Henry 18
shipbuilding 15, 172, 174, 176, 181, 200
shops 174, 203; women employed in 79, 202, 203
Sinn Féin 16, 126, 155, 162
Somme, Battle of the 126
spinning (wool) 77, 89
steam engine 172, 184
Talbot, William Henry Fox 44

Tarmon, abbey of, Co. Leitrim 24
Tenant League 74
tenants, smallholding 36–37, 43, 79, 80, 120; eviction of 41, 70–77
thatch 86
'Three Fs' 74, 77
Titanic, launch of the 176
tourist industry 27, 178
trade and traders 15, 181, 198, 204
transport 177–78 see also railways and roads
Trevelyan, Charles 36, 39
'Troubles', the 22
turf see peat bogs
uilleann pipes 208
Ulster Division, 36th 126
Ulster Volunteers 124
Union, the 34; repeal of 39 see also Act of Union
unionism 17–18, 21, 120, 123, 124, 126; resistance to Home Rule bill 124, 142; Unionist Party 15, 20, 21, 27, 133
uprisings: of 1798 11, 120; of 1848 14, 120
Valera, Eamon de 79, 149, 160, 162, 181
Victoria, Queen 11, 20, 124, 136
War of Independence (1919–21) 16
Warenne, Louisa 96
weaving 77, 176
Welch, Robert 79, 172, 178
whiskey 70, 79
Wilde, Oscar 62
William of Orange 20, 21, 127
women 27–30, 79; agricultural work 88, 92; 79; domestic service 203; employment in factories 79, 176, 203; employment in shops 79, 202–3; exclusion from clubs and societies 30; fishwives 93, 96; joining religious orders 193; nursing 193; suffrage 155
Wood, Sir Charles 37, 39
wool 89, 93
working class 14, 31
Workman, Clark and Company 172, 176
Yeats, William Butler 141
'Young Ireland' 16